SEEING IN SIXES 2018

Six-image Projects from LensWork Readers

BROOKS JENSEN & MAUREEN GALLAGHER

Editors

Photography & the Creative Process

Books by LensWork Publishing

Books by Brooks Jensen

Letting Go of the Camera
The Creative Life in Photography
Looking at Images
Photography, Art, and Media
The Best of the LensWork Interviews
Single Exposures
Single Exposures 2

Books by Brooks Jensen and Maureen Gallagher

Seeing in SIXES 2016
Seeing in SIXES 2017

By David Hurn/Magnum and Bill Jay

On Being a Photographer

By Bill Jay

The Best of EndNotes (LensWork #83)

2018 Seeing in SIXES

Six-image Projects from LensWork Readers

Brooks Jensen
Maureen Gallagher

Editors

LENSWORK PUBLISHING
2018

INTRODUCTION

For some years two independent ideas rolled around in opposite corners of my brain — neither of them fully developed nor coming to fruition — until 2016 when we invited our readers to participate in a new LensWork community book project we titled *Seeing in SIXES*. The resulting deluge of six-image entries challenged us to edit the field down to 50 projects for publication. It was clear that the LensWork community loved the concept. So, for the third year in a row, we present our selections for *Seeing in Sixes 2018!*

A little background might be important for those of you who are new to the *Seeing in SIXES* concept. It is a blending of two ideas that form the foundation of 6-image projects.

Idea #1 — Small Projects

You are all familiar with the Japanese form of poetry called the *haiku* — micro-sized poems that are restricted to just 17 syllables. Are you familiar with a similar concept in fiction writing called the *six-word story*? Ernest Hemingway (who was famous for his brief and compact writing style) was offered a wager that he couldn't write a story in just six words. "Easy," he said, and immediately offered up the following:

Baby Shoes For Sale
Never Worn

From this, an entire genre of writing was born which can be seen at a very entertaining website, www.sixwordstories.net.

I love the core idea of both the haiku and the six-word story: an art form of exceedingly compact style that as producers challenges us, and as readers engages our visual imagination. Well, if this is a good idea for written art forms, why not for photographic ones, too?

Since the beginning of photography, the multiple-image project has been a part of our medium. Most famously, the ubiquitous "photo-essay" was a staple of such publications as the long-defunct *Life* and *Look* magazines. Of course, here at *LensWork*, we have a 25-year history of publishing multiple-image projects. We studiously avoid the more common photographic phenomenon we refer to as "greatest hits" photography.

Yes, but …

There is a world of difference between a large *LensWork* portfolio of 12-20 images and a compact project that fits in half a dozen.

More to the point, you would be amazed how many absolutely wonderful portfolios we review and ultimately reject for *LensWork* because the project begins to repeat and/or devolve to secondary images after the first half-dozen amazing images. We've noticed this for years and it has been a frustration in our selection process. Quite simply, we see so much wonderful work that is just too short for the portfolio format of *LensWork*!

In fact, this is so common that for years I've wondered *why*: Is there something inherent in photography that lends itself naturally to a deeper exploration than is possible in *one image*, but fully satisfied in just a few additional ones? I've been exploring this in my personal project I call *Kokoro* — small bodies of work each encapsulating a single subject or idea. (see www.brooksjensenarts.com). I publish them as PDFs, but they could just as easily be gathered together in book form. Perhaps I will, someday.

So, what if there were (to pick a number almost at random) a six-image presentation format for photography? Well first, there is an inherent problem in a six-image presentation: Where does one show it? This is too many images for a "greatest hits" presentation — either framed above the fireplace or published in single-image magazines; it's too short to be a book or even for publication as a portfolio in *LensWork*. To make matters worse, for *LensWork* we typically require 30-40 images in a submission so we have some editorial flexibility. Such a volume of work can be overreaching for many projects.

Elsewhere I've written about a similar problem with the fiction genre known as the *short story*. In essence, the format you and I now know as "the short story" simply didn't exist until the magazine business became ubiquitous. Without a medium for publication, there was no outlet for an author to find an audience for short fiction — so it literally didn't exist. Instead, writers wrote for the medium that could find an audience: long-form fiction which could easily be published as books. With the invention of the magazine business (roughly the mid-1800s), short fiction had a home and a new genre of writing and storytelling was popularized.

Similarly, where does the photographic project of a few images find a publication home? Simply said, without a vehicle for publication, the small, micro-project struggles to find an audience.

So, why not create a vehicle for such projects — a book of short … um … what shall we call these? I struggled for a name that defines them clearly:

- Micro-project (too brewery-sounding)
- Mini-portfolios? (too Austin Powers)
- Photo-essay? (too W. Eugene Smith)
- Short story? (too O. Henry)
- Sketches? (too Charles Dickens)
- Photographic sketch? (too Photoshop)

Perhaps a look at the content might help.

Small bodies of work tend to fall into a number of styles or categories. The most common are:

Exploring a common subject
Exploring an interesting place
Exploring an idea or concept
Personal diary, exposition
Narrative story, often over time
Extended portrait

There are, of course, numerous other possibilities, but these appear most frequently — at least in the form of submissions to *LensWork*.

I'll bet every one of you reading this has at least a few small projects of images that fit one of the above categories. Perhaps they would be a perfect fit for presentation of a half-dozen images, seen as a group.

And I should add, these are not diptychs, triptychs, or grids, i.e., multiple images intended to be seen as a *visual singularity* in the same field of view or picture frame. Instead, a *Seeing in SIXES* project is a compact expression of a single nature, possibly a story, definitely a theme, held together stylistically, and making a whole that is greater than the sum of its parts: tight, distilled to the essentials, impactful, deeper than what is possible with a single image.

I still don't know what to call them, but *Seeing in SIXES* is the title we've used the last two years and it seems to have stuck. *Seeing in SIXES* it is!

Which brings me to the second idea that has been rolling around in my brain …

Idea #2 — Juried Publication
In photography today, juried events are fairly common — in the form of magazine contests, gallery exhibitions, and even state fairs! We've always avoided that type of thing here, but in some sense, *LensWork* itself is "juried" — i.e., not everyone who submits work for review can be published. We do our best to bring you the best of what we see — and to some degree one subscribes to *LensWork* because of one's confidence in our editorial process. That's the nature of anthology publications.

The Book Concept
Other magazine publishers have "contests" for their publications, but as far as we know, none of them result in a book publication with all the attendant qualities of state-of-the-art printing that we use here at LensWork. We want this book to be an inspiration for the long-term — not a 30-day disposable "exhibit." These photographs (and their creators) deserve more attention than that.

Now with this third edition, we've published 150 projects selected from roughly 3,700 entries we reviewed — a mere 4% of the work received. This brutal competition saddens me a bit because there were so many projects that we simply did not have room to include that truly deserve to be seen.

In 1993 Maureen and I founded *LensWork*, and further developed it to feature the work of contemporary photographers who had little hope of being published — because they weren't "famous dead guys." Since then,

we're proud to say that we've published (and launched the careers) of many deserving, living photographers.

Similarly, the three *Seeing in SIXES* publications are *LensWork* community book projects. Our faith turned out to be well-founded, but we completely underestimated our readers' response. As in the previous two years, it was a painful process to cull the 2018 entries down to the 50 you see here. Talent and productivity in photography (and particularly in the universe of *LensWork* readers) is incredibly abundant. We are so honored to have all of you in our publishing family.

So, here are the 50 chosen projects. It is perfectly natural to wonder about our criteria for inclusion in this book. We looked for several things, not necessarily in this order: originality; consistency of style; engaging content that grabbed our attention; projects about *life* rather than about *photography*; images that complemented and supplemented one another instead of becoming repetitious; projects that engaged our imagination; projects that included compelling text that expands the viewing experience; projects that reflect a photographer's point of view rather than a camera's view; excellence of craft both photographic and with text; projects that create their own small world within the limitation of six images only. Selections like this are, of course, a matter of personal taste. We didn't always agree as we were reviewing all the projects, but all of us did agree on the projects that made it into the book—and in truth, another 100 or so we could just as enthusiastically included had there been room for them.

What an anthology! Landscapes, still life, street photography, travel photography; intimate stories, poetry, narrative, no text whatsoever; abstracts, straight and classic black and whites as well as heavily imaginative Photoshopped flights of fancy—all of which you will find in these pages.

Most importantly, these are visual expressions of **life**. Excellence in craft is fundamental, but as you will see in this book, it is content *about life* that still remains king. Sometimes that "about life" is as simple as a moment of observation and reflection, sometimes it is deeply personal and revealing, sometimes it is full of questions with few, if any, answers. It is life that binds us to each other and makes our photographic expressions accessible to non-photographers. We sincerely hope this book is of keen interest to the latter.

We've specifically sequenced this book so that every turn of the page to a new project brings a surprise and another small world to explore. Sips or gulps—however you choose to enjoy this book—we have no doubt you will return to it over and over again.

Needless to say, with such abundance in our *LensWork* community, we are already looking ahead to another project like this in 2019!

Brooks Jensen
Maureen Gallagher
Anacortes, Washington
2018

Table of Contents

Alphabetical List by Photographer

High Country - Denali, Alaska

by **Anonymous** (at the photographer's request)

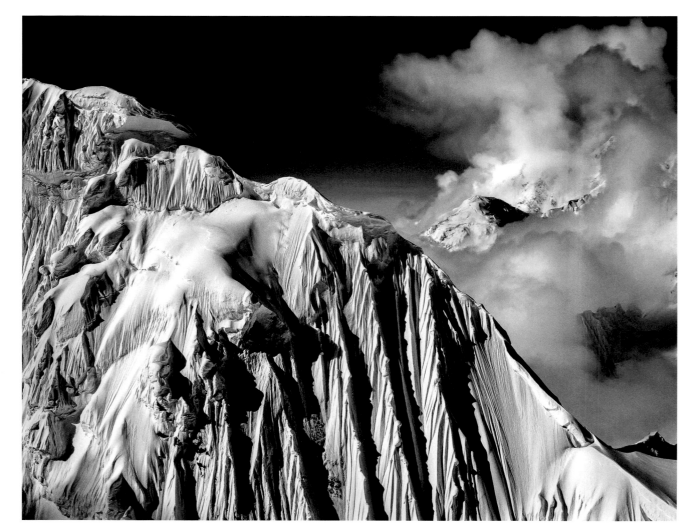

North Face Mount Huntington, Detail

The land retains an identity of its own, still deeper and more subtle than we can know. Our obligation toward it then becomes simple: to approach with an uncalculating mind, with an attitude of regard. To try to sense the range and variety of its expression — its weather and colors and animals. To intend from the beginning to preserve some of the mystery within it as a kind of wisdom to be experienced, not questioned. And to be alert for its openings, for that moment when something sacred reveals itself within the mundane, and you know the land knows you are there.

~ *Arctic Dreams*, Barry Lopez, Chapter Six – *Ice and Light*

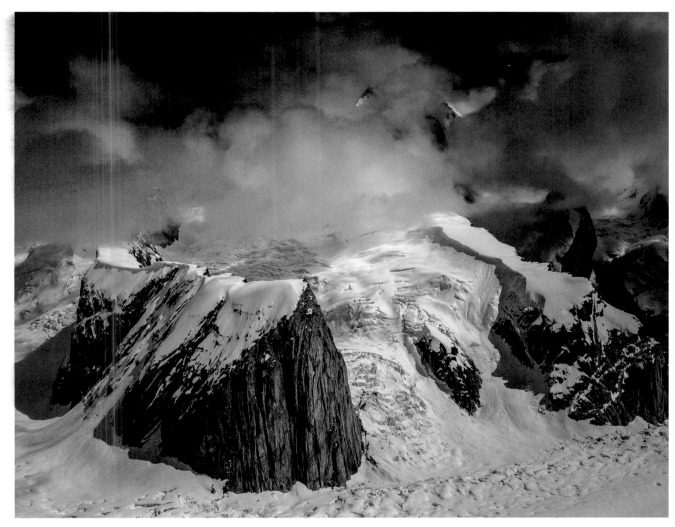

East Side, The Gateway

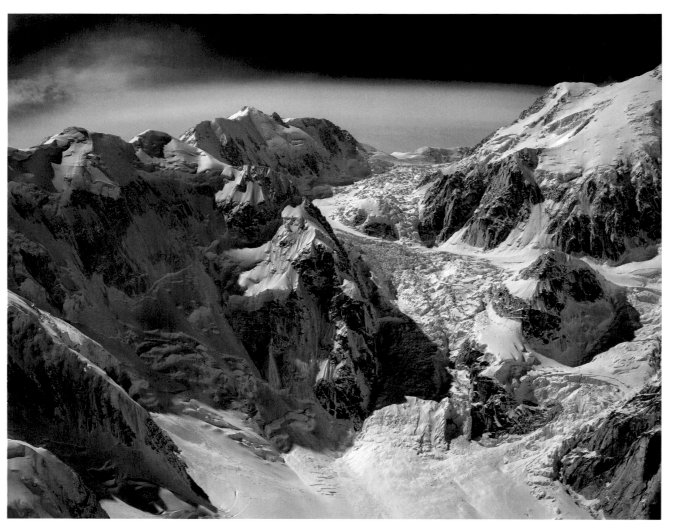

Traleika Glacier Ice Fall

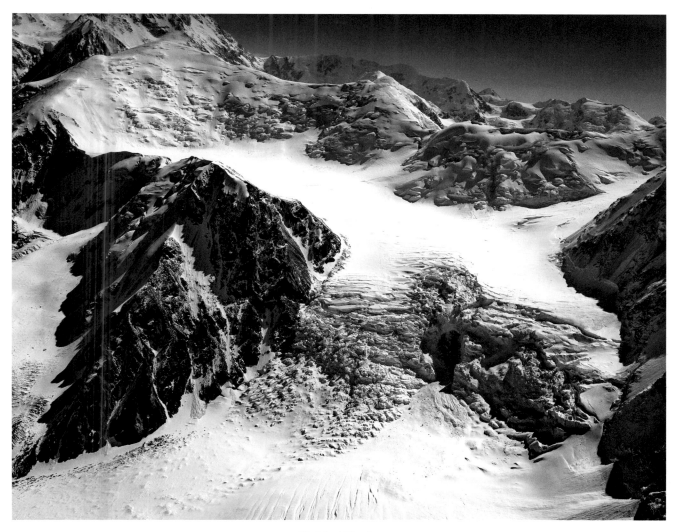

Divided Glacier

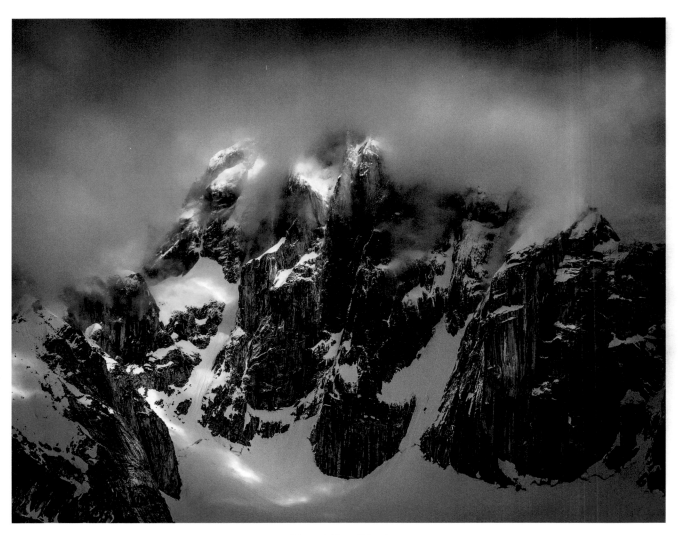

Mount Dan Beard

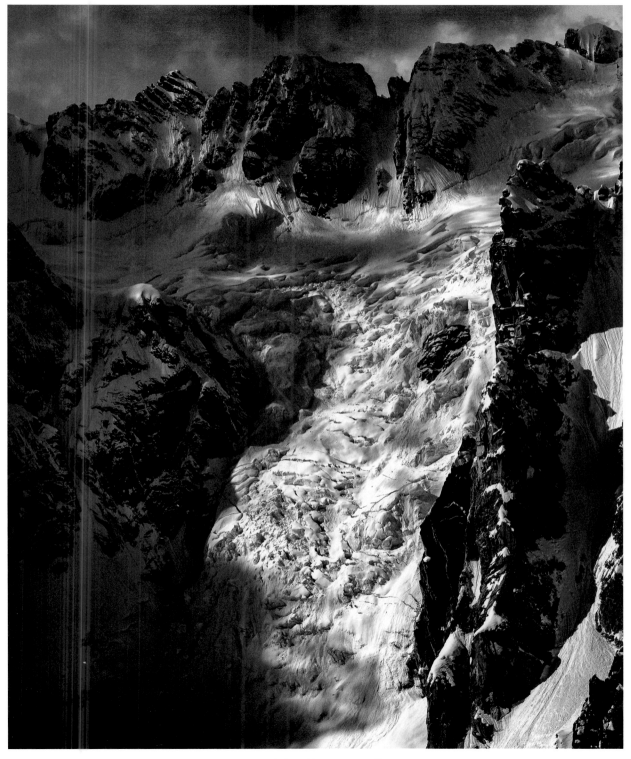

Buckskin Glacier Ice Fall

Fertile Fields
by Steve & Ellen Konar-Goldband

Portfolio.Goldband.com • steve@goldband.com

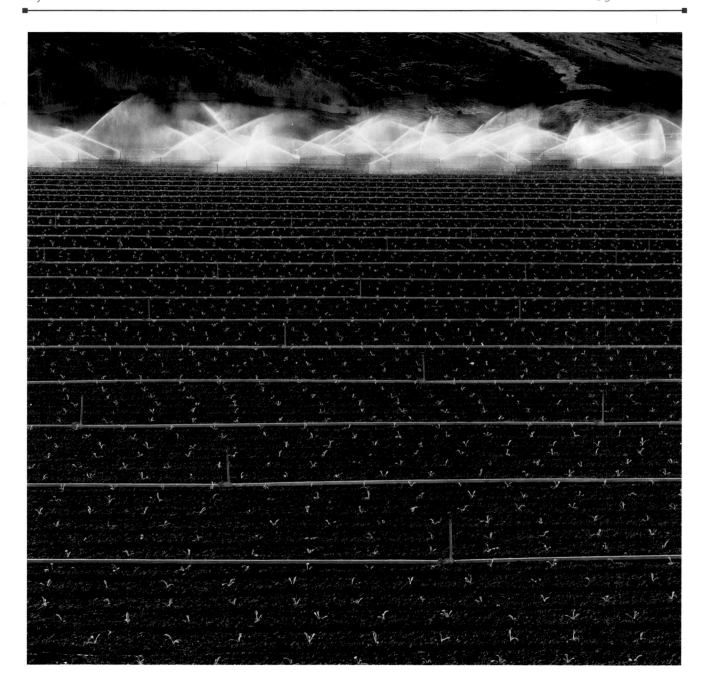

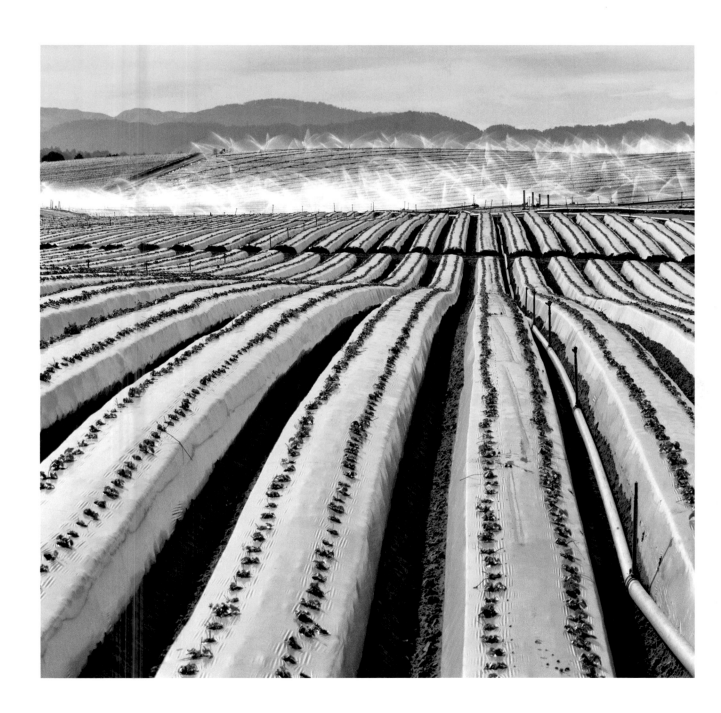

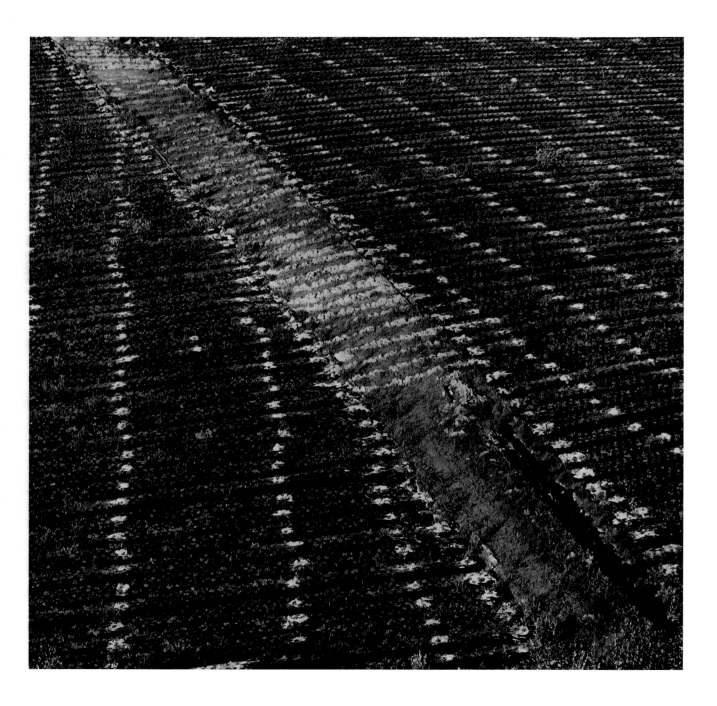

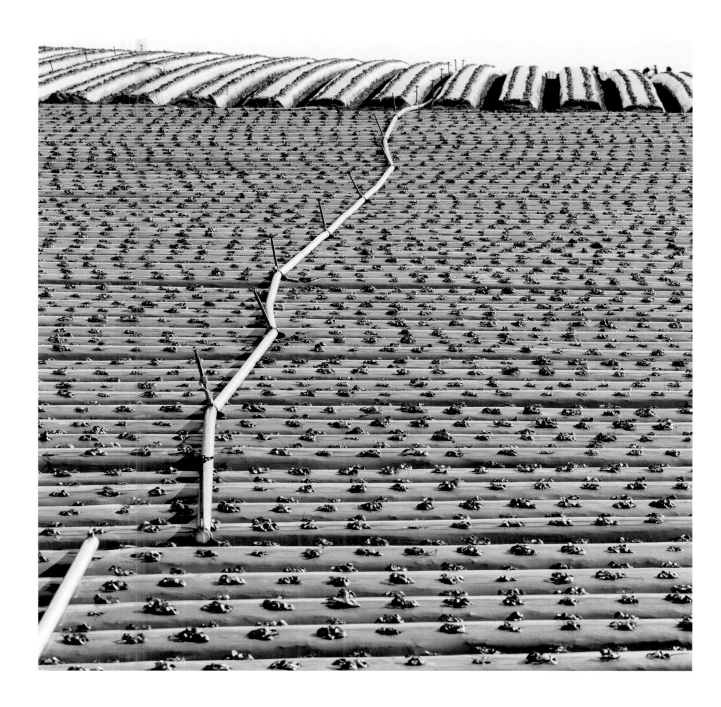

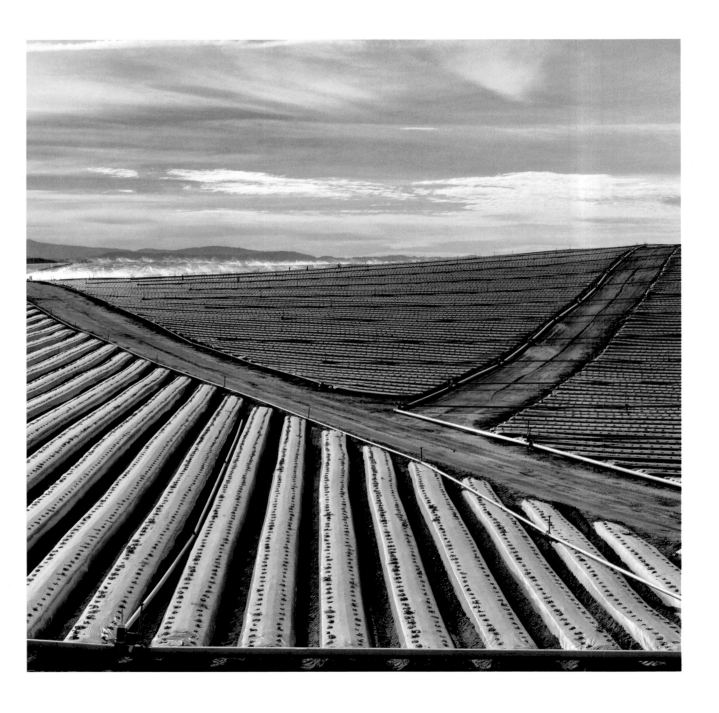

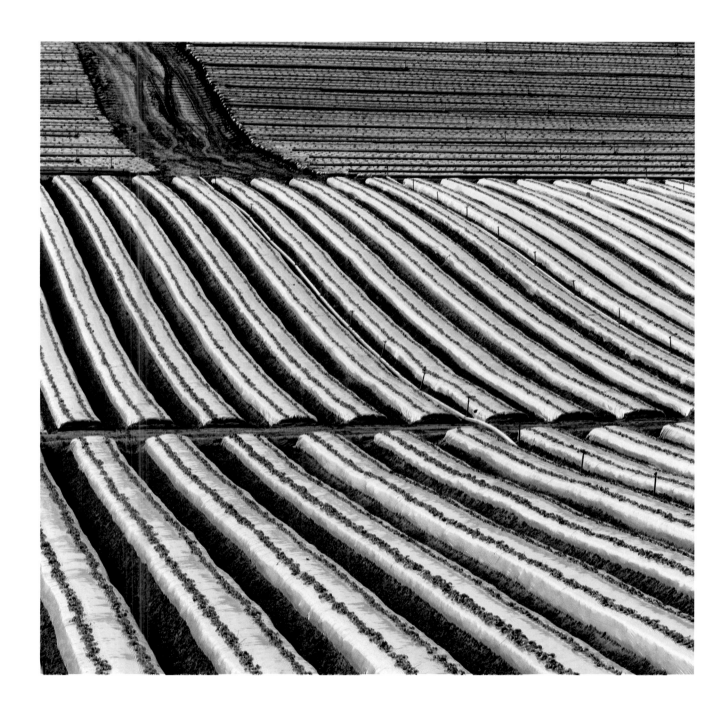

Grand Central Terminal: A City Within the City

by Gene Nemeth

Instagram: gene.nemeth • gene.nemeth@verizon.net

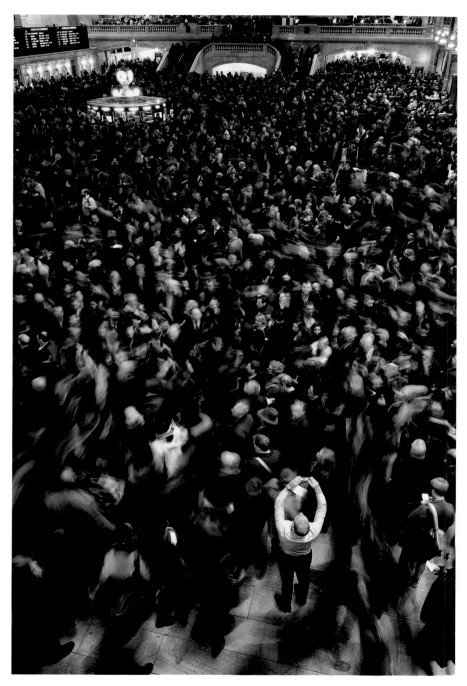

The Scream Redux

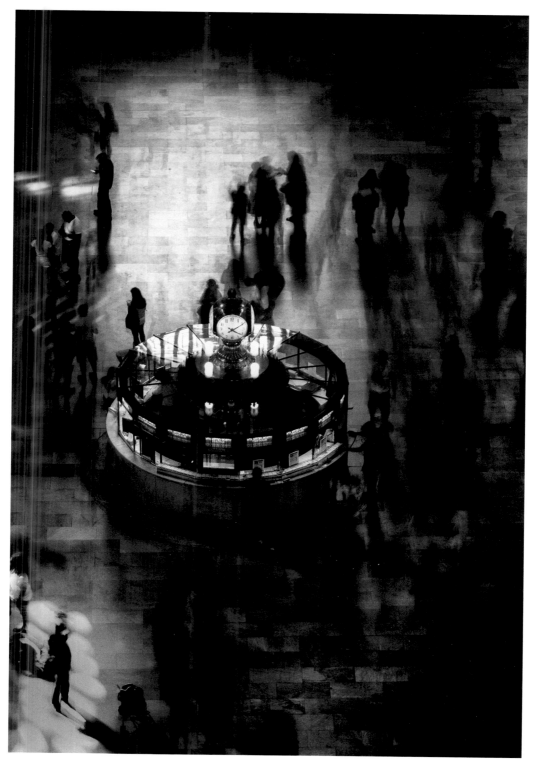

Time in Motion

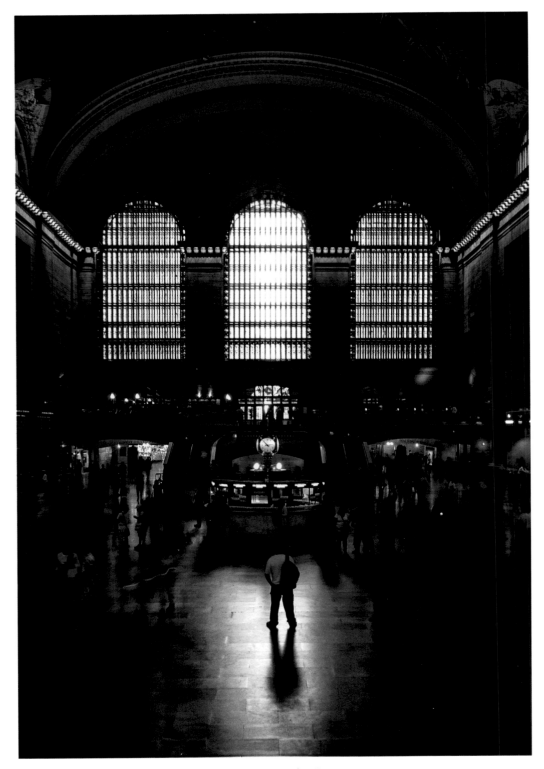

Lone Man in The City

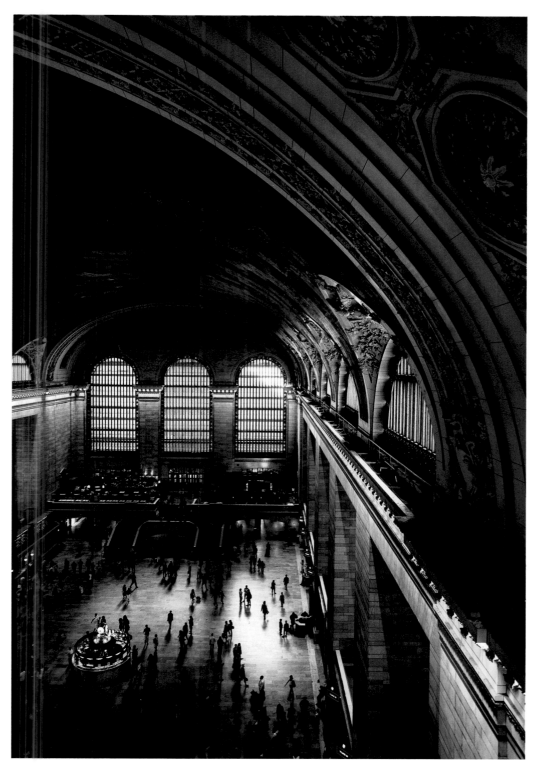

Soaring Above

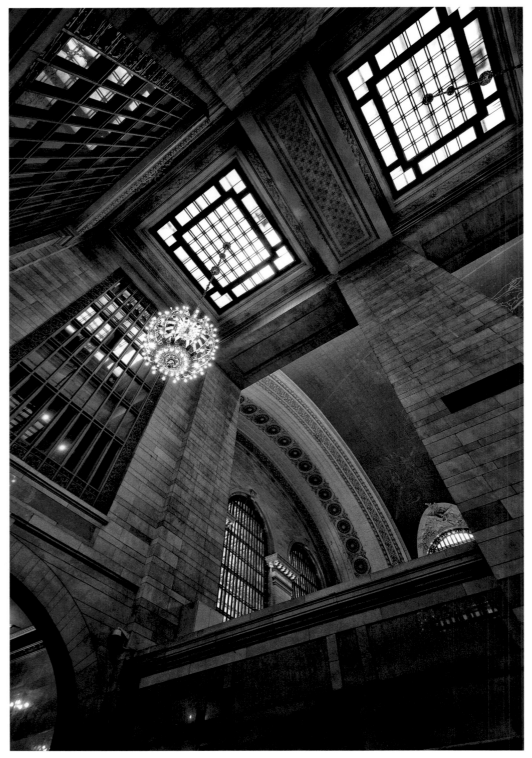

Looking Up in The City

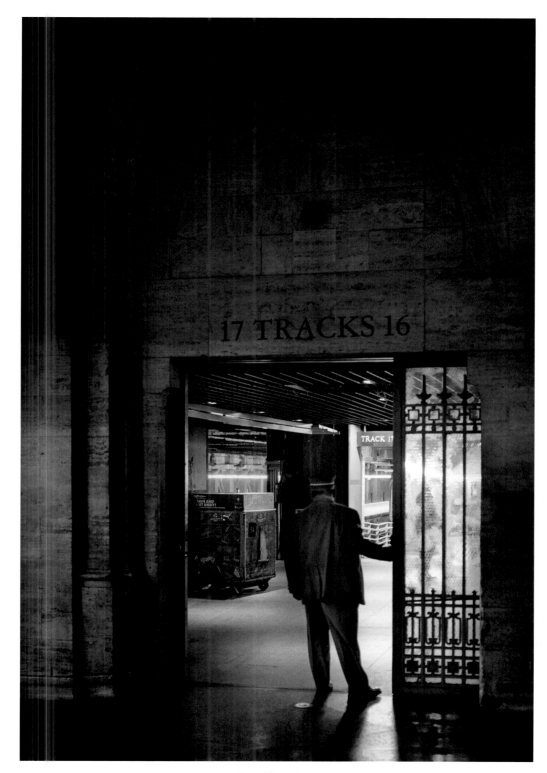

Last Train Out

Dhobis of Banganga
by Shourya Ray

www.ShouryaRay.com • shouryaray@me.com

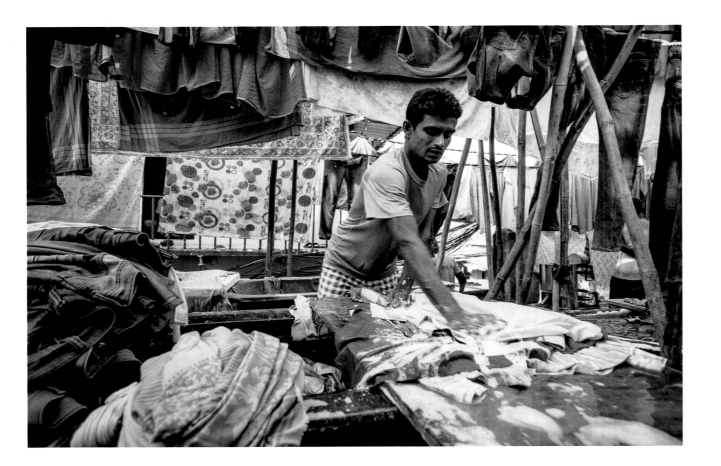

Beyond the famed Jain Banganga Tank and the Walkeshwar Temple, in the shadows of luxury condo towers, sandwiched between the boulders exposed by the receding tide and the ramshackle huts is a colony of *dhobis* (traditional washermen) at an open air laundry.

Dozens of men, essentially human-powered washing machines, beat the dirt out of thousands of soiled clothes and linen. Furious scrubbing by hand is followed by dousing in discarded fiberglass bathtubs that have now been repurposed for laundry. Stubborn stains are removed by soaking the garments in a boiling vat of caustic soda. The clothes

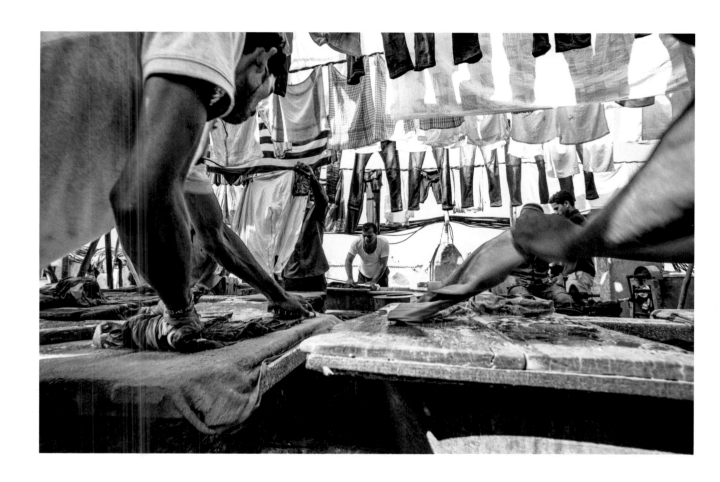

are then flogged in concrete wash pens, the rhythmic slaps of the garments and grunts of the men echoing over the crash of the ocean waves.

Further away, clean clothes are hung up to be dried on brightly colored rope lines, the salty ocean breeze playfully filling the clothes like so many landlocked sails. In the huts, that have congealed together with warrenlike alleyways to separate them, the women turn the dhobis' homes into a makeshift ironing operation: heavy wood-burning irons are used for pressing and neatly folding the clothes back into tight bundles that will be delivered back to their owners later in the day.

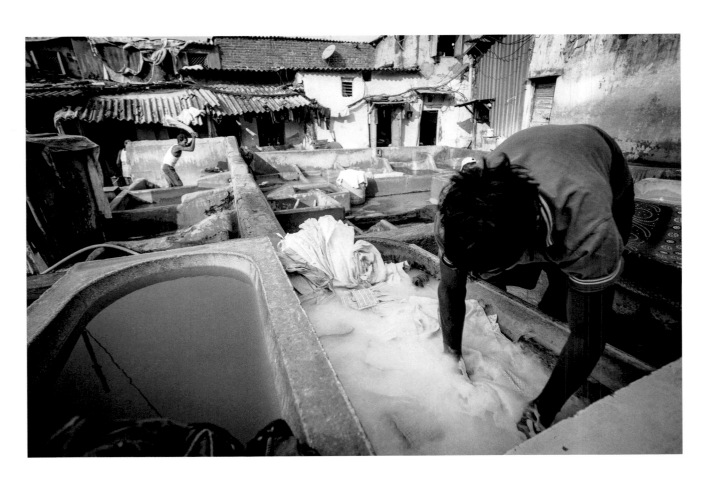

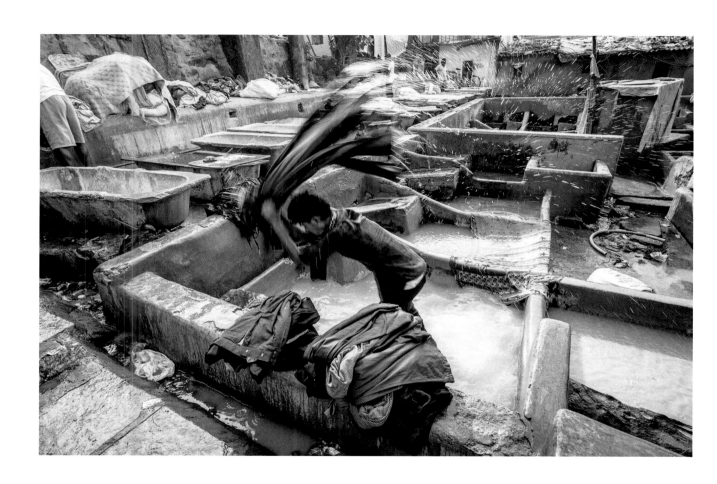

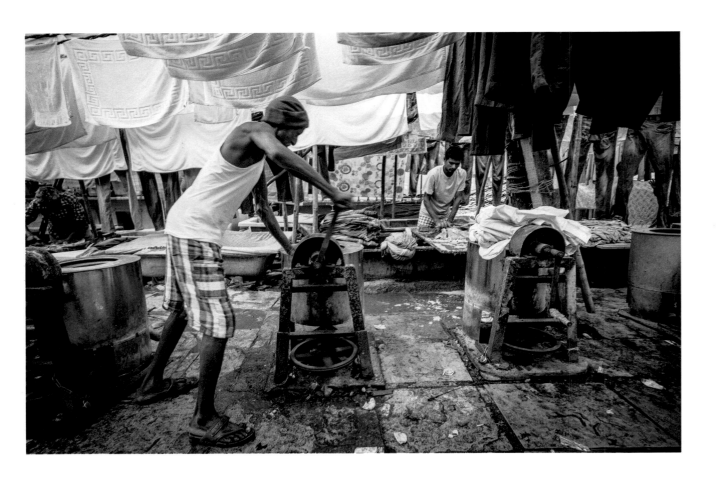

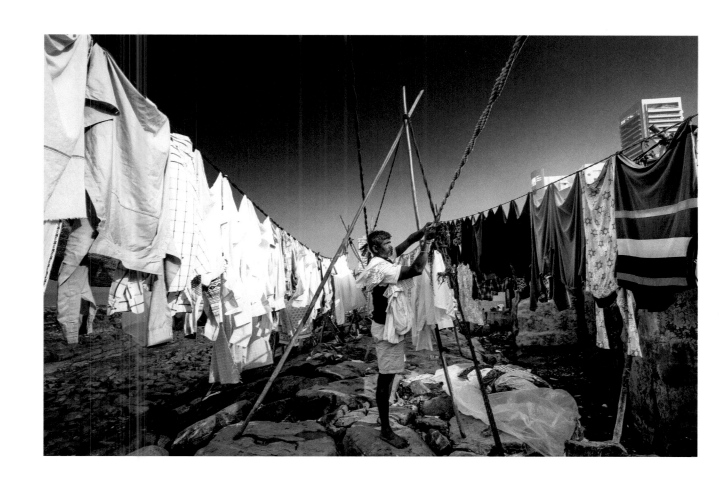

Abstract Visions of Architecture

by Jim Riche

www.JimRiche.com ♦ jim@jimriche.com

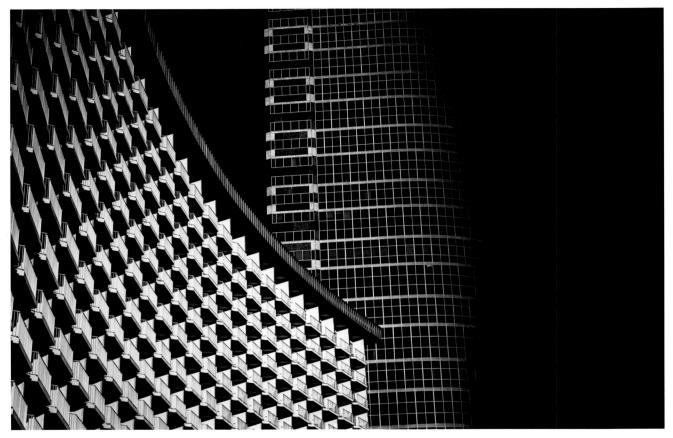

The Century Plaza Hotel, Los Angeles

The shapes, contrast, negative space and light I see in early morning light is transformed by the unique shapes of modern architecture. I see the patterns and the designs that these hard man-made structures present and I use them to create an artistic, abstract image in black-and-white. From Los Angeles to San Francisco and New York they all come together and form a pattern of their own.

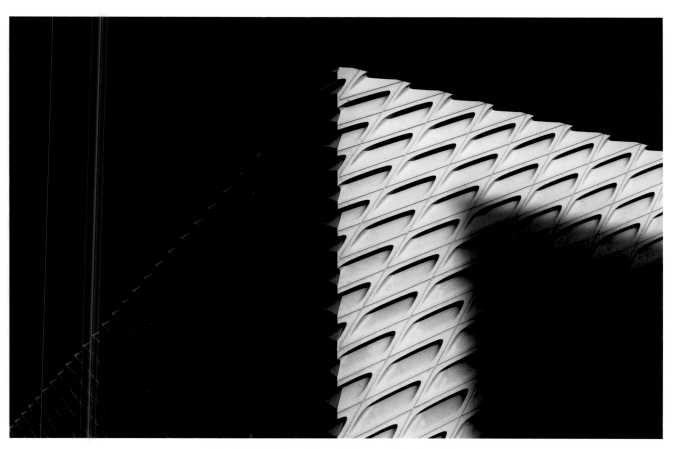

Sunrise Shadows, Broad Museum, Los Angeles

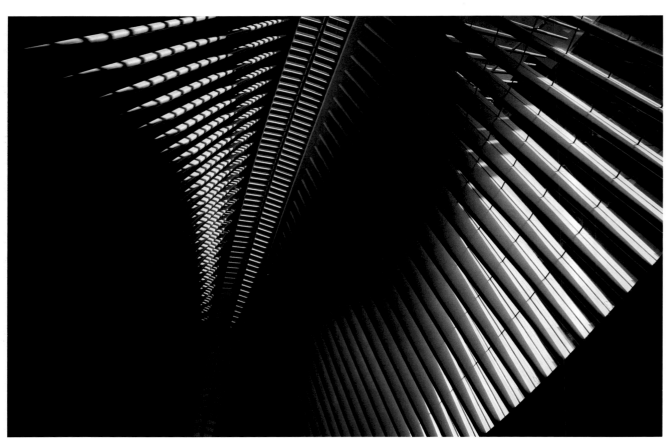

Main Hall, Calatrava Transportation Center, World Trade Center, New York City

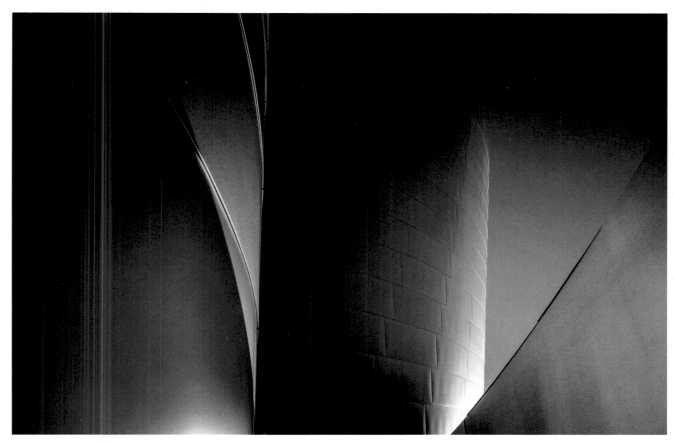

Disney Concert Hall, Los Angeles

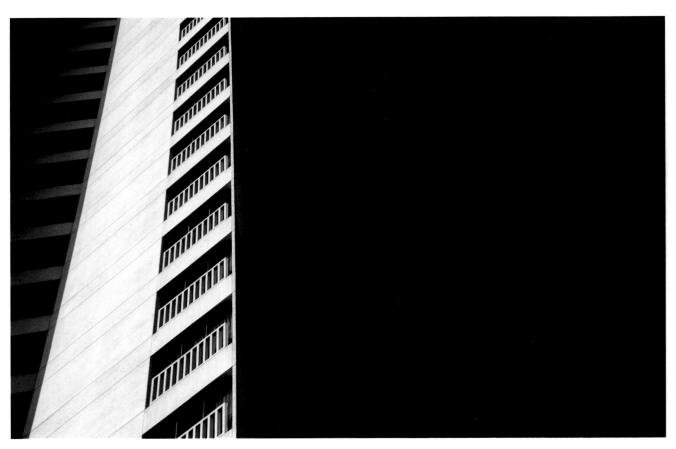

Sunrise, The Embarcadero Buildings, San Francisco

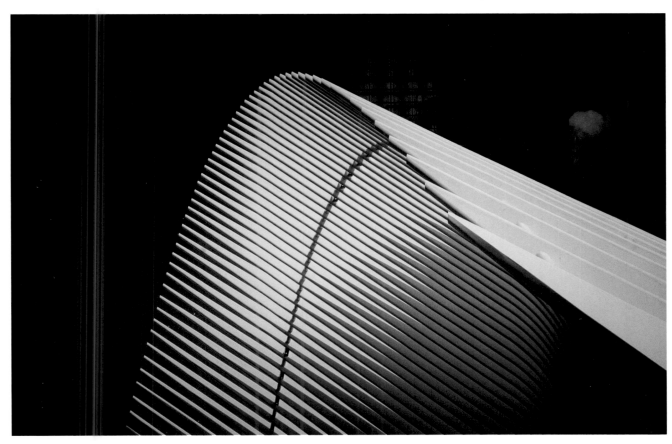

Calatrava Transportation Center, World Trade Center, New York City

Details From Above
by Mitch Rouse

www.MitchRouseAerials.com • photo@hawkeyeranch.com

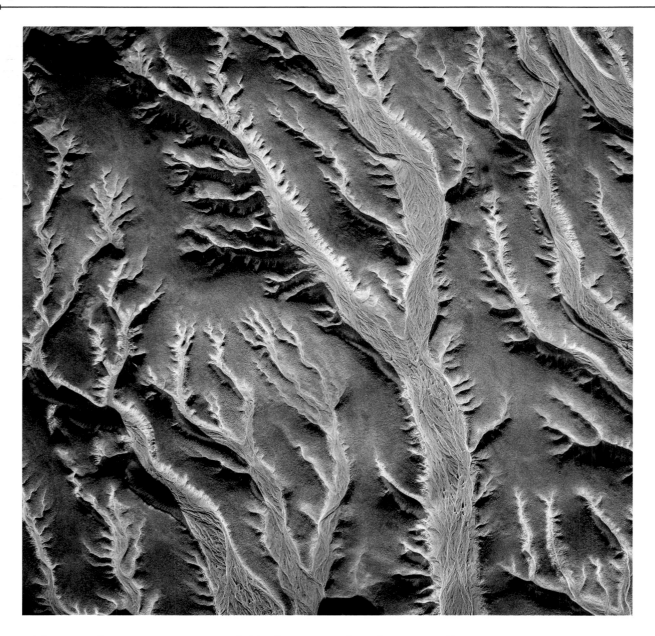

Very rarely do we, as terrestrial beings, get the chance to fly and enjoy the perspective from above. I began taking aerial photographs a year ago. Every time that I look down at the endless patterns and colors, I find myself in awe of our beautiful planet. Much of what I see through the view-finder are colors, but from time to time I find that a black-and-white photograph reveals the abstract

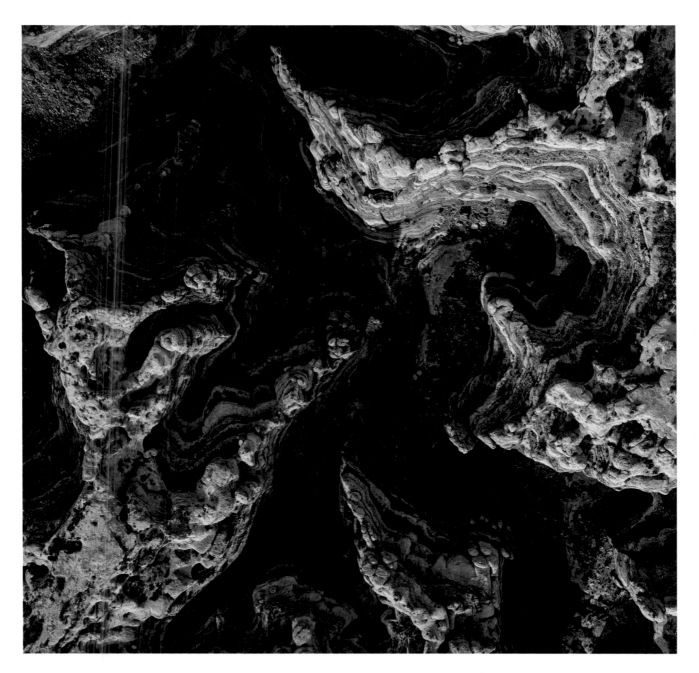

textures and tiny details more clearly. These are those moments — the moments that you see without the distraction of color, and appreciate the rich textures that were hidden. It's that moment that reveals a deeper layer of the image and opens your understanding to something just a little greater than it was. For me, it's a moment of appreciation and humbleness for such an amazing place we live.

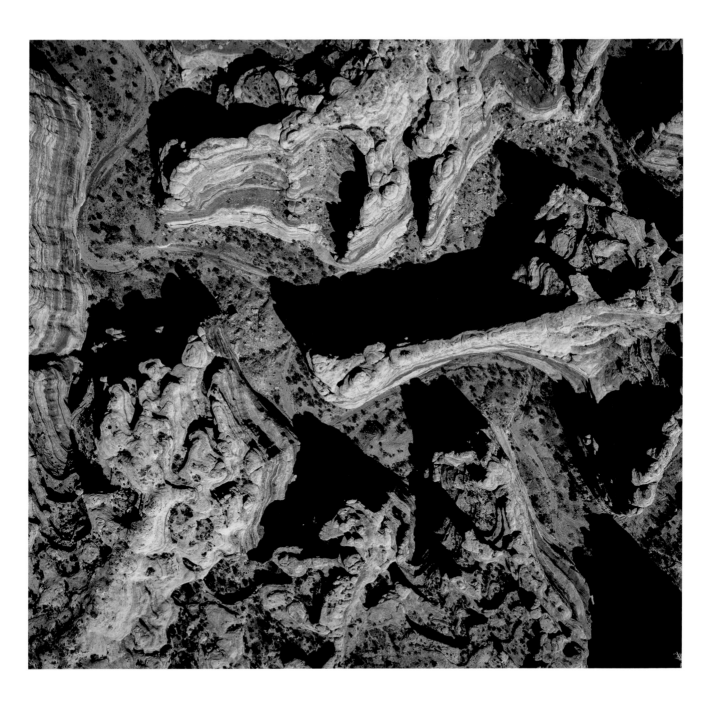

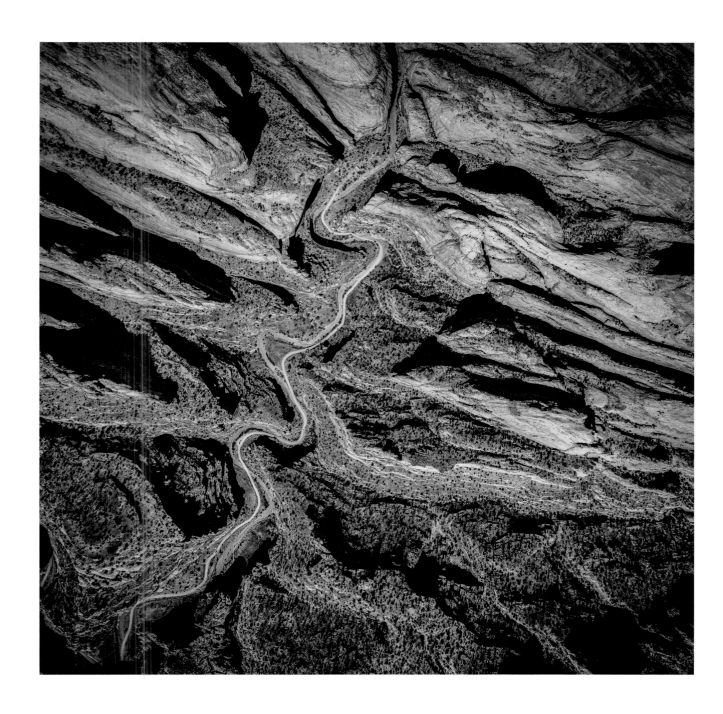

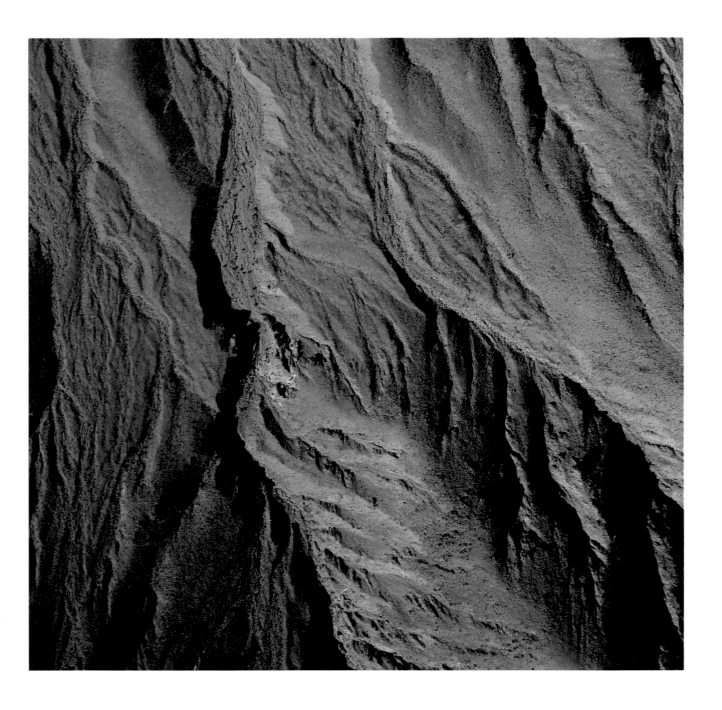

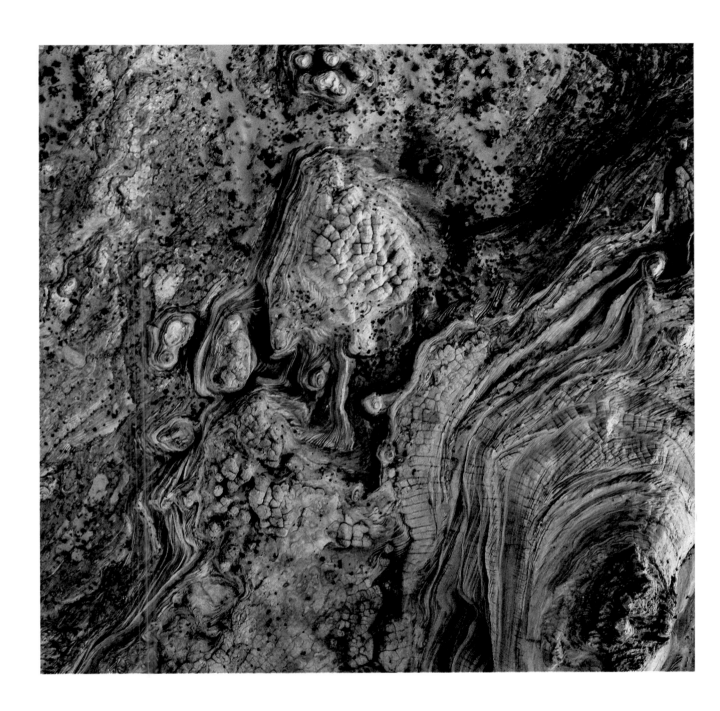

Icelandia
by Tim Holte

flickr.com/photos/tholte ♦ holte.tim9@gmail.com

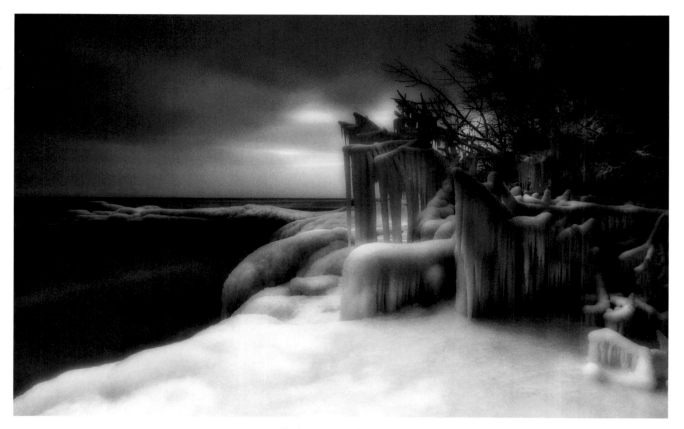

Shelter From The Storm

Icelandia: A stretch of shoreline along Lake Michigan in Milwaukee where I discovered a winter wonderland of ice.

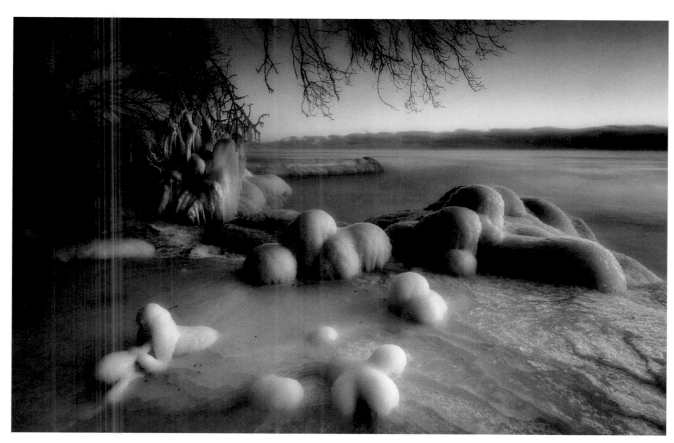

Simple Twist Of Fate

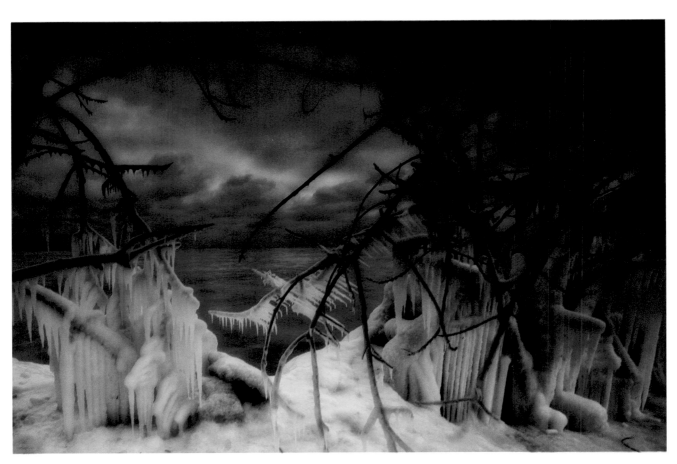

Winter Of My Discontent

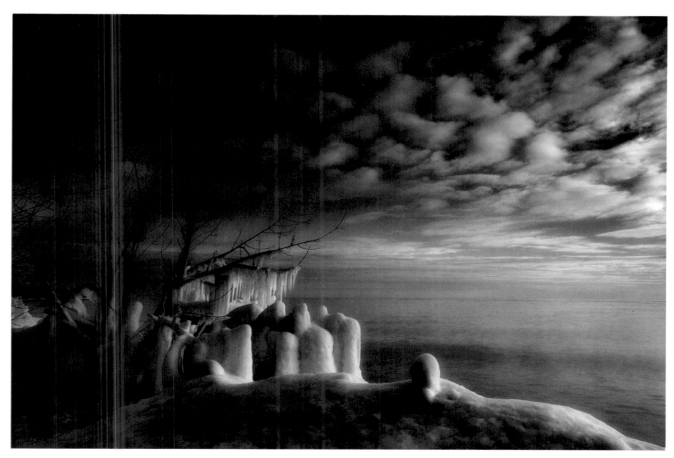

From Here To Eternity

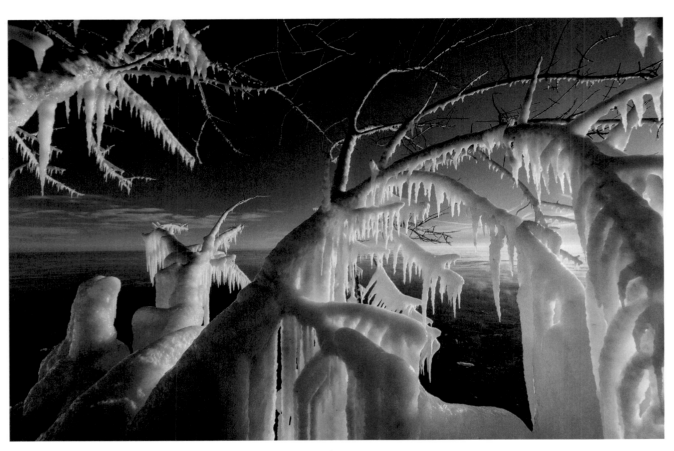

All Quiet On The Western Front

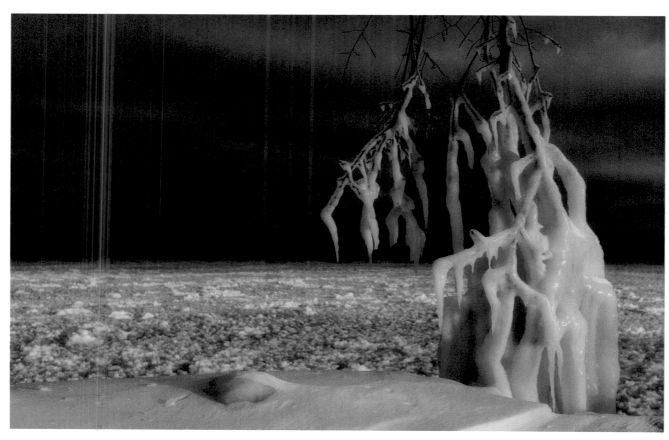

You Can't Go Home Again

of Shadows and Dreams

by Justin Hayden

Instagram: justin_t_hayden ♦ Jth93456@hotmail.com

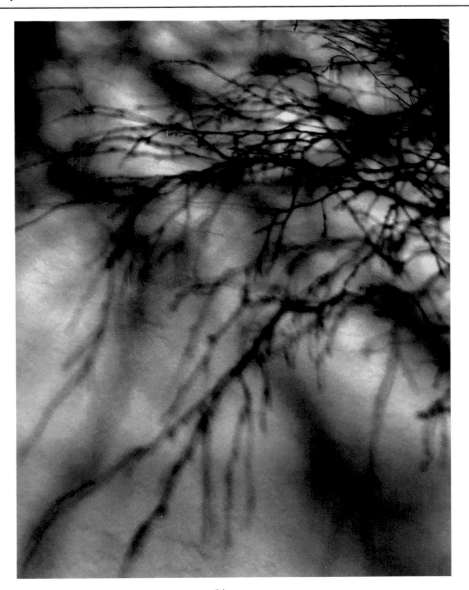

Obscure

During the duration of sleep, nightmares and dreams feel real in the moment but never physically happen — much like a tree's cast shadow. If it is cloudy, the shadow would not exist. Both dreams and shadows, in a sense, are merely illusions. The shadows resemble the interconnected thought pattern of various dreams: at times linear, but most times a tangled network of inescapable emotions… unless awakened, of course.

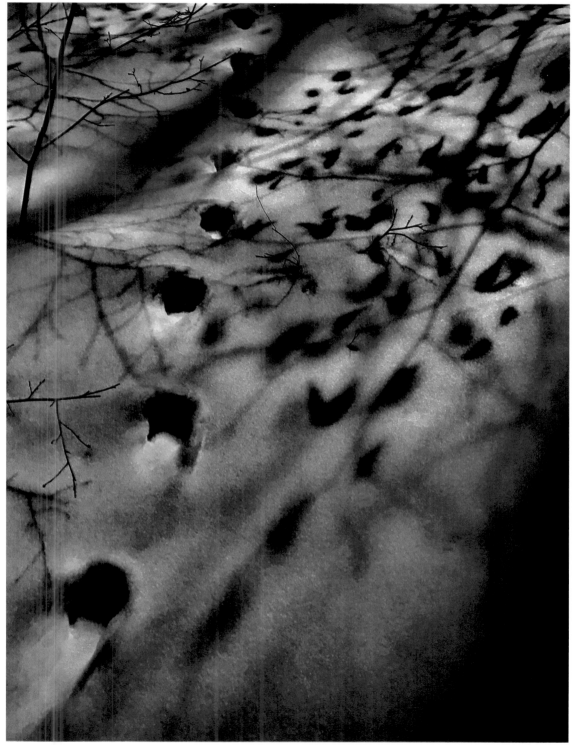

Sleepwalk

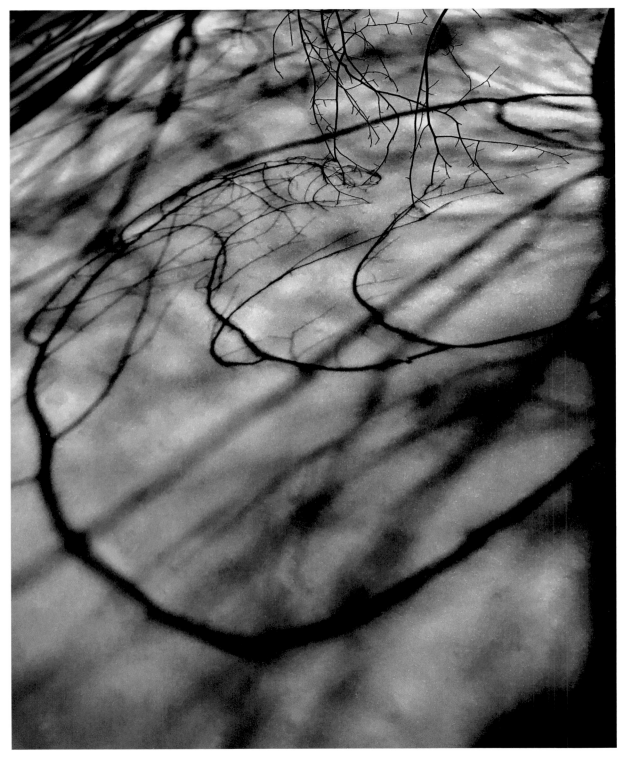

Reoccurrence

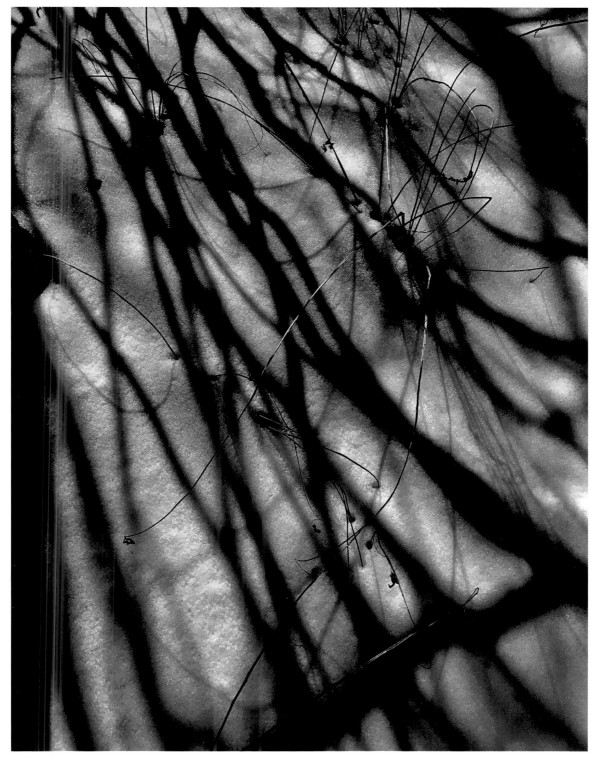

Entrapment

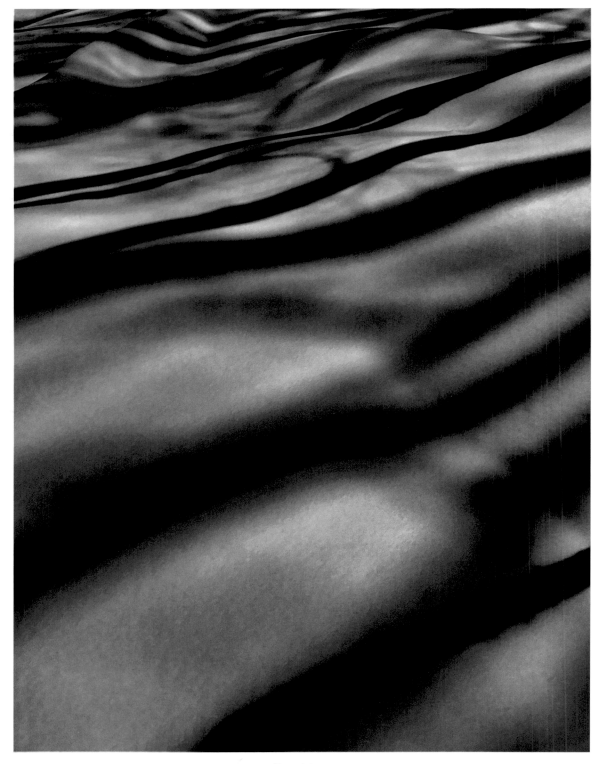

Transitions

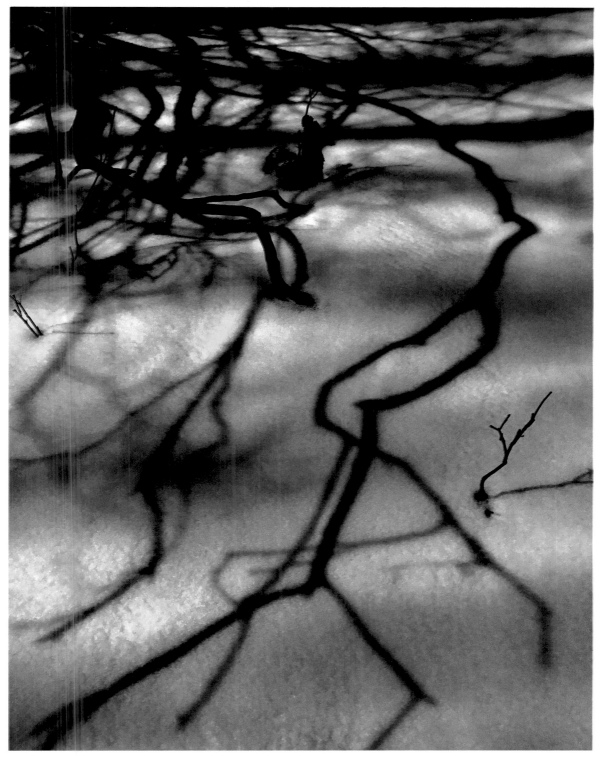

Night Terror

Abandoned Leisure
by Hank Gans

www.HankGans.com ◆ hank@hankgans.com

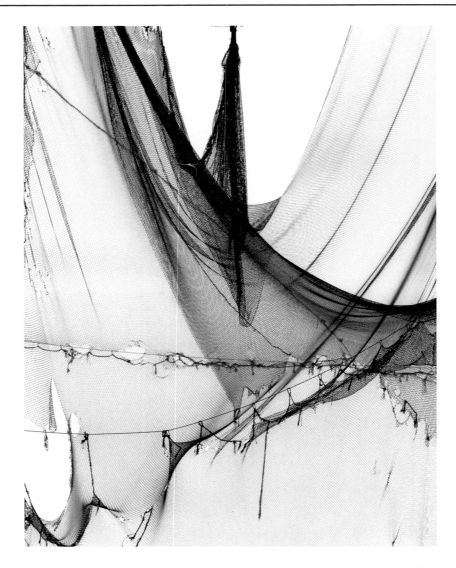

These are the nets that, until recently, surrounded a New Jersey golf driving range that overlooked the Hudson River and Manhattan. For decades the several story tall nets protected passersby on the river walk bordering the golf range. Development has boomed along the Hudson River and the land has become too valuable to be occupied by a driving range; it will be replaced soon by an apartment complex. The range and its nets have been abandoned. The nets were always vulnerable to the strong winds of coastal storms, but were quickly repaired when the range was open. Now storms and strong winds are shredding the enormous nets — which change their shape from moment to moment as they disintegrate.

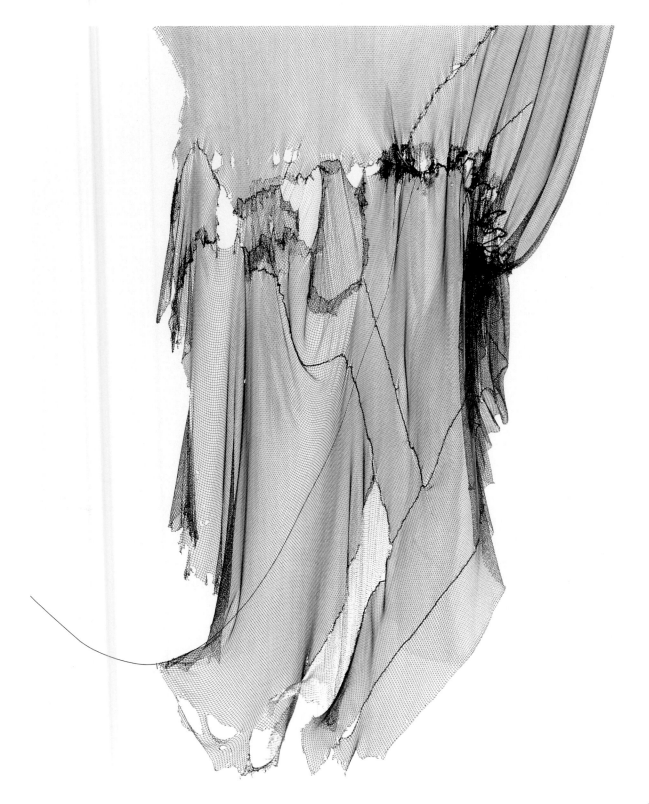

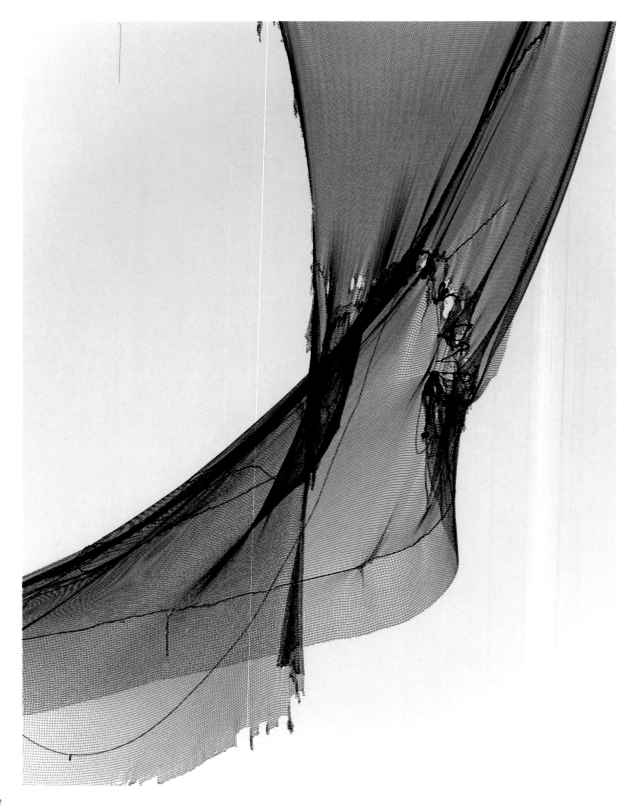

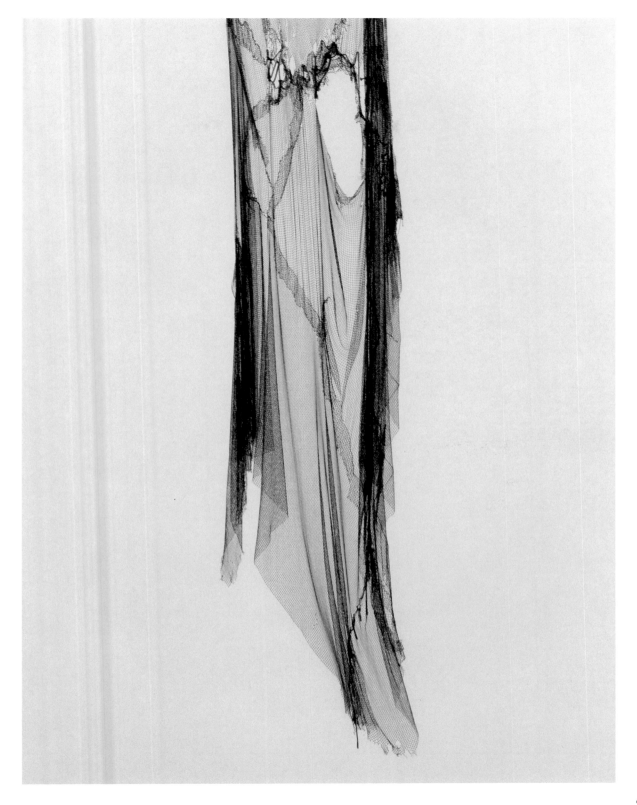

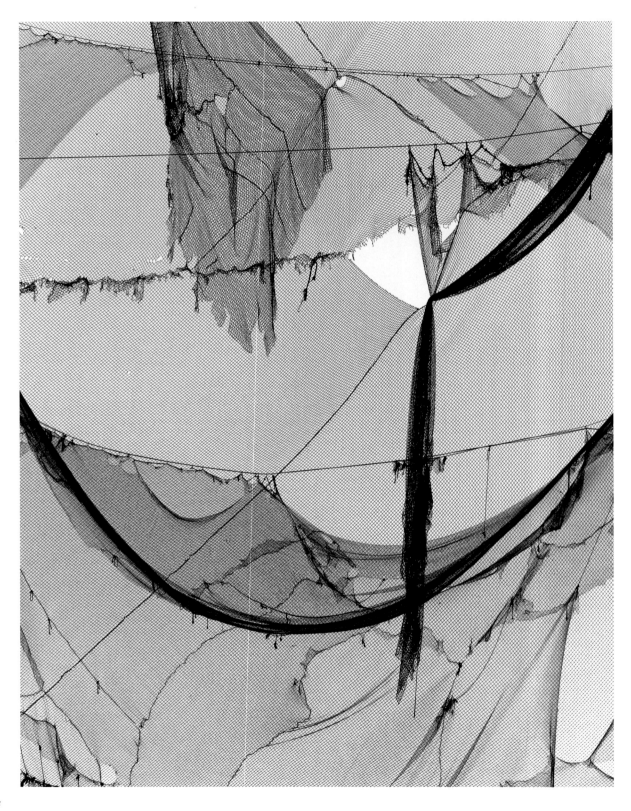

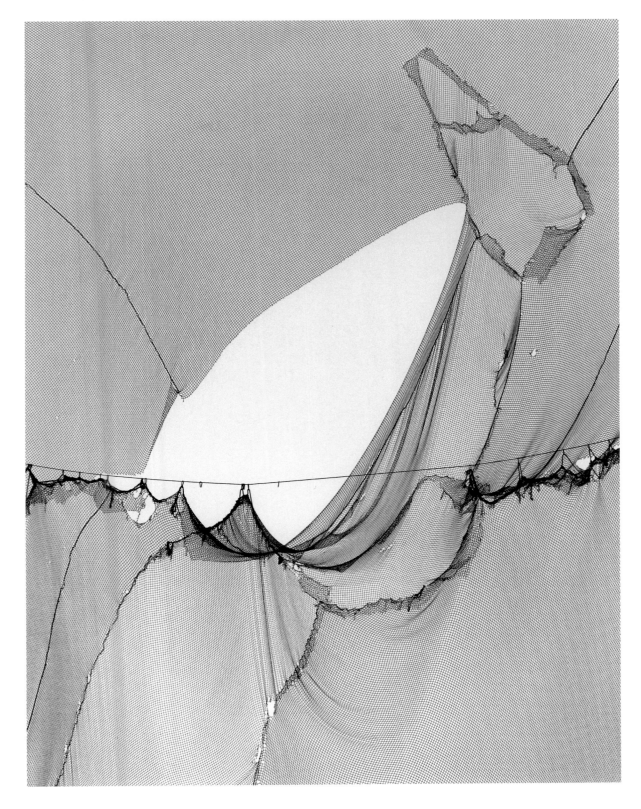

The Motion Of Dance

by Dennis Ninmer

www.DennisWNinmer.Photography • dwnfap@charter.net

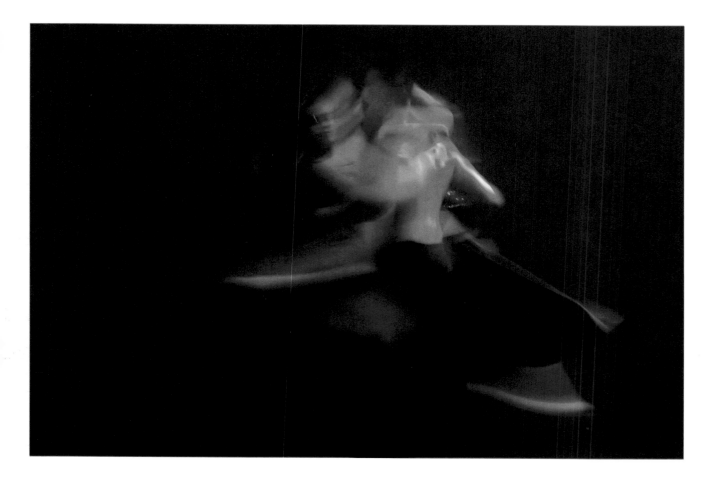

Dance, a form of poetry in itself. To be able to slow down the gracefulness of dance and show the softness of the motion, I found to be very artful. To look in each image and see the emotion in their faces and be swept up in what they are performing, enhanced by their every move. A quote from Mata Hari, "The dance is a poem of which each movement is a word." I believe this can be seen in the study of the six images in *The Motion Of Dance*!

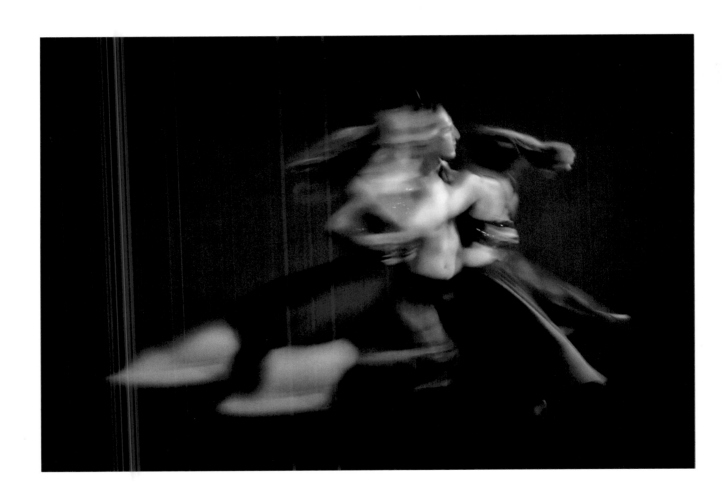

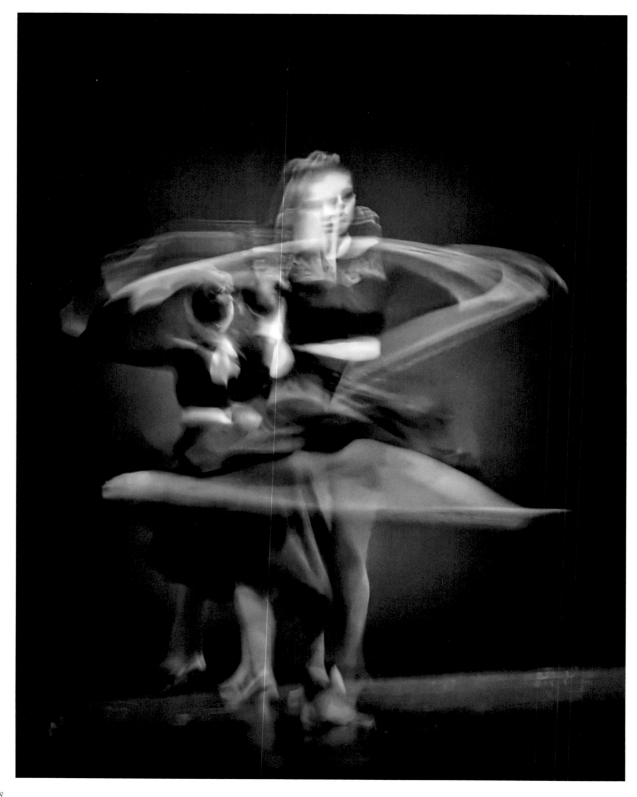

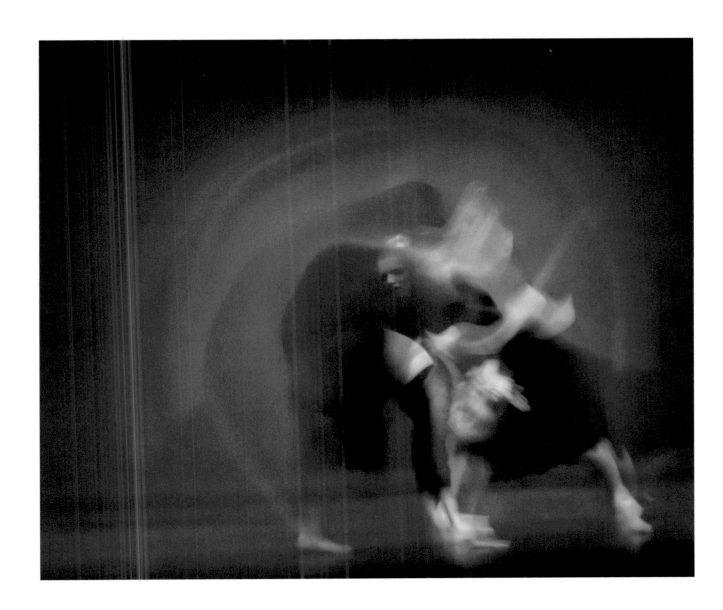

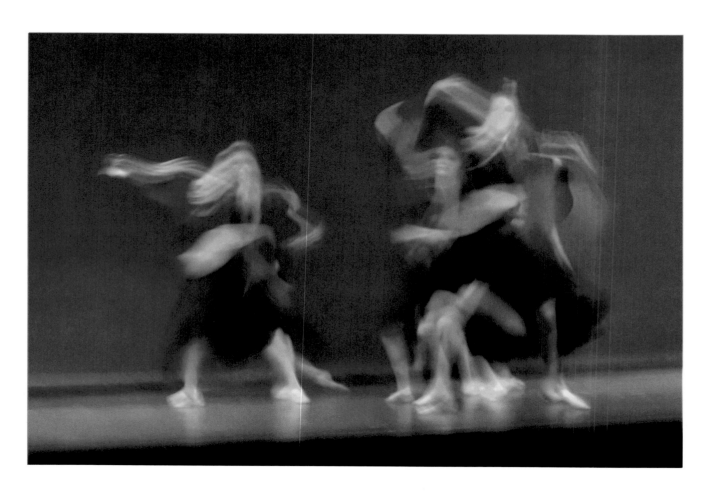

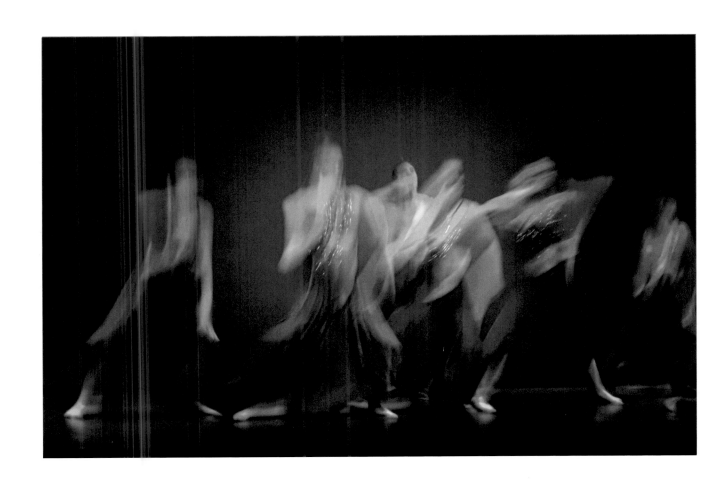

Great Egrets
by Gary Chappel

www.GChappelPhotography.com • gchappel@tampabay.rr.com

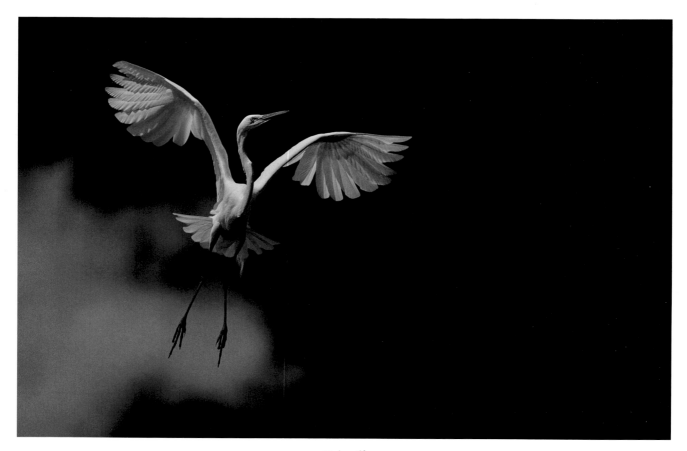

Takeoff

I have been a radiologist, studying human disease, for over 40 years. This is a profession that trains you to think about and see images differently. The images I study are monochromatic, usually with only a few shades of gray and white against a black background. With knowledge, the complex images and patterns of life simplify. The vitally small details become more apparent. Cancer has a shape and texture, but it does not have a color. I found when I brought these same parameters into my photography, new insights developed.

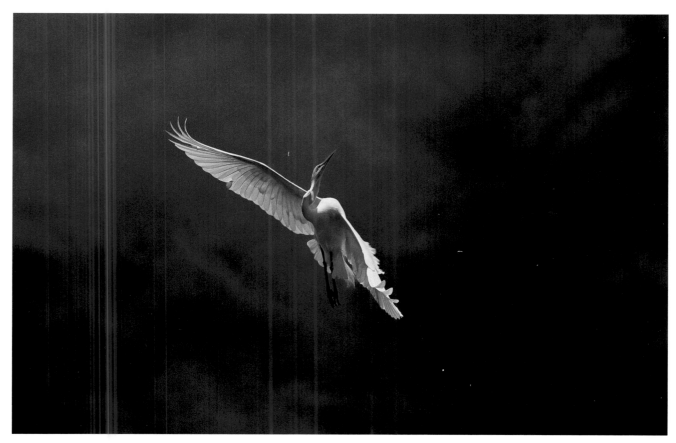

Incoming Storm

My present photographic project involves egrets. In the past, these birds were nearly hunted to extinction. They were hunted for their plumage. In my monochromatic world, it is these wonderful feathers that I find so interesting. I watch and study. As a radiologist understands better than almost anyone, the smallest distortion of a shape can change everything. The slightest wrinkle in a feather and the flight course changes. With a ruffle, lift is lost and the bird slows. Such beautiful creatures, and we almost lost them. For the feathers.

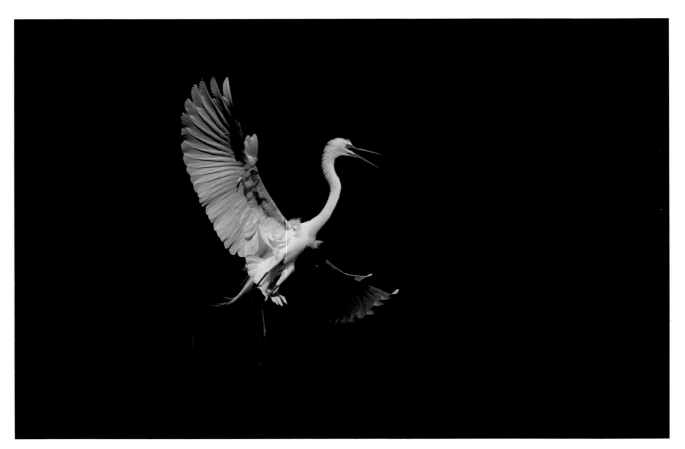

Joyful Flight

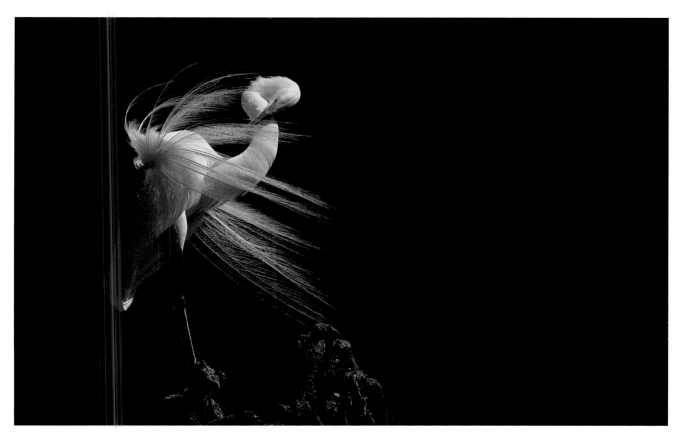

I'm So Pretty

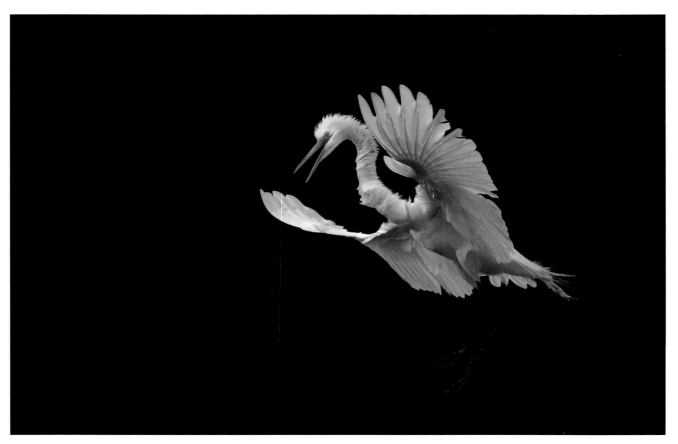

Landing

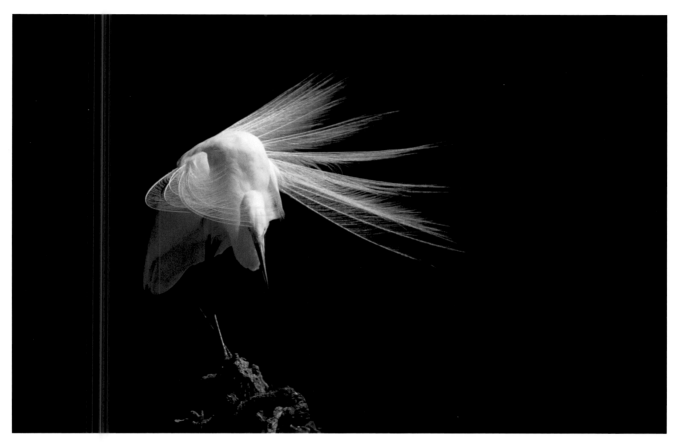

Bashful

Nebula & Supernova
by Simon Pearce

www.SimonPearcePhotography.com • simon@envirosafety.co.uk

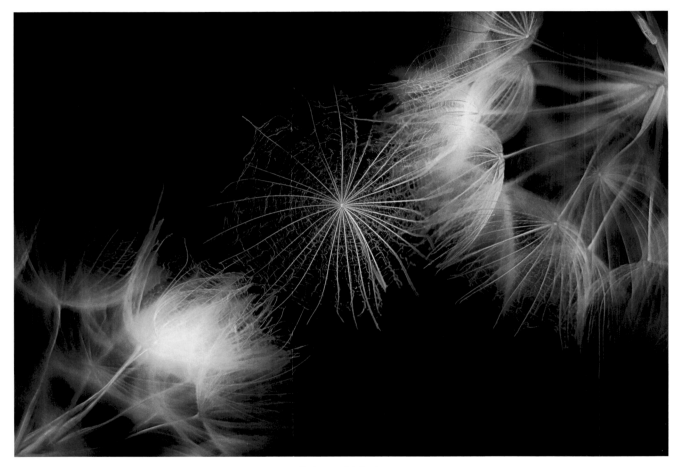

Balance Nebula

While walking the dog through a wildflower meadow, I noticed a seed head with one of the seeds about to break free. The beautiful structure of the seed head and the whole process of ejecting the seed made me think of nebula and the birth of stars. The idea of the small-scale world at my feet visually linking to the creation of stars gave birth to this series of images.

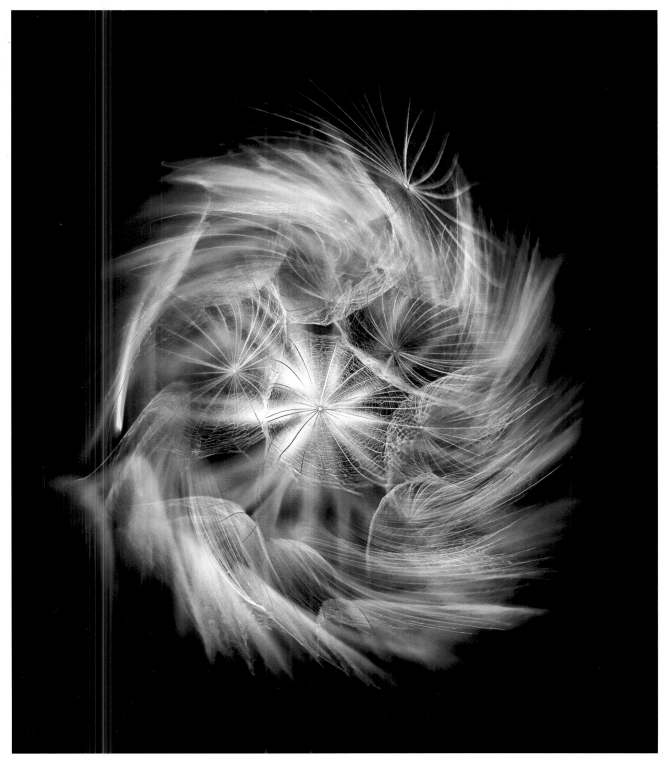

Eye Nebula

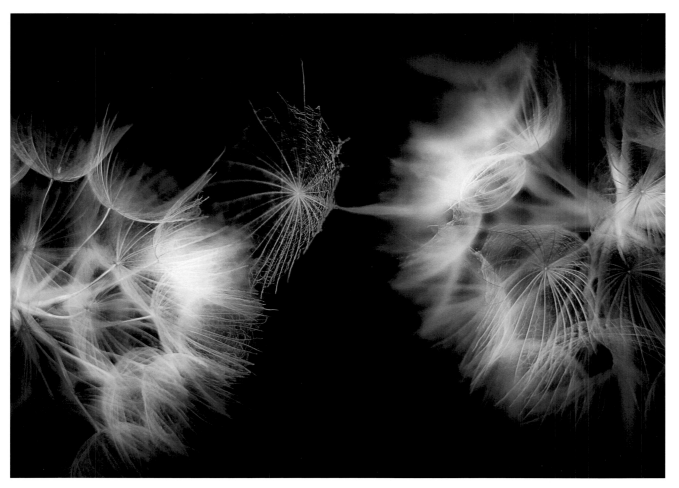

Planetary Nebula

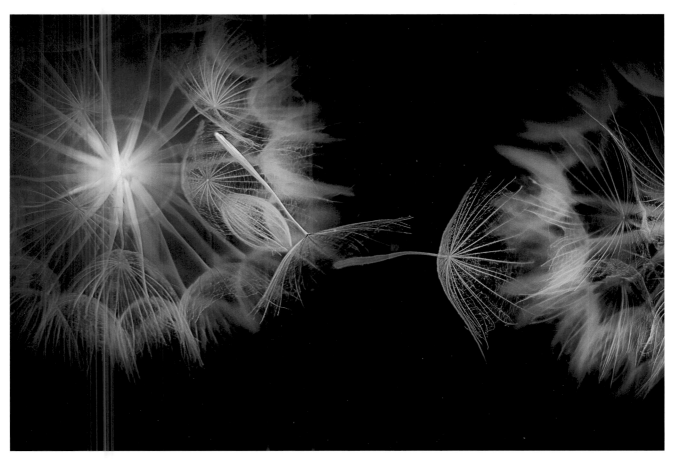

Protoplanetary Nebula

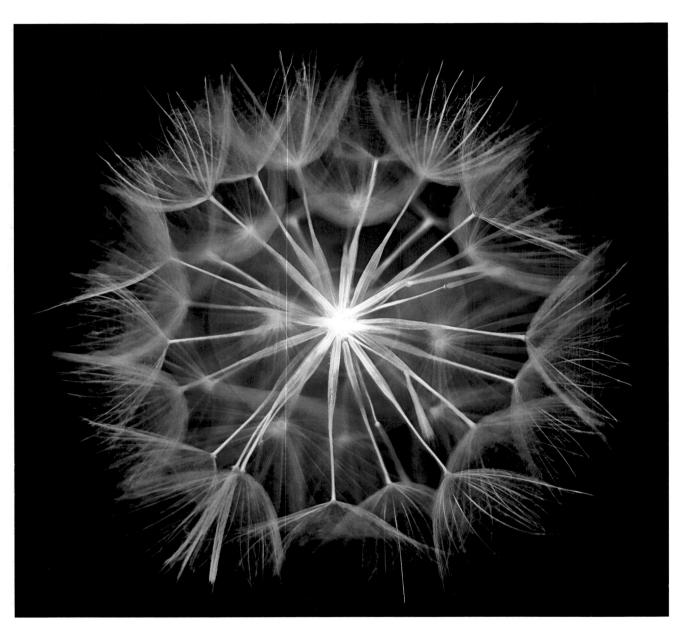

Supernova

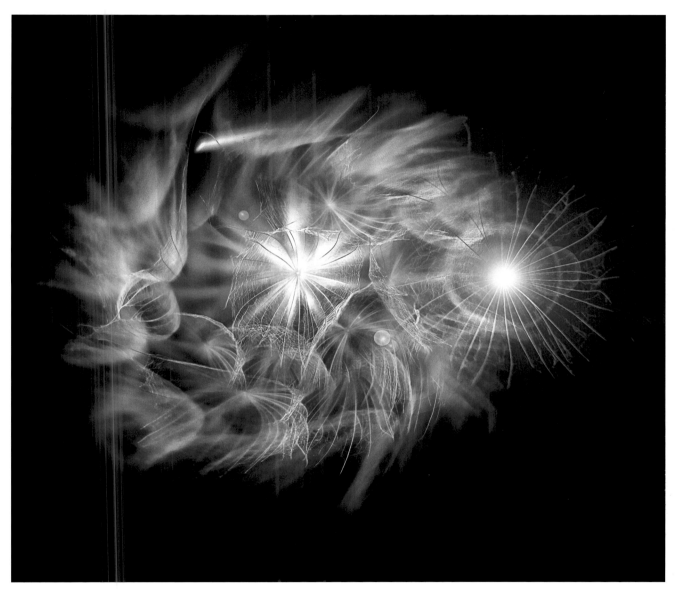

Twin Nebula

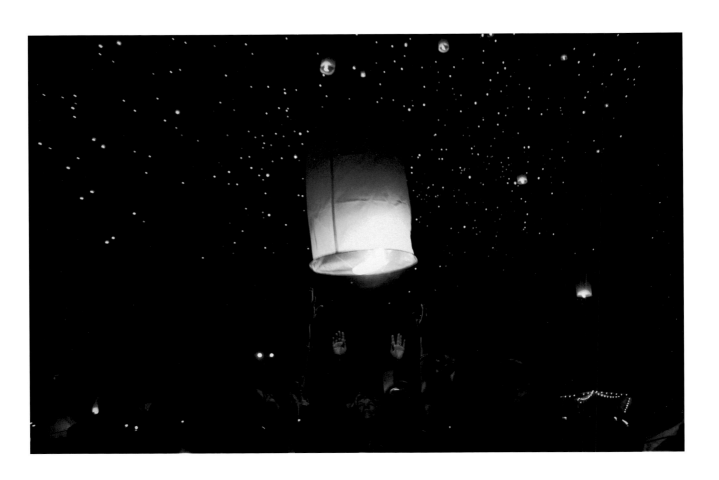

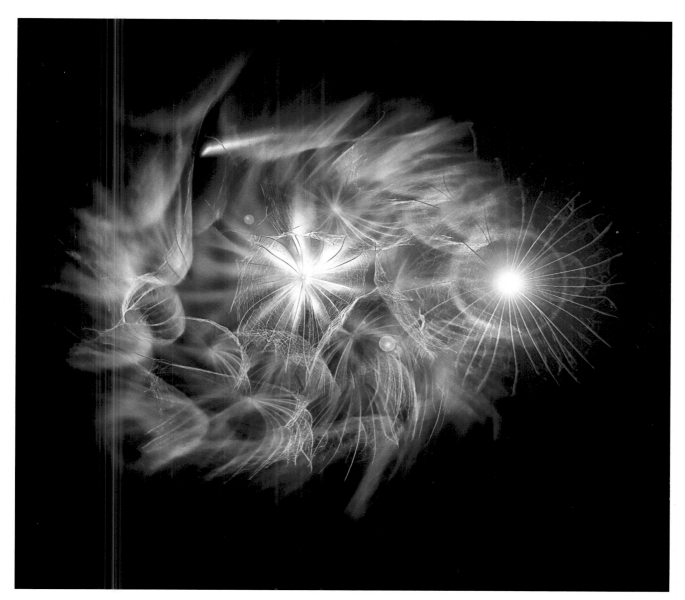

Twin Nebula

Letting Go
by Donald Kim

89mindphotography@gmail.com

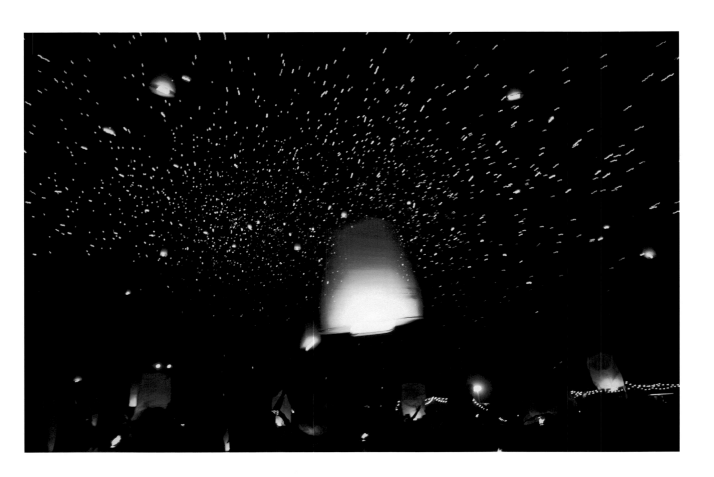

There were many that night…

Their eyes stood out the most.

Hopes and fears.

Love and lost.

Longing and acceptance.

Pieces of us into the ether.

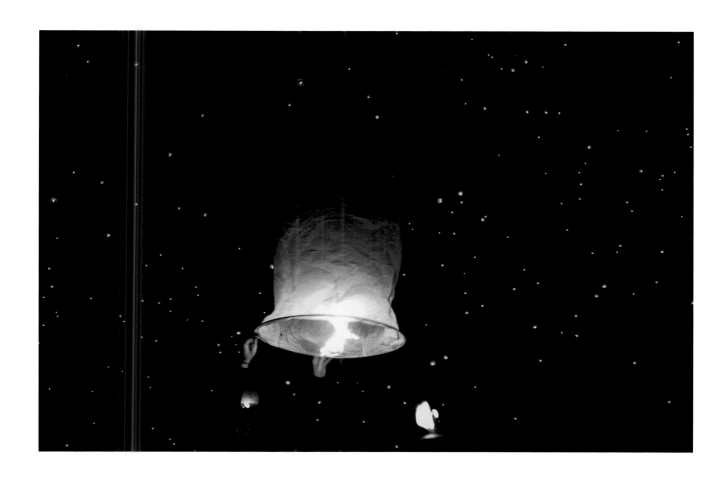

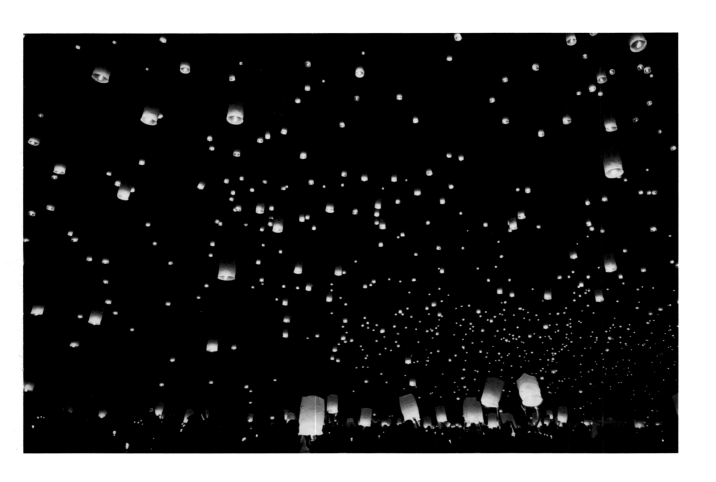

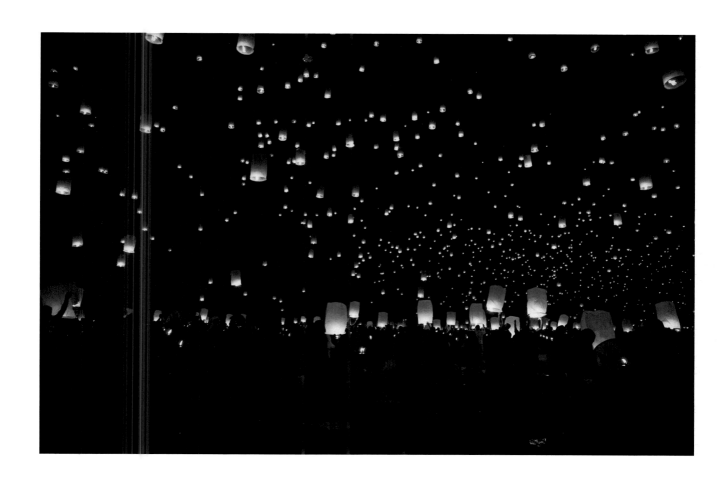

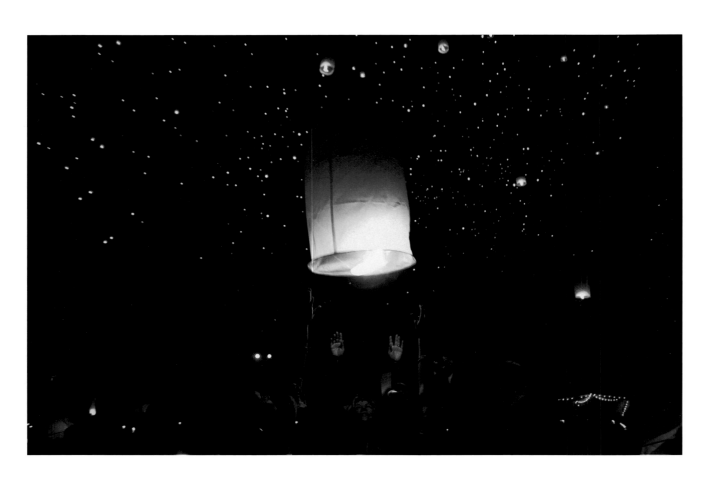

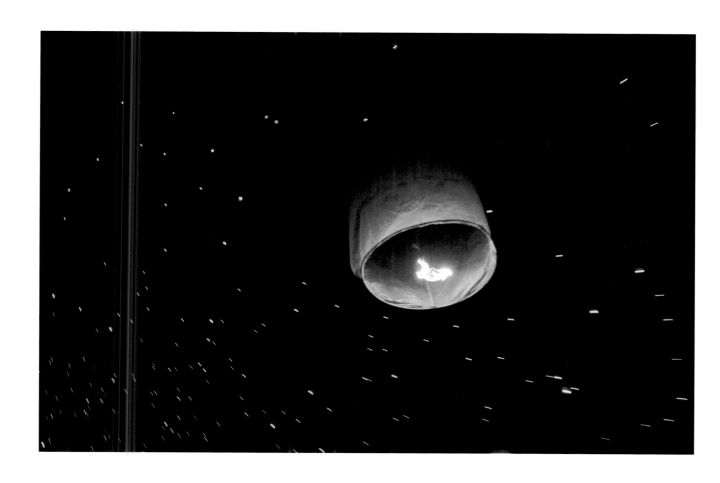

Kite Ballet: Steadiness and Motion

by Volker Kesting

www.VolkerKesting.com ◆ volkes@caiway.net

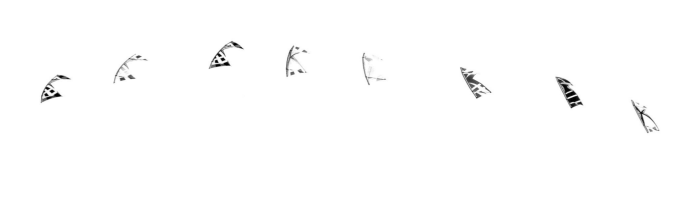

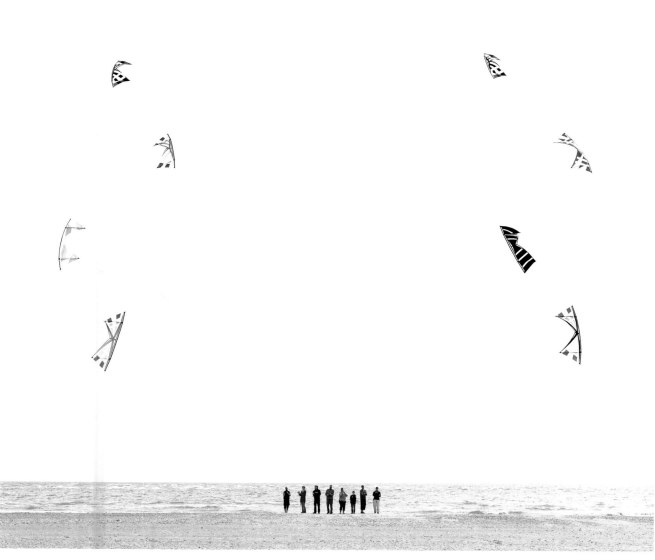

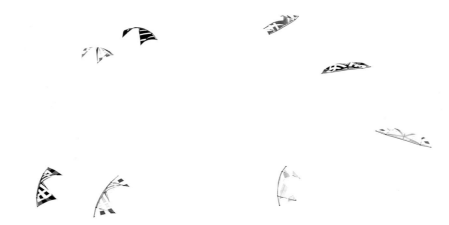

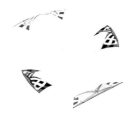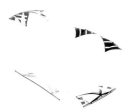

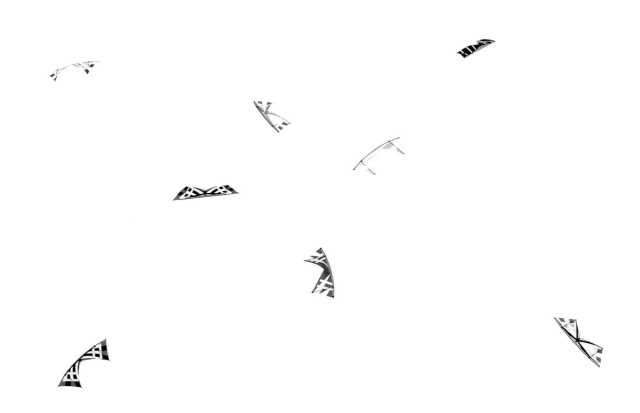

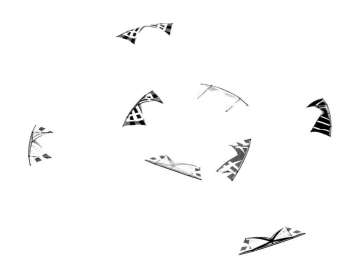

Winter Blues

by Tanya Lunina

www.TL-Photography.com • info@tl-photography.com

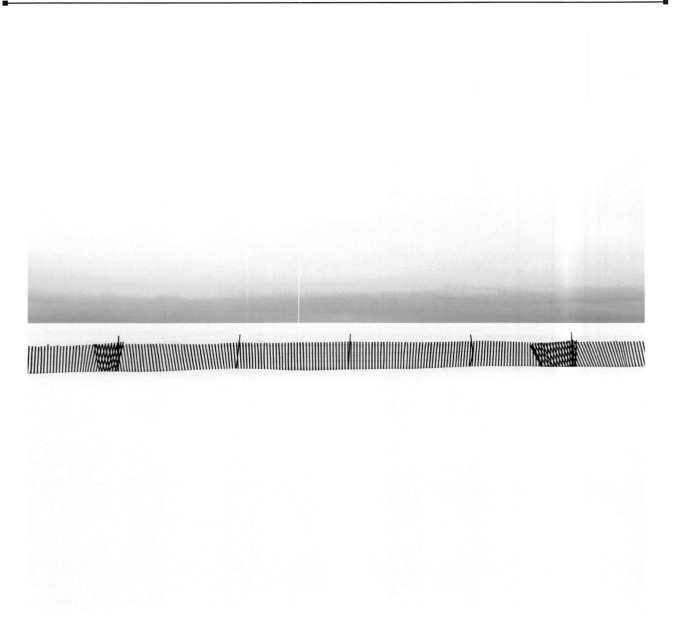

The Lake in the Windy City has disappeared under a white blanket of snow. The scene is going endlessly towards the horizon, where a touch of blue brightens this winter palette. In a vast open space, a howling wind moves freely breaking the stillness of the day. A bit of imagination and it sounds as if the wind is playing its winter blues.

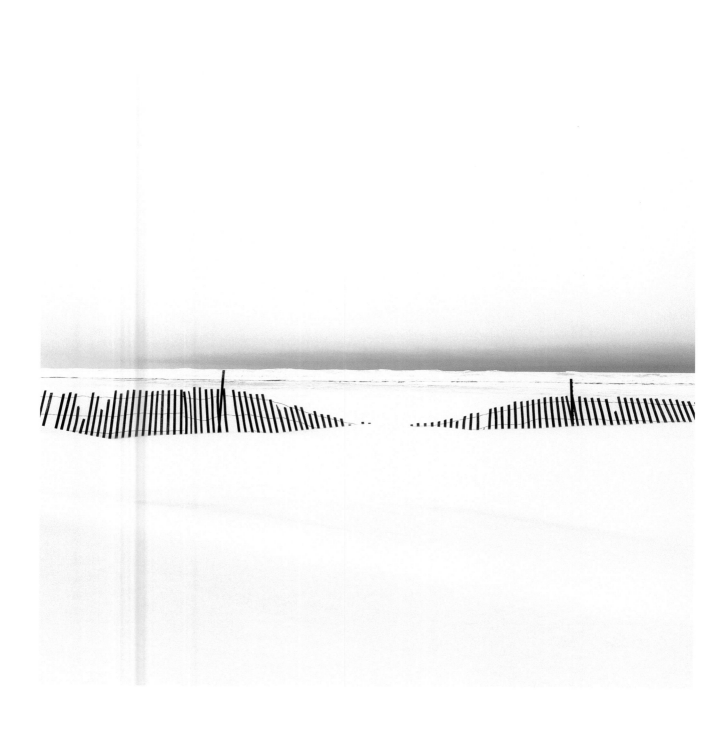

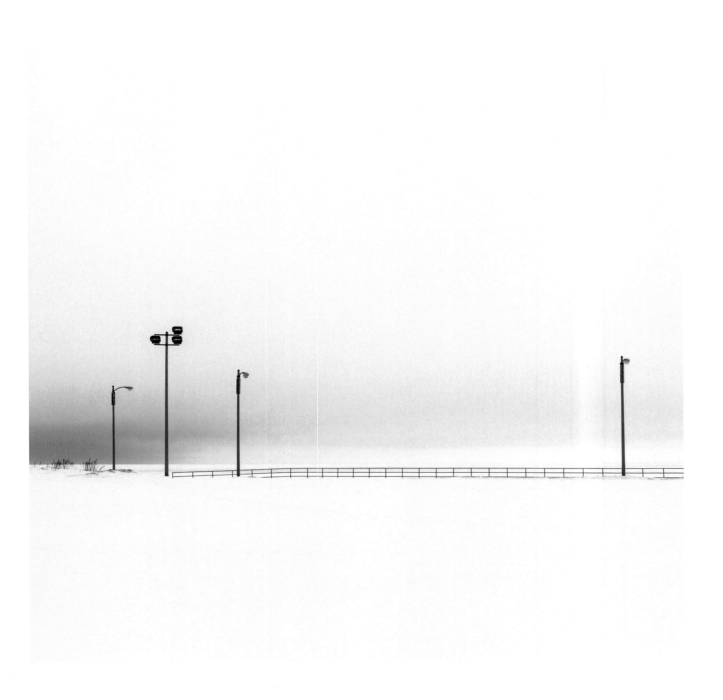

Aunt Elisaveta
by Andrei Baciu

www.AndreiBaciu.ro ♦ ierdnaclaudiu@yahoo.com

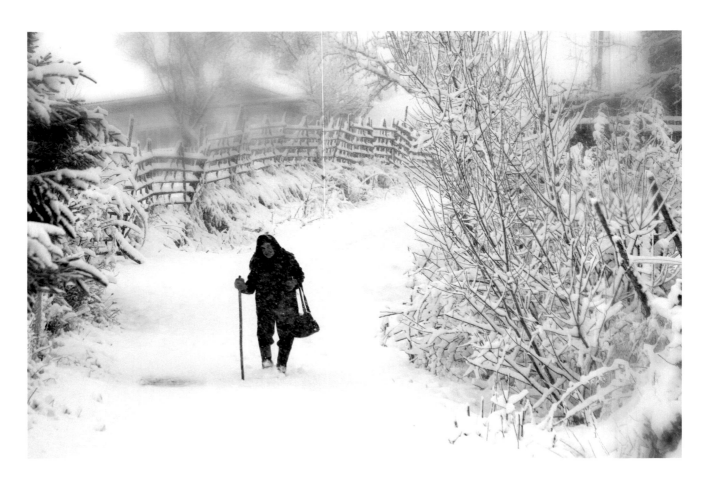

Aunt Elisaveta is descending, she's descending from her house up on the hill, as she has been doing for decades.

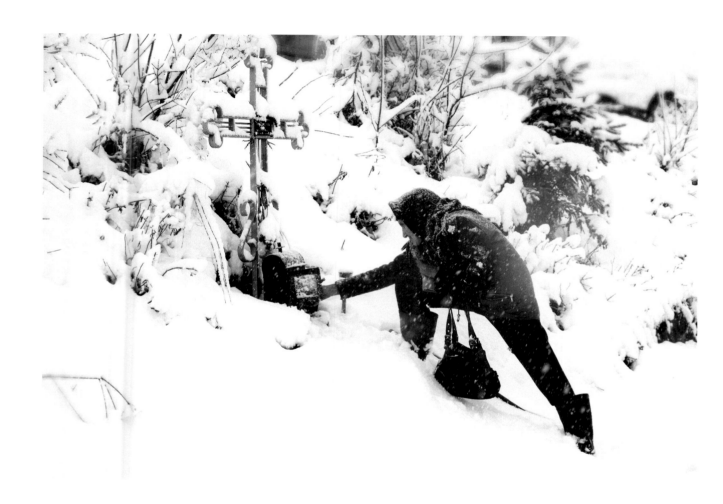

It's snowing like in a Chekov story and, while she is descending, down in the valley, the Lake Bicaz never ceases to wave. In the old woman's path, there always is her son's funeral cross. She lost him a few years ago. Aunt Elisaveta is now all alone.

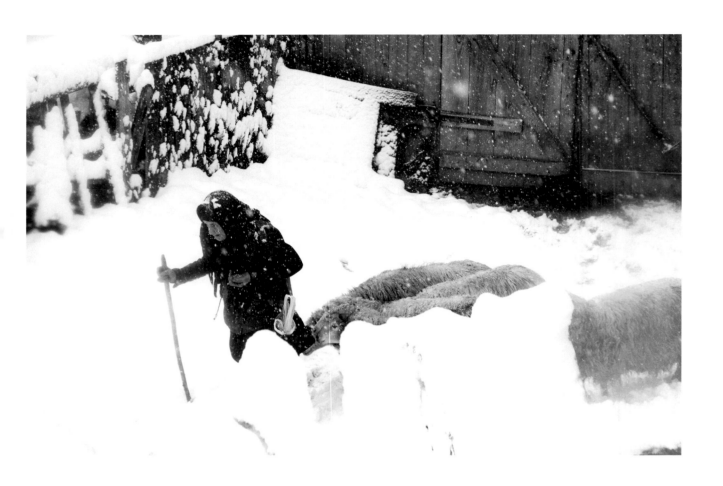

Because this is the first snow of the winter, Aunt Elisaveta is descending the hill all the way to her relative, in order to bring her sheep back home. Happy in their turn, the sheep have been waiting for her. She is giving them corn, and they are following her quietly. They've known each other for such a long time, after all.

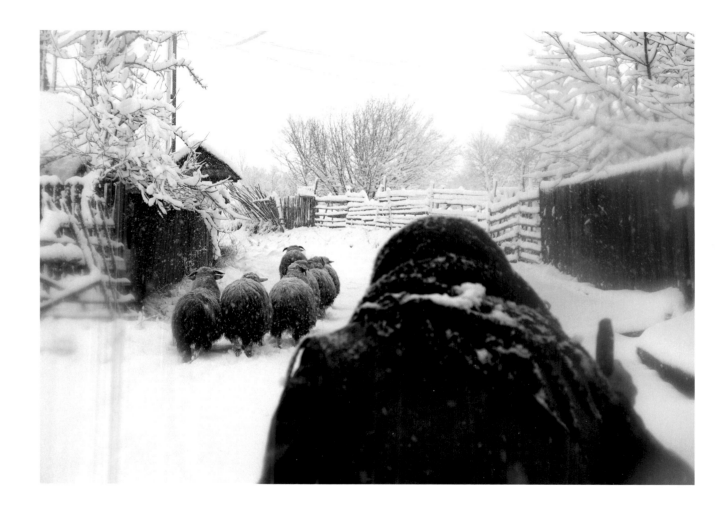

Aunt Elisaveta is ascending, she's ascending to her house up on the hill, as she has been doing for decades. It's as if, when seeing the world from her standpoint, everything looked a lot clearer, even the electricity lines and poles. She and her family had been living near the river, down in the valley, but were forced to move by the Communists. They had to give way to the waters of the dam.

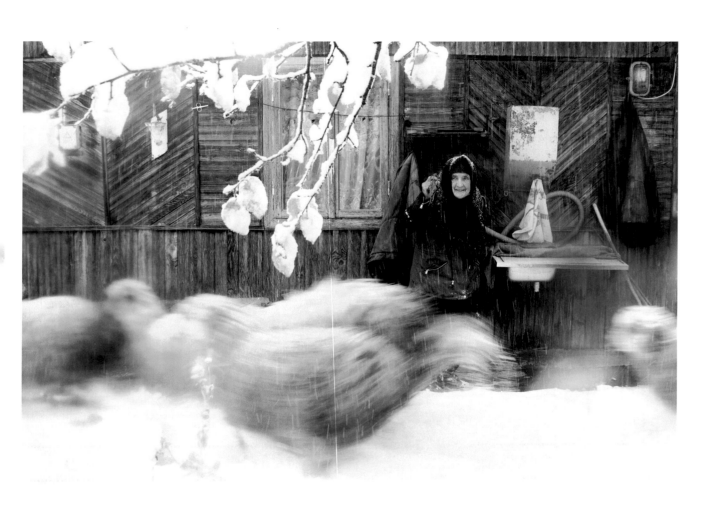

Once at home, the sheep are frisking about, and their master is fetching a key.

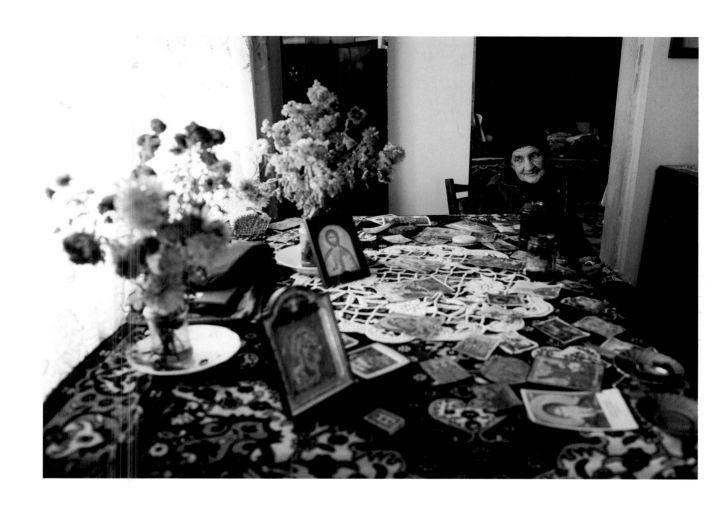

When there is no one to see her eyes, what does Aunt Elisaveta do? She is smiling now: "It's hard, but you pray. The Mother of God is there to listen."

The Glassal Pool

by Linda Lashford

www.LindaLashford.PhotoShelter.com • lindalashford@hotmail.com

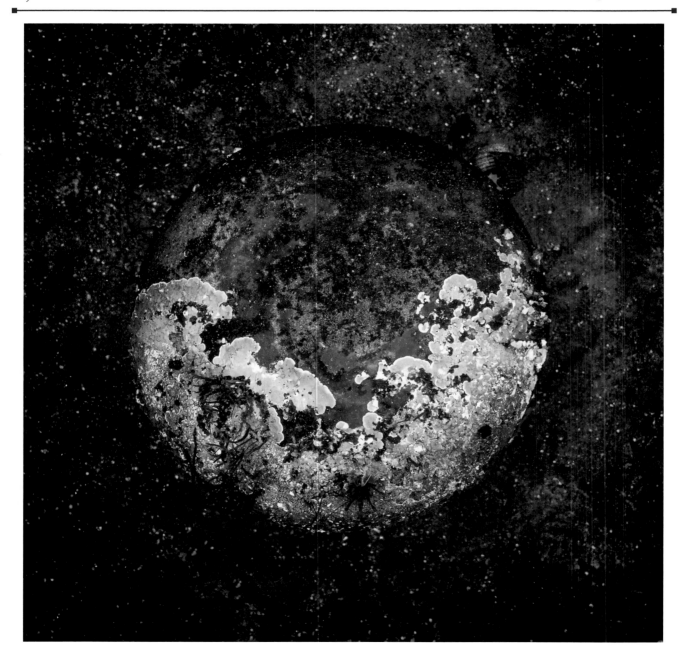

Cradled between a shallow, landward rise and a porous boundary of seaward rocks, the glassal pool pulses to the rhythm of the tides. Replenished by periodic highs of flushing flow, it ebbs to stillness and mirror like, forms the landscape of my enchantment. I turn to the pool on days of subtraction: threadbare,

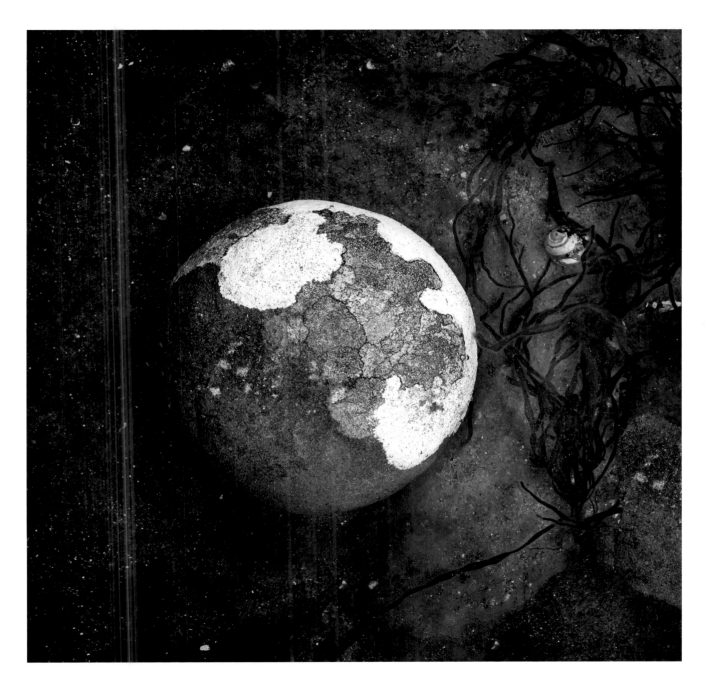

icebound days of bleaching gray, when the light is cold and low, and skeins of thickened cloud wad the distant hills. Amongst so many winter days, I hold out for singular dawnings of unruffled calm… for early mornings, when the wind has faded to a purr upon the water and the weighty silence is broken by a flurry of rising ducks and the oystercatcher's piping skim.

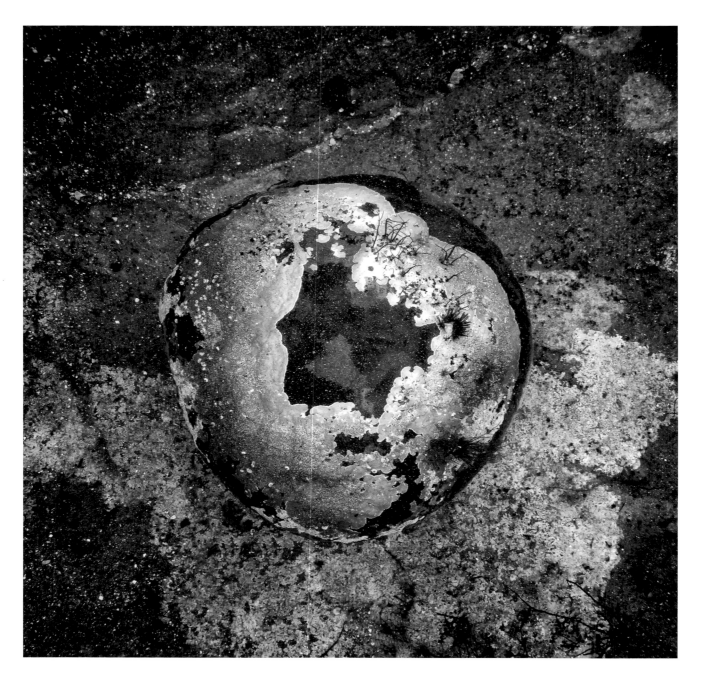

Negotiating the shadows of early light, I pick my way across the beach, thick with erratics and the tang of kelp. A break in the cloud brings a brief flare of red over Coigach. It ripples across the skyline and quickly dies in a dawned transition. I hear the unexpected snuffling song of a curious otter at my feet and just beyond, I glimpse the pool; its surface an opalescent stain of reflected light. I have little interest in how the weathered drama will play out across

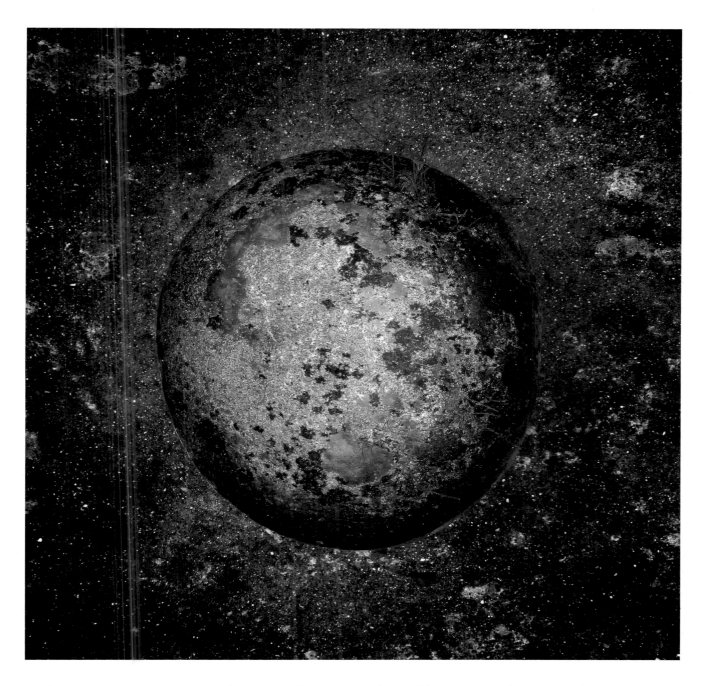

the framing mountain view. I am only interested in the immediacy of this particular shore and in the persistence of an absent wind that leaves the surface of the tidal pool unperturbed.

Entering the water, I wade through a boundary of mirrored cloud to join my treasury of stones. Vivid, gems of crimson and mottled jade, they remind me of Fabergé's eggs, encrusted in a filigree of cream. Wetting my arm,

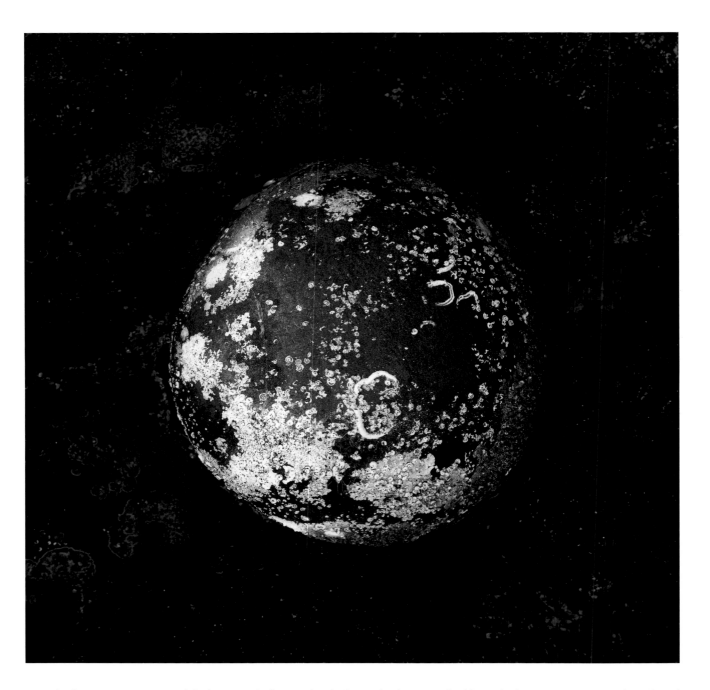

I reach down to turn a tumbled stone. Pulling it back through the portal of liquid glass, I cup it in my hand and contemplate its form. Delicately, I stroke its surface, freeing it of speckled dirt.

Plucked from the tidal pool the stone has lost its luster, fading from a bloody red to an indifferent russet brown. Its verdant floating frill, reduced to a sodden tangle of sorry weed. Carefully, I place the stone back in the pool. Solitary

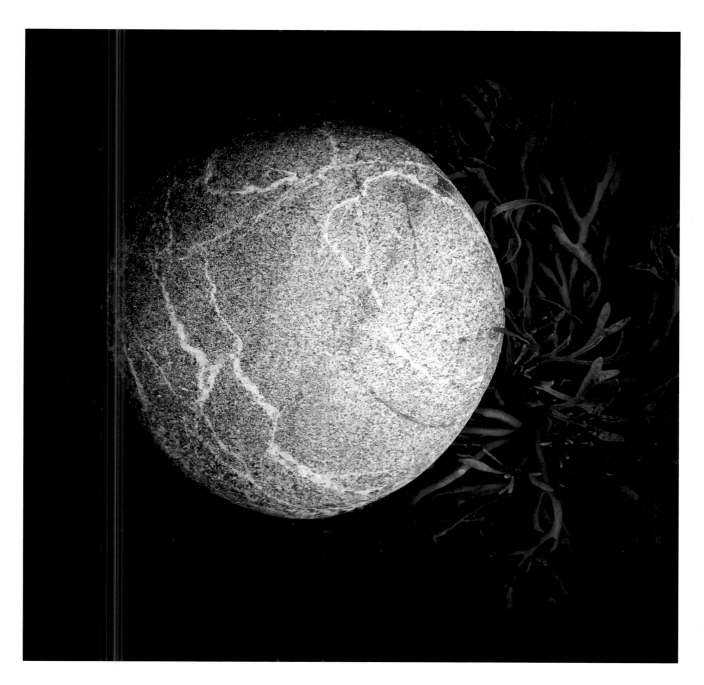

now, it sinks against a background of marled bedrock and scattered shells. My own movement raises a thin film of silted sand and as I wait for it to settle, I am twice transported. Into the unbounded universe of my imagination where pitted, jewel-like planets lie suspended in a wrap of stars. And, in this seeping morning chill, to my childhood, briefly captured in a memory of stones.

Winter's Decline
by David Fox

www.4dfp.com • dafoxman@gmail.com

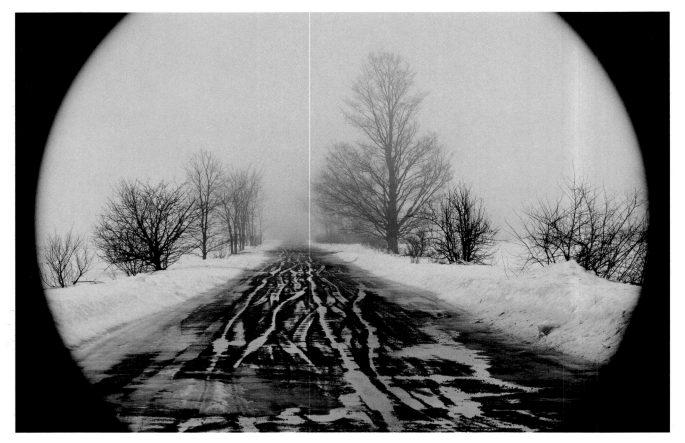

Only Road Home!

As Winter begins to decline, the warmer air flowing over the melting snow produces fog. Each year I look forward to the days with fog and seek out the isolation it produces and the rural scenes of the Northwestern lower peninsula of Michigan.

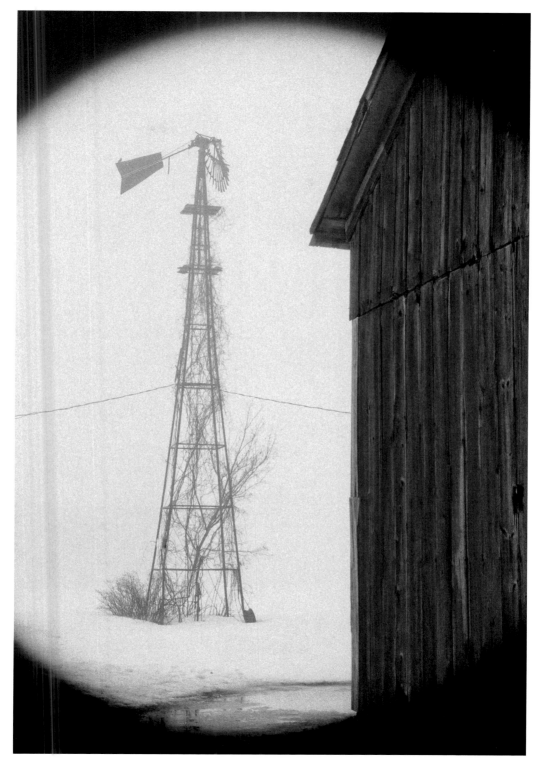

Time Builds Character

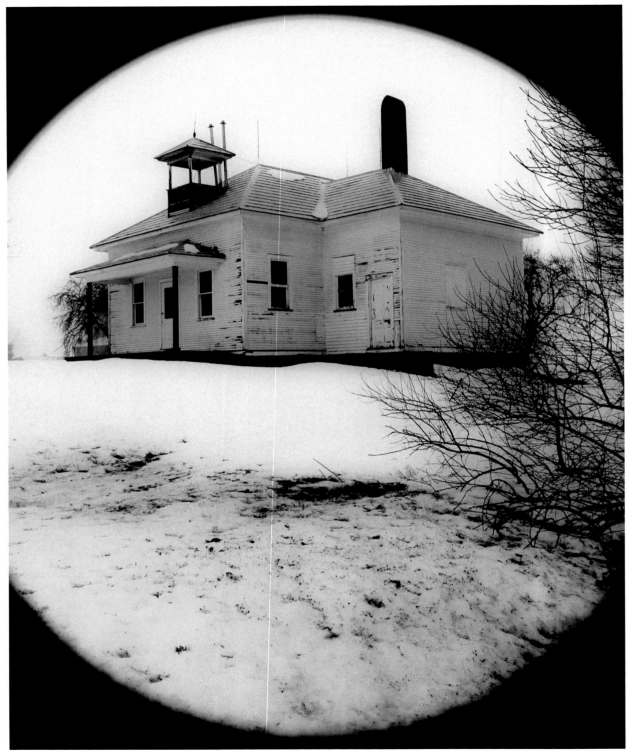

La Canada School

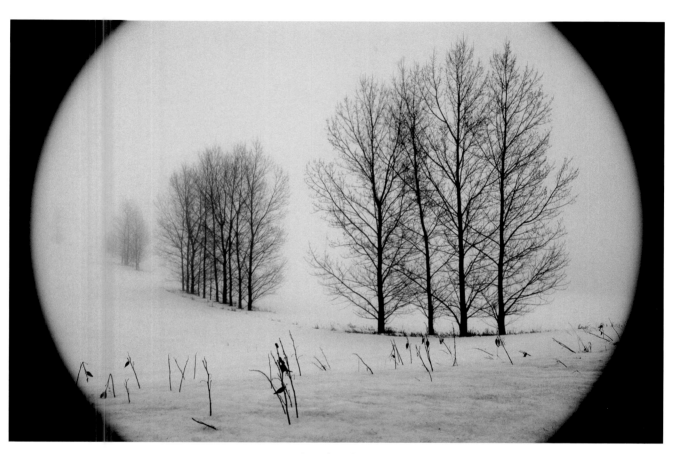

Desolate Row

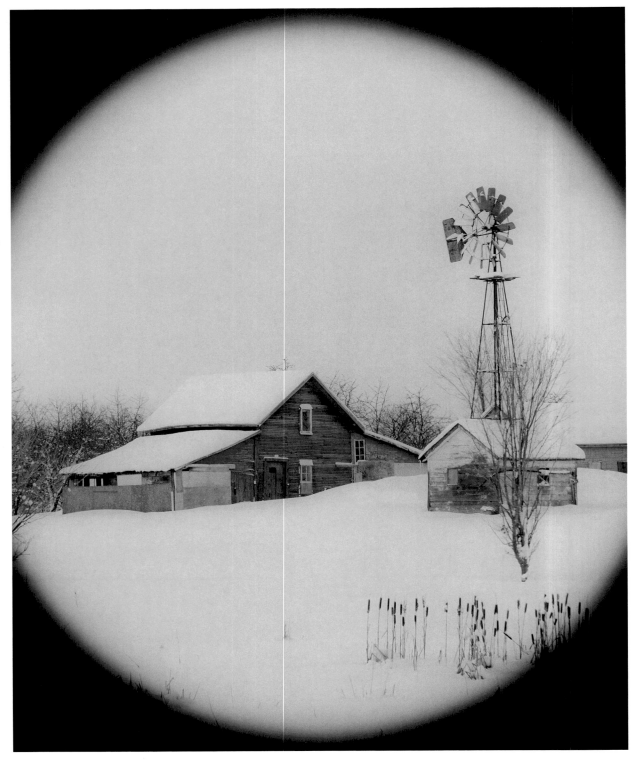

Old Man Potter's Farm

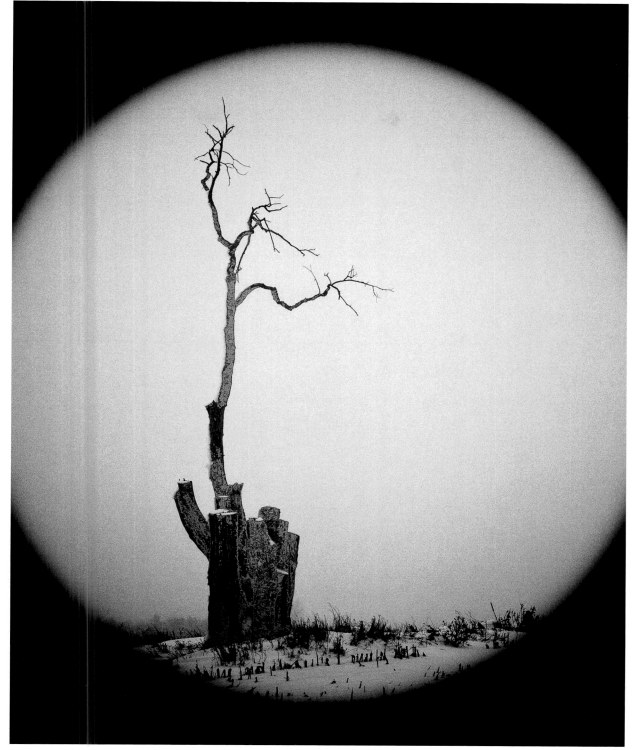

Defiant

The Presence of Absence

by Daniel Goldberg

www.instagram.com/daniel.from.princeton ◆ dcgphd@yahoo.com

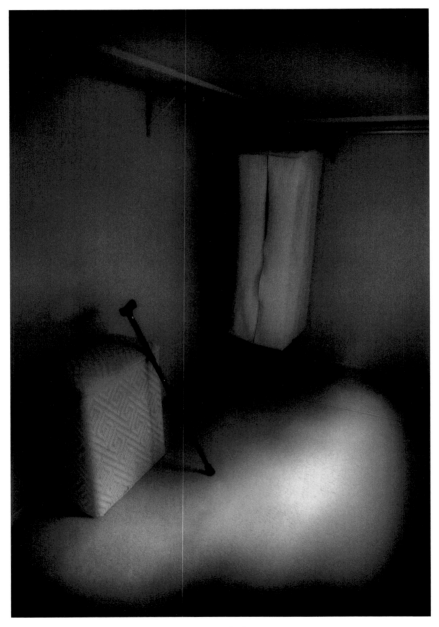

Empty light

In the moments after my mother died this past summer, I had the impulse to go and photograph her house. Her house would ground me, I hoped.

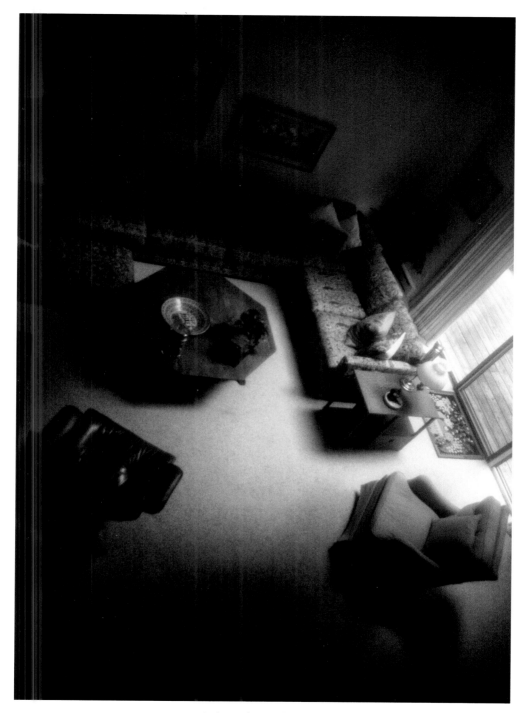

Where she gathered us

My biggest fear was that I would lose a sense of her, that I wouldn't be able to sense her, hear her voice, touch her existence.

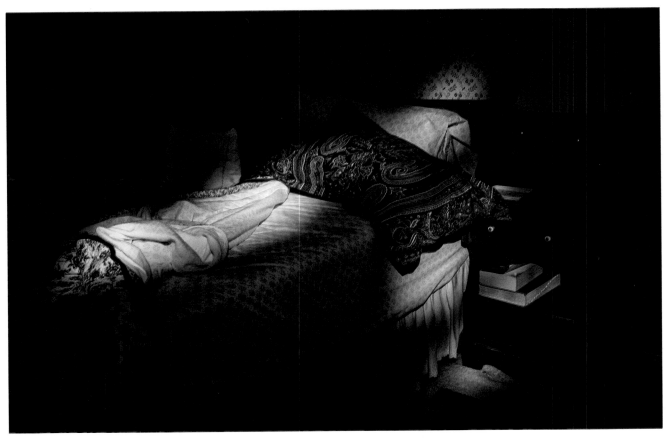

The last sleep

Maybe if I walked around her house, I would be able to experience her presence. Or maybe I'd better inhabit the notion that she had indeed died. Photographs might help me capture her absence, an attempt to balance the impermanence of life with the seeming permanence of a photograph. She is still here, in this house, some ineffable quality of being here, and yet she isn't here.

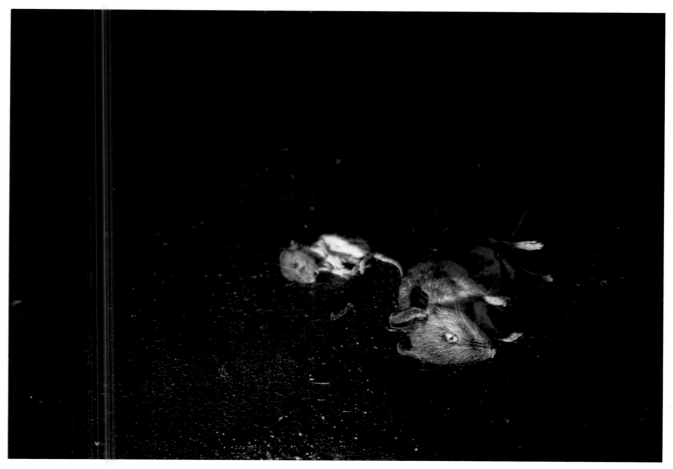

Upon finding you in the basement

I visited her home four hours after she had died in the hospital. A month later, I returned after much of the furniture and clothes were taken away. Could I capture this sense of loss? I slowly walked from room to room. I stood in spots and didn't move. I took deep breaths when I remembered to breathe. I discovered the bedroom with her unmade bed, her nearly empty closet, the dead mice in the basement, an empty refrigerator except for what no one could dare to throw out, and my own sadness caught as I glanced at her bathroom mirror. Yes, my breath. Keep breathing.

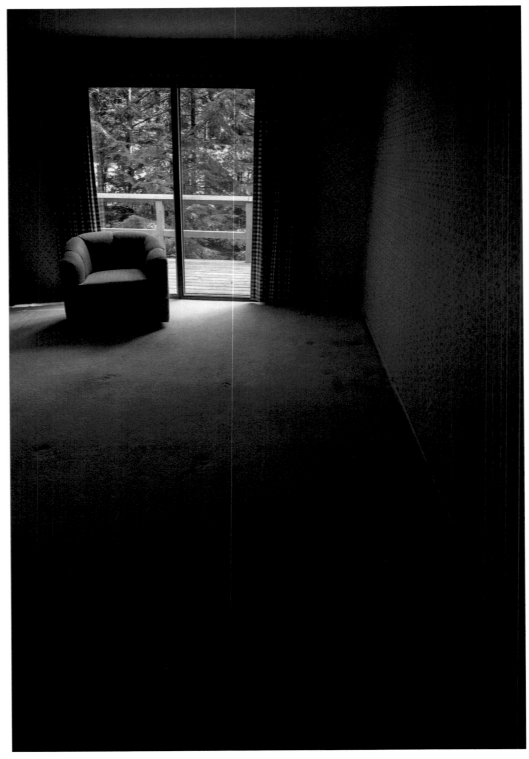

Without you

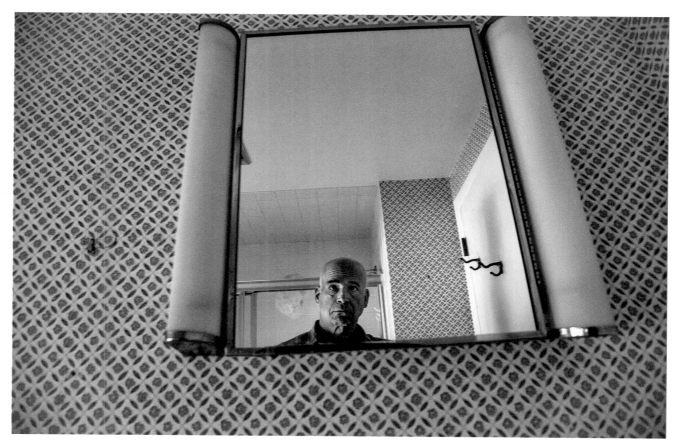

Unspeakable

I could feel her and then in the next moment, I couldn't feel her at all. She was gone.
But the presence of her absence definitely remained.

Disorder
by Andrew Schirmer

www.AndrewLSchirmer.com • devschir@comcast.net

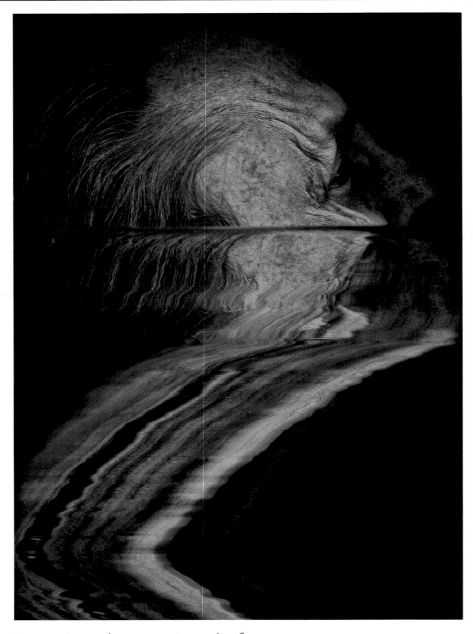

imagine then a simple future
reflected on as many times before
till light begins to shiver it to bits

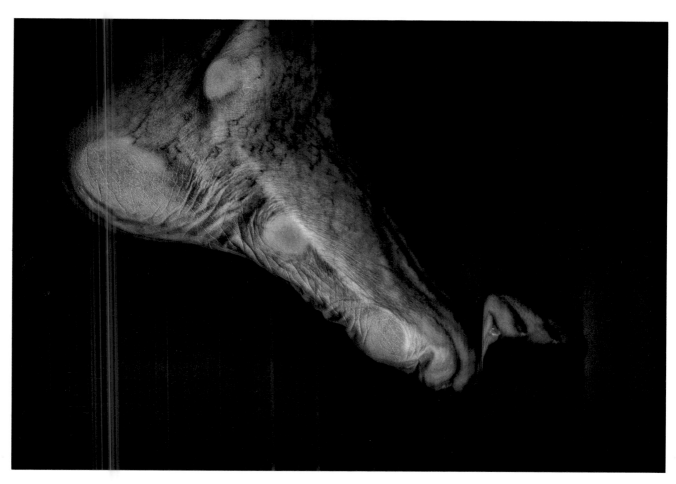

time stops or trips and you
run madly just to halt the monolog
of variations and alternatives

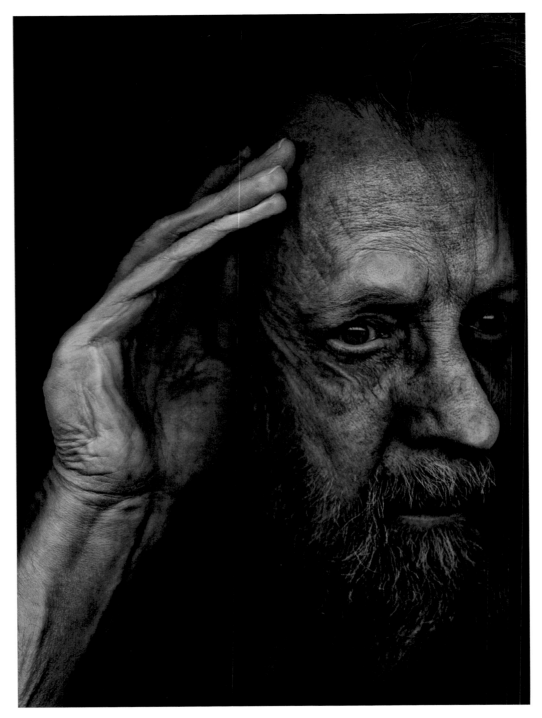

silence puts a hand up in the back
the light goes dark or so it would appear
awareness stiffens catatonic and inert

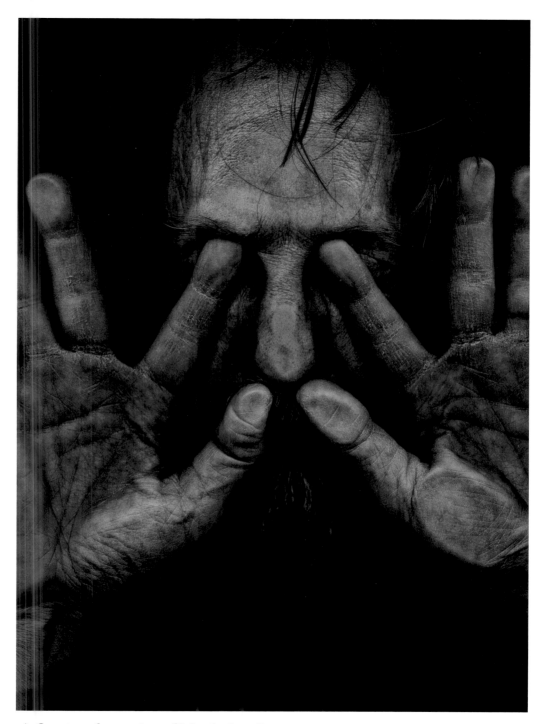

deflecting fantasies of black detail
you want to fight the shrinking edge
that holds you up against your will

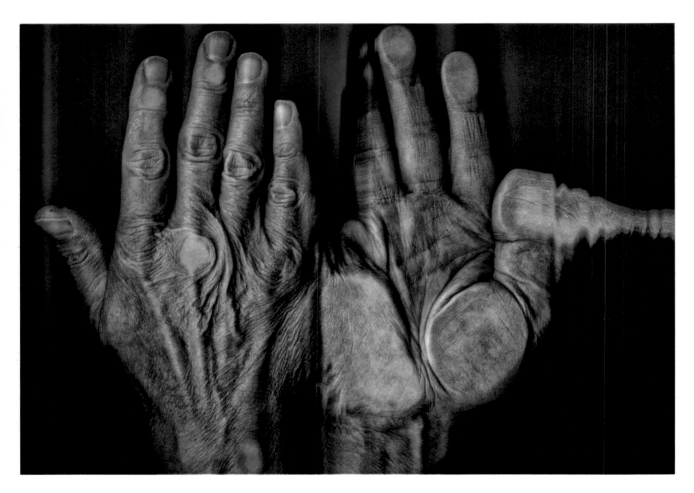

but why is here and what is where
perception of perception blurs in time
with nowhere feelings lost beside restricted dreams

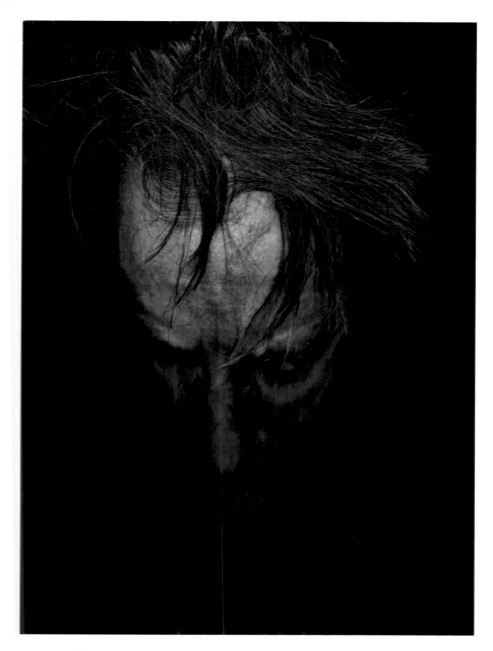

and drifting downward counting out unequal
turns of night and day you wonder still
if you must drown or simply pray

Cosmos in a Pond
by Bonnie Lampley

blampley@lwrnc.com

A short time ago, in a pond near, nearby…

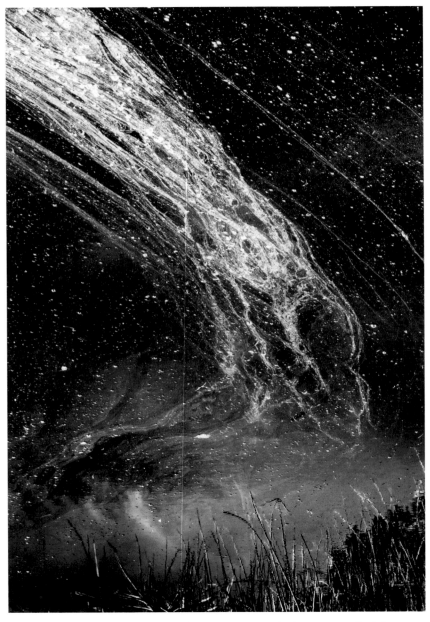

Somewhere, something incredible is waiting to be known. ~ Carl Sagan

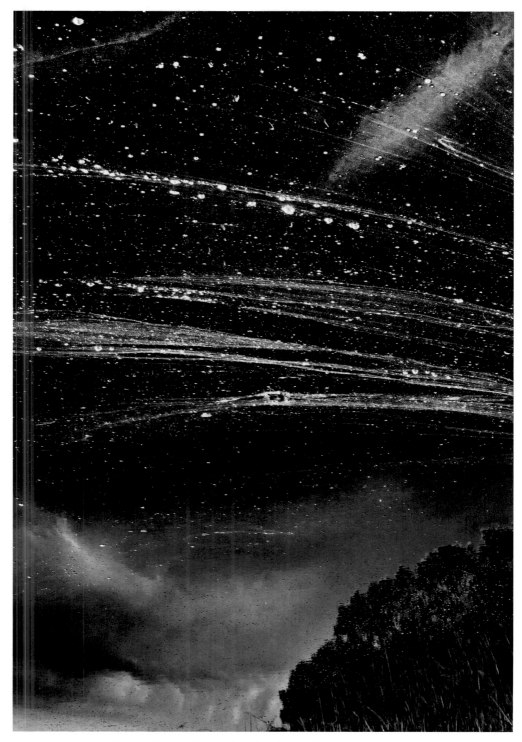

The surface of the earth is the shore of the cosmic ocean.
From it, we have learned most of what we know. ~ Carl Sagan

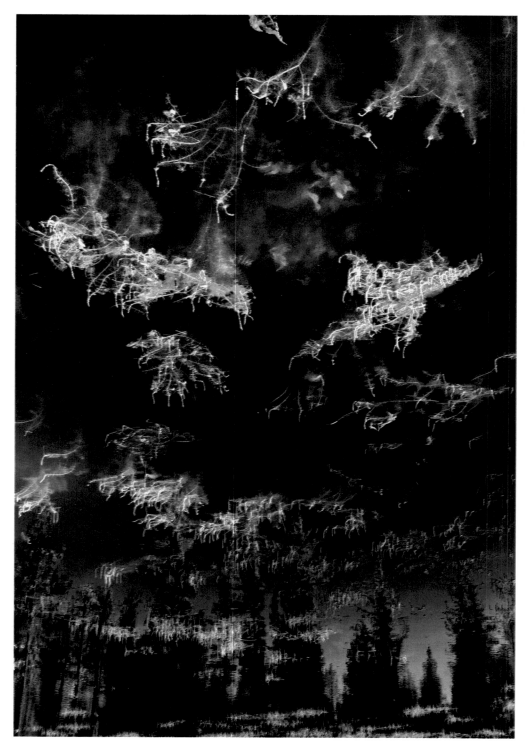

The most beautiful thing we can experience is the mysterious.
It is the source of all true art and science. ~ Albert Einstein

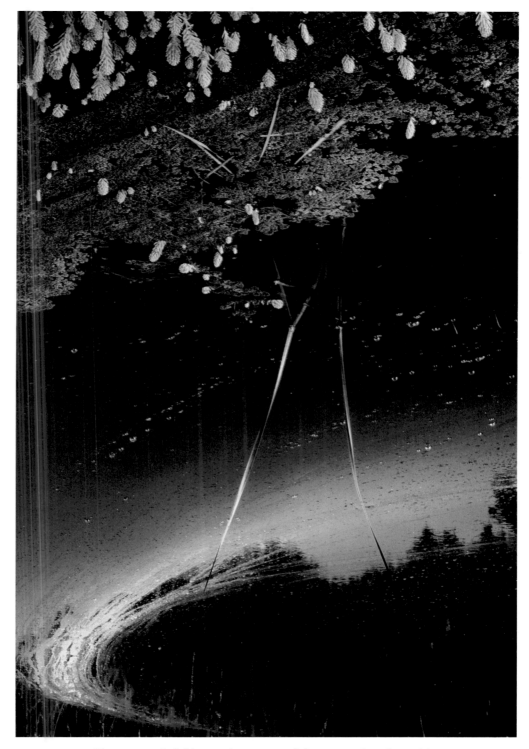

The cosmos is full beyond measure of elegant truths, of exquisite relationships, of the awesome machinery of nature. ~ Carl Sagan

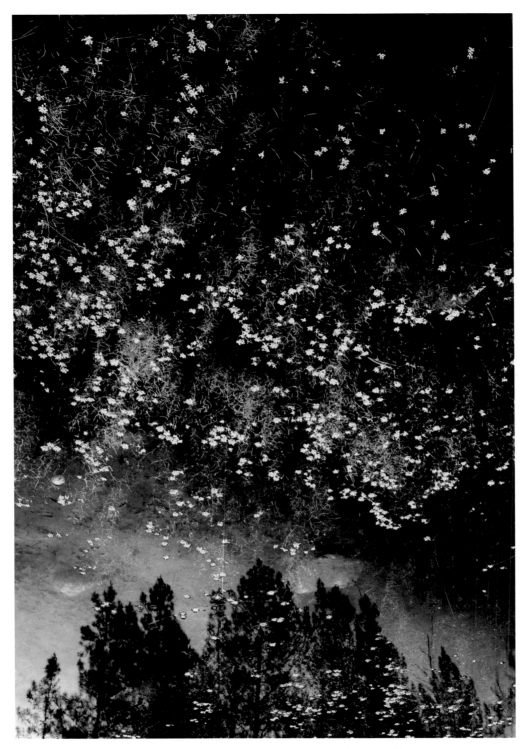

The cosmos is within us. We are made of star-stuff.
We are a way for the universe to know itself. ~ Carl Sagan

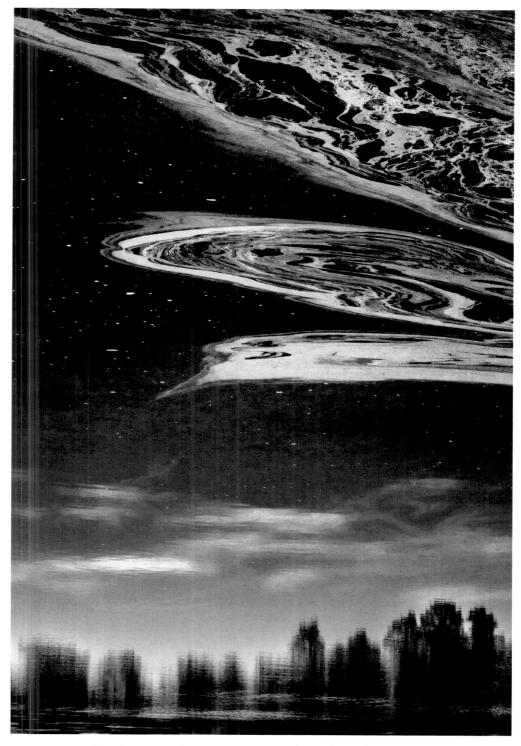

*He who can no longer pause to wonder and stand rapt in awe
is as good as dead; his eyes are closed.* ~ Albert Einstein

Honu
by Don Whitebread

www.DonWhitebread.com • don@donwhitebread.com

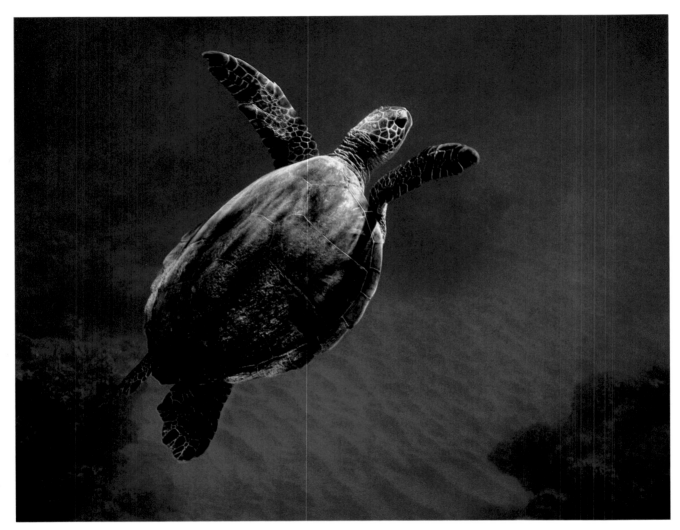

Swimming Toward the Light

In the Honolua area of northwest Maui, the Green Sea Turtles, called Honu by the ancient Hawaiians, have persevered through decades of hunting, habitat reduction, and pollution. These images from a multi-year project document the grace and beauty of the turtles' lives, and the mesmerizing, wave-scattered light that falls on them.

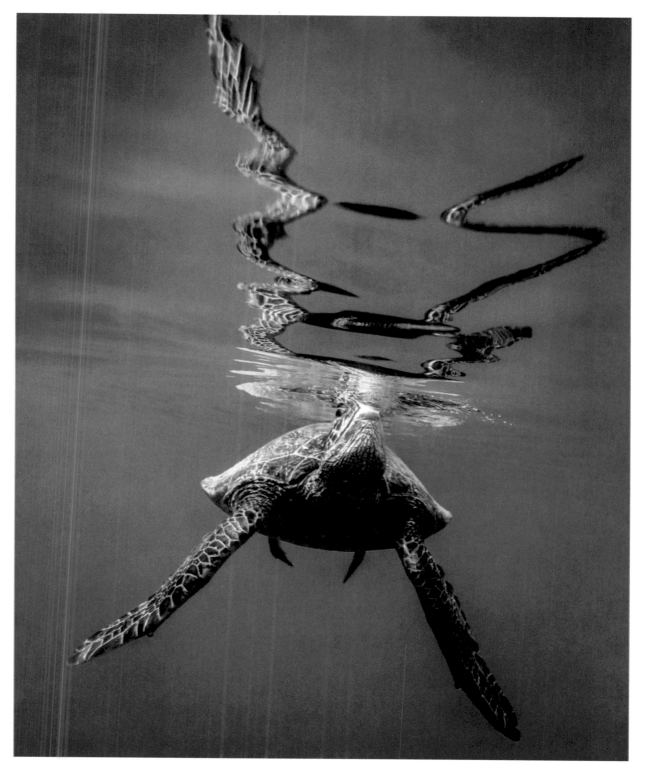

Reflecting on a Breath of Fresh Air

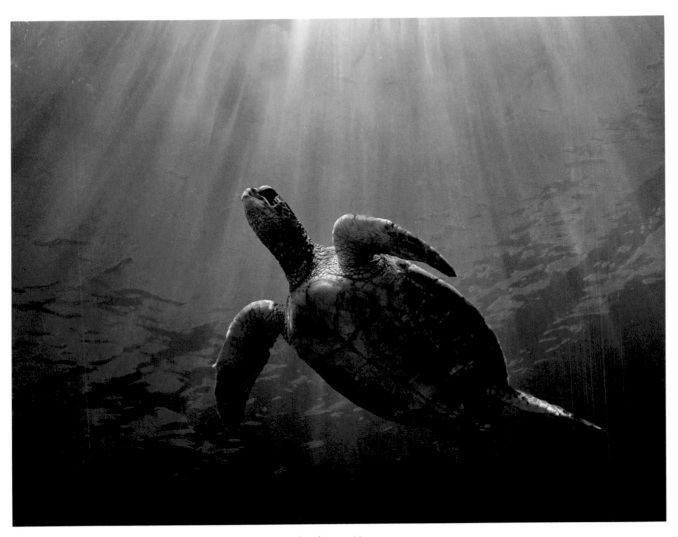

Sunbeam Honu

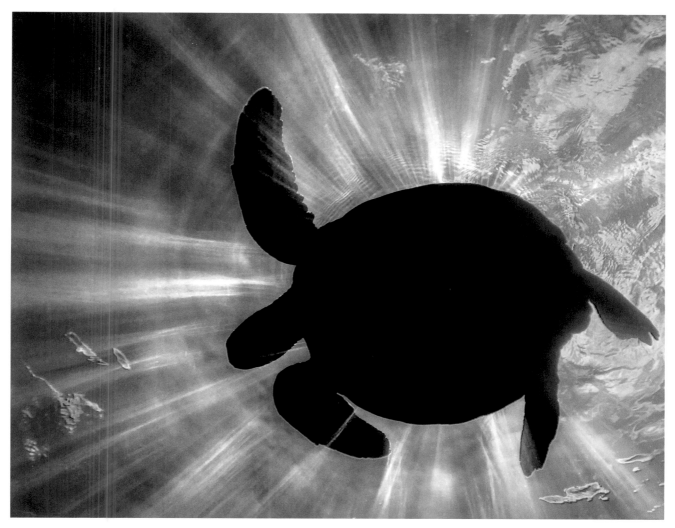

Turtle Eclipse

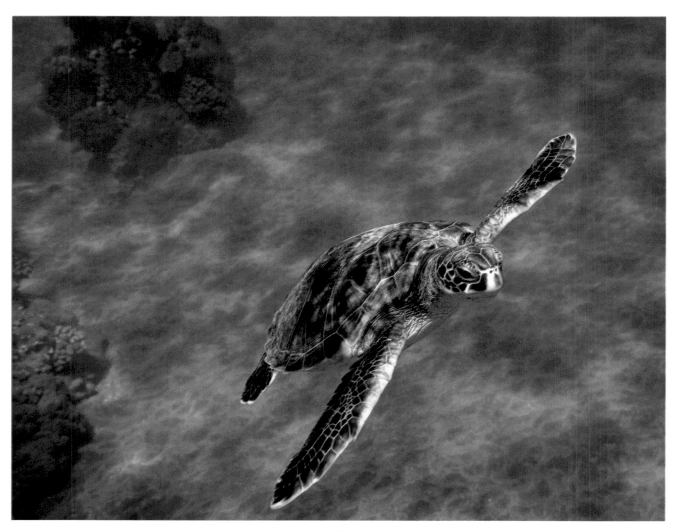

Gliding off the Sand

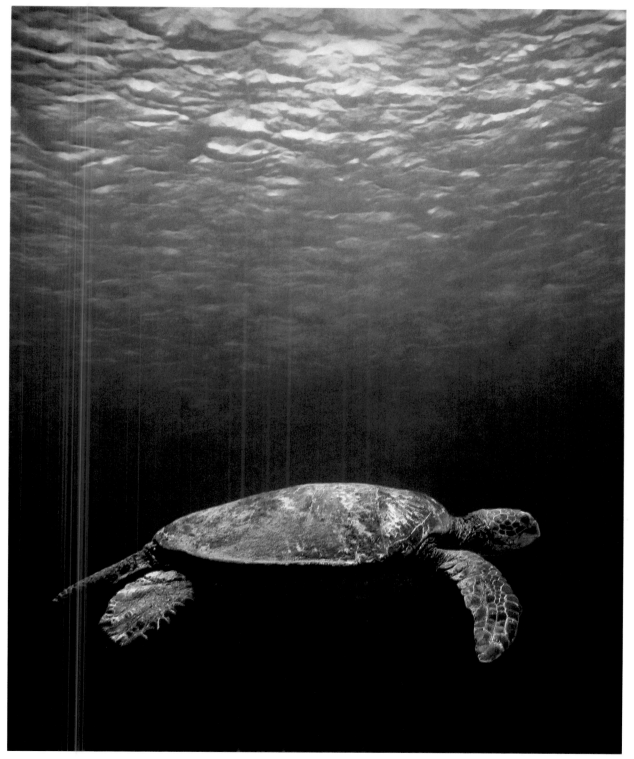

Honu Cruising

Re/Creation

by Seamus Ryan

www.SeamusRyan.com ♦ info@seamusryan.com

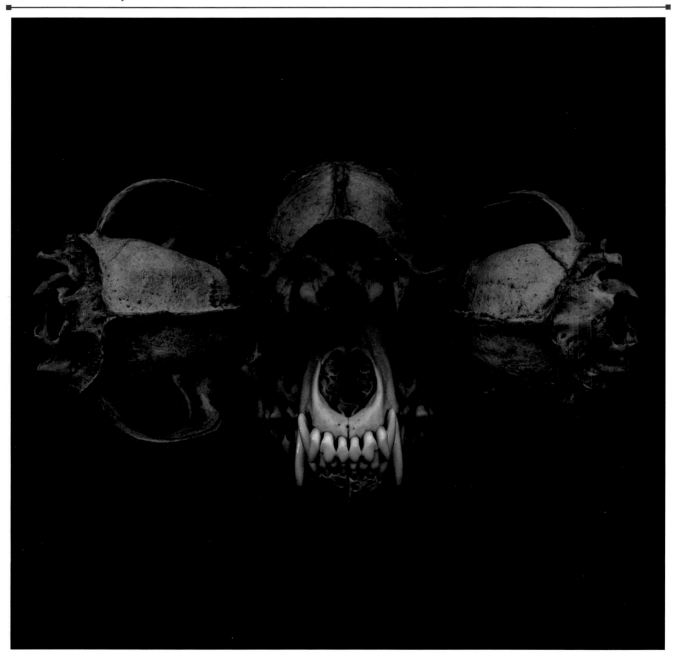

Having spent the last six years observing my students photographing these skulls, I felt it was time to tackle them myself. Bypassing the obvious still life way of photographing them, I decided to see if I could physically make something new from them and photograph the result. This is only the start of the journey.

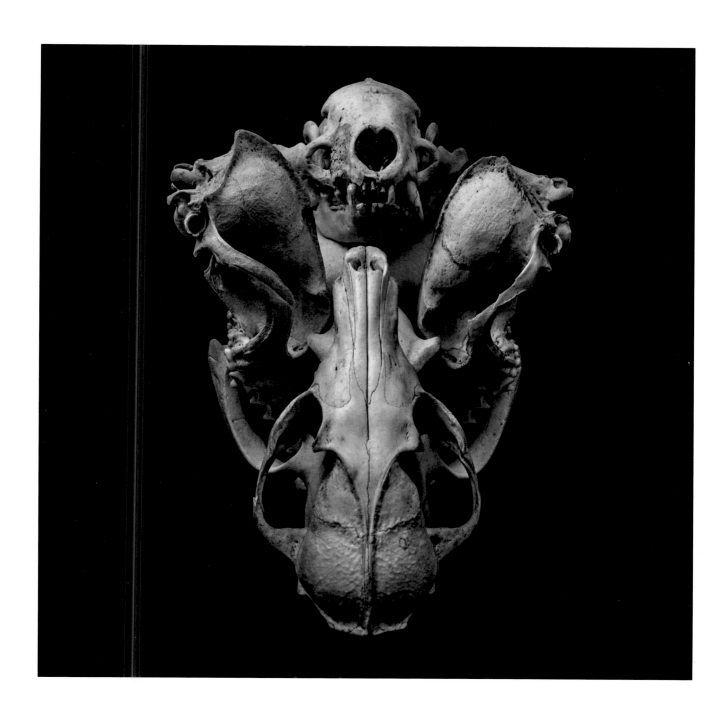

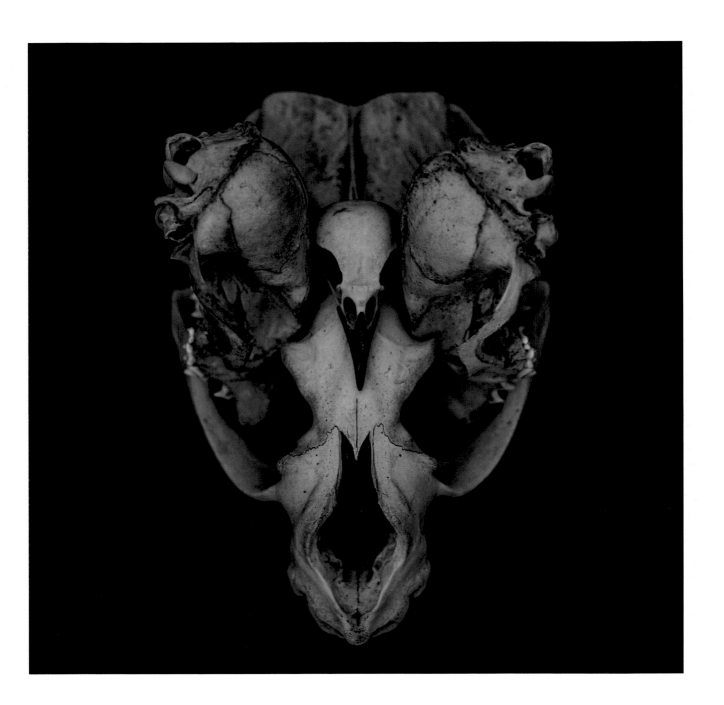

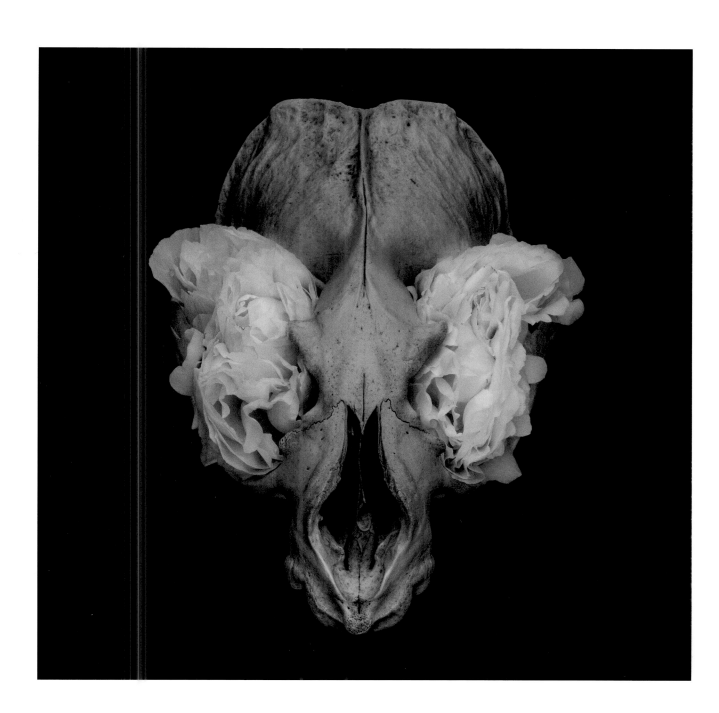

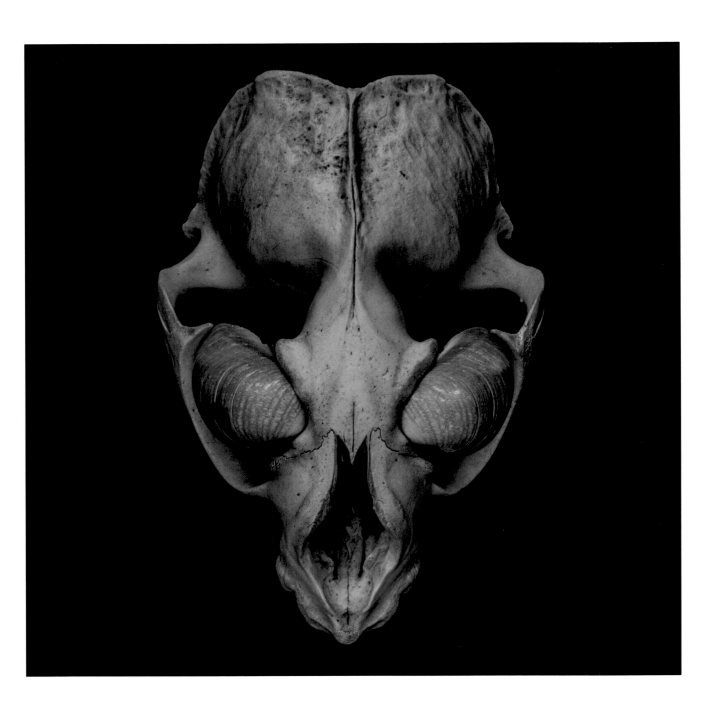

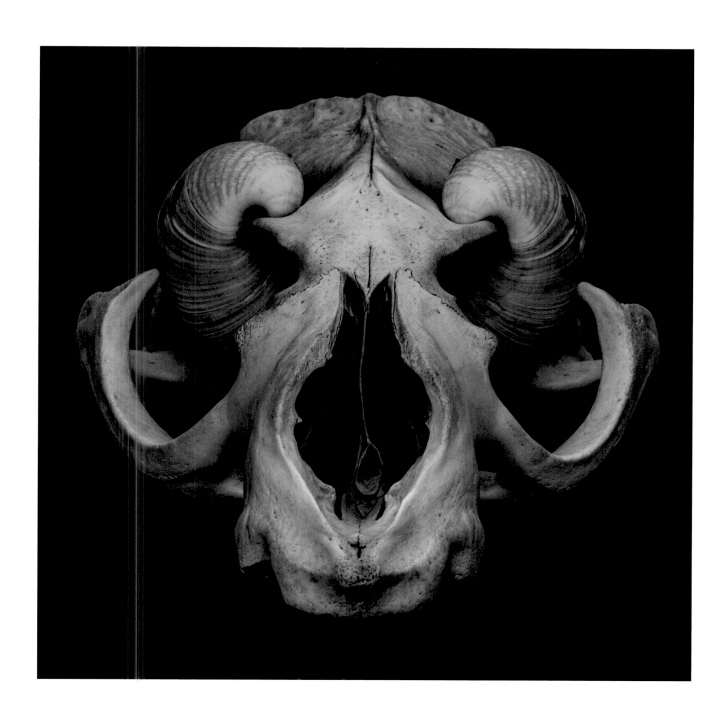

A Handmade Tale
by Manoj Gurnani

www.ManojGurnani.com ♦ manojmg@yahoo.com

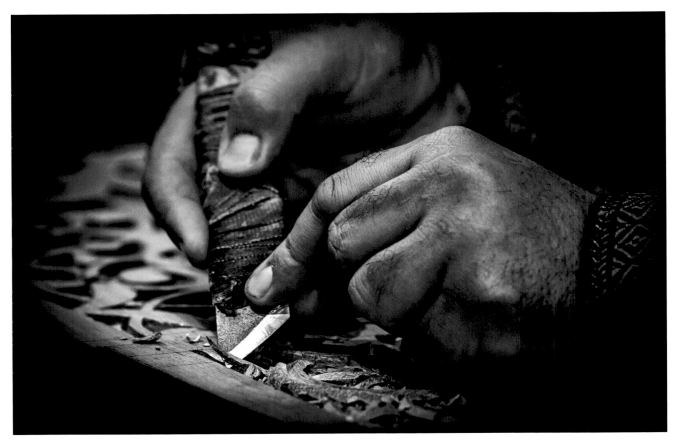

Hands deftly carving

We take our hands for granted. Pause just enough to wonder how much we rely on our hands—from the time we wake up to the time we sleep, from the womb to the tomb. Ponder to start counting things our hands accomplish for no more than a minute and the mind begins to boggle. To quote Joni Mitchell, "You don't know what you've got till it's gone."

This series of images is a tribute to an unsung, unassuming part of our body that follow unquestioningly the orders fired in by our neurons. And how! No matter how much age ravages the body, hands remain loyal to our pursuit to

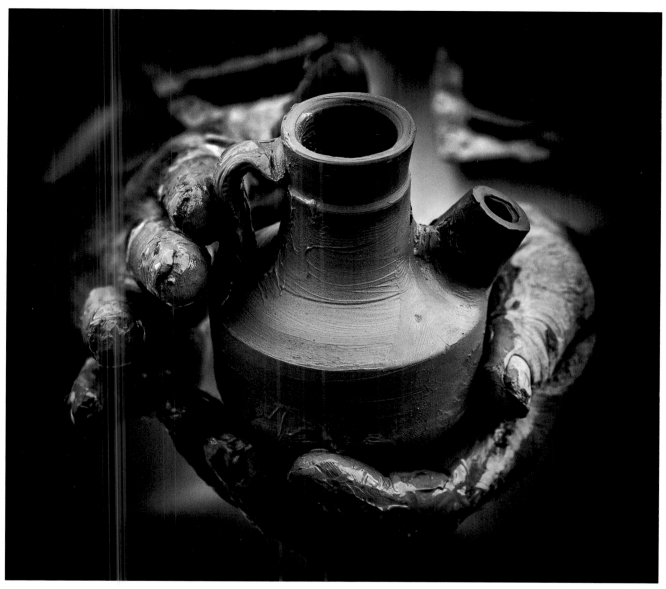

A newborn vessel

remain meaningful and expressive till our dying day. Hence we have chefs barely able to walk still working magic in the wok, painters in their sunset years creating masterpieces, and wizened hands of nonagenarian musicians tapping out tunes on the flute — to mention just a few.

Human hands in the midst of creating art are a delight to hold. Watching the delicate dance of fingers, the pressure applied, at times tender, at times firm, the deft handling of the tools of the trade — a sewing needle, the henna cone, glistening soft clay being molded into a pot — are no less an art being performed than that by musicians.

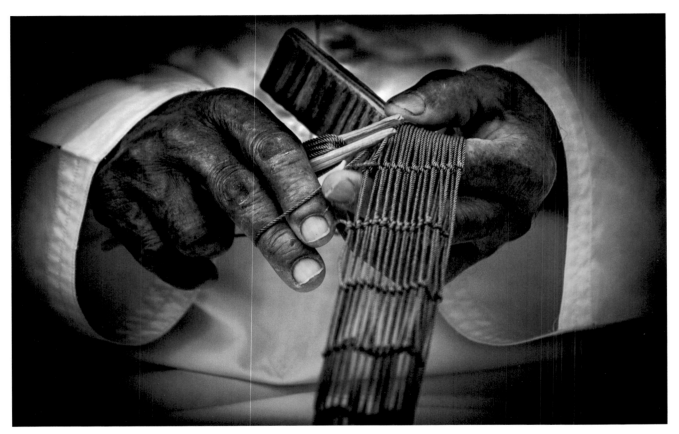

Knot-tying of a fishing net

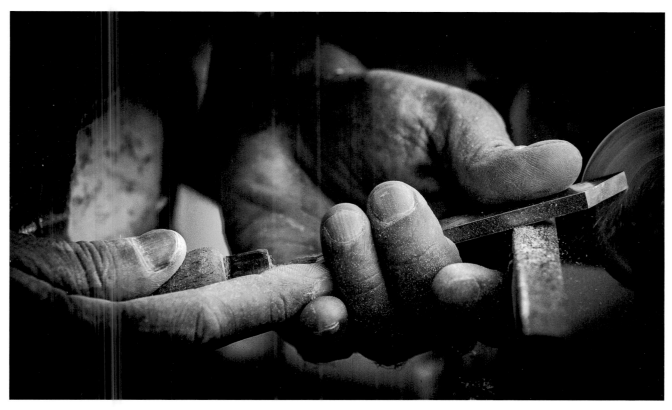

Shaping a wooden toy

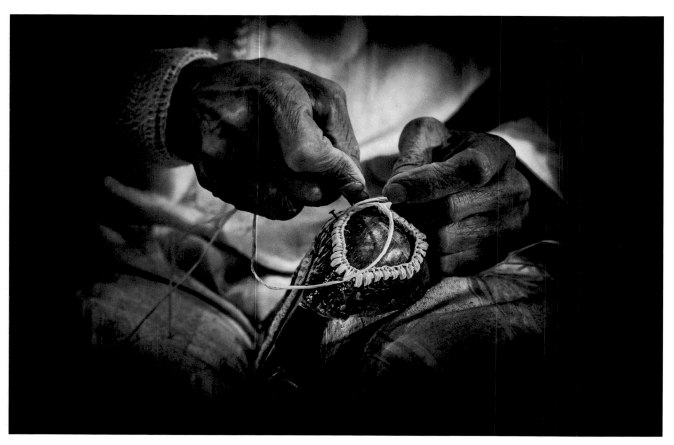

Making of Yemeni footwear

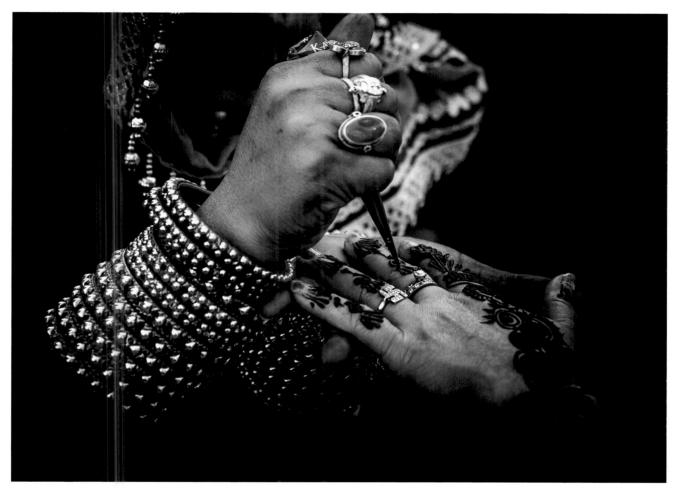

Applying henna art

Once Remembered

by Dan Katz

www.GalleryKatz.net ◆ thatzkatz@gmail.com

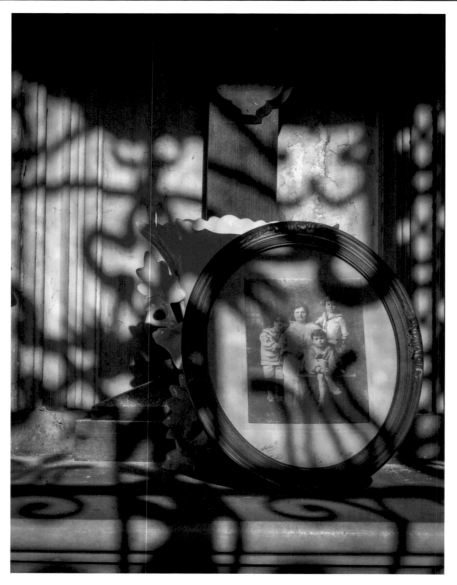

Once Upon A Time A Family

A visitor to Recoleta Cemetery in Buenos Aires would find it hard to forget, yet so many who are there were forgotten ages ago. It's an eerie, impressive, sprawling city of the dead — the final home of presidents, generals, Nobel Prize winners and Eva Perón. But within, among its countless crypts, are many once-sacred memorials to loved ones, long since abandoned, vandalized, scattered with decaying memories. I find a strange beauty within the decay and shadows of love cast upon the fractured urns and peeling lacquer.

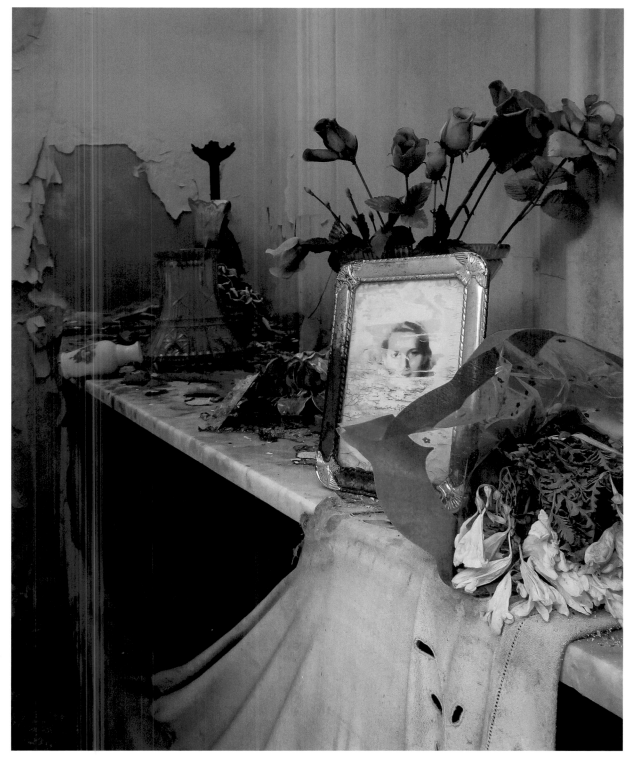

The Cellophane Bouquet

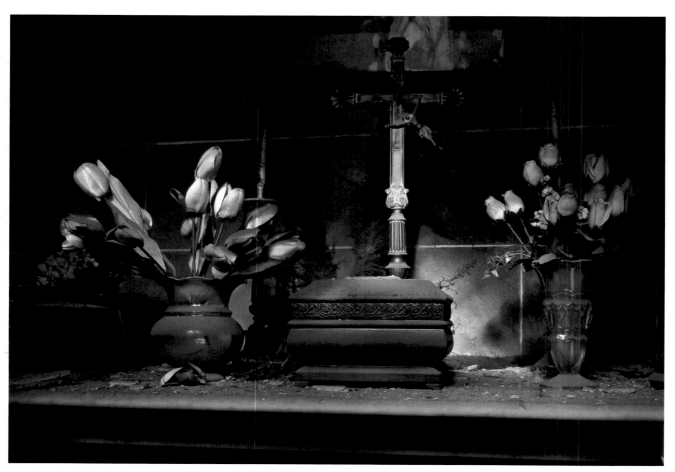

In Christ's Care Now

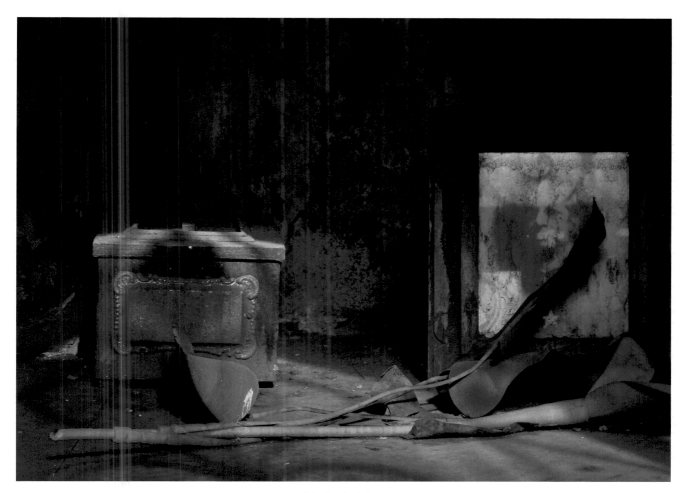

Mother's Ashes

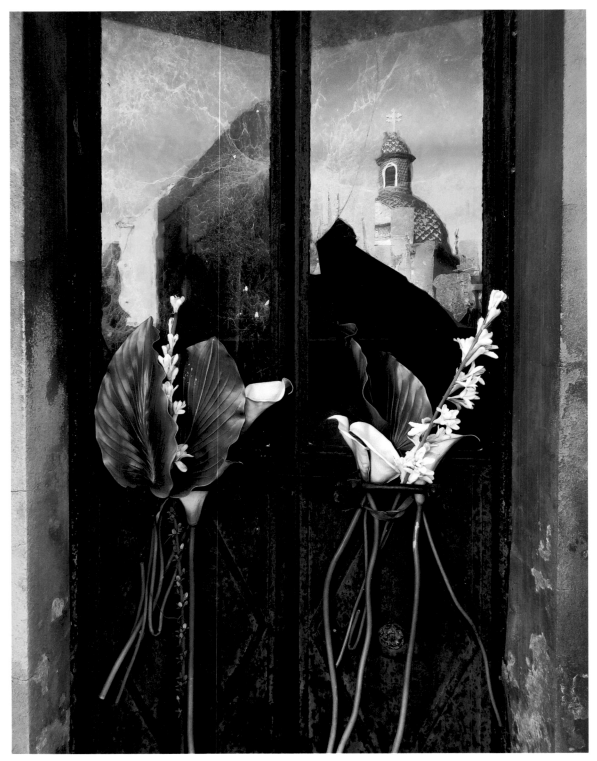

Palms, Lilies, and Broken Panes

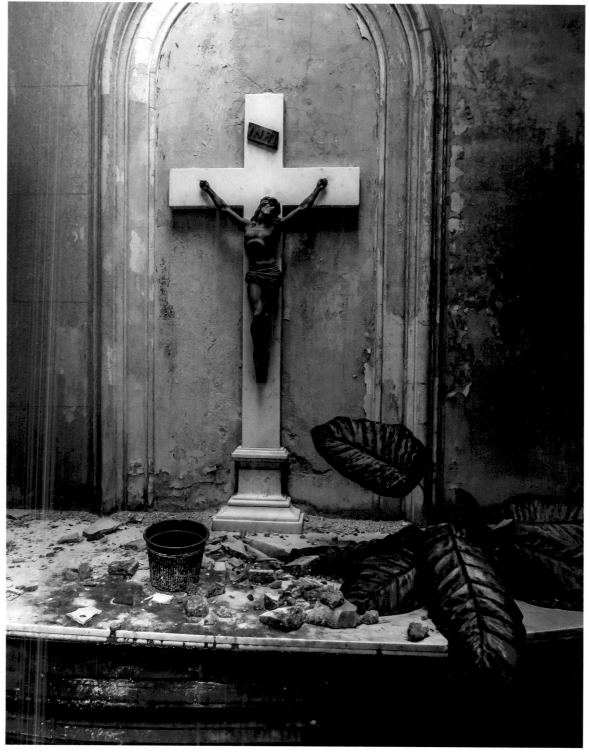

Requiem

A Whiter Shade

by Barbara Warren

www.BarbaraWarren.com ◆ barbwarrenphoto@gmail.com

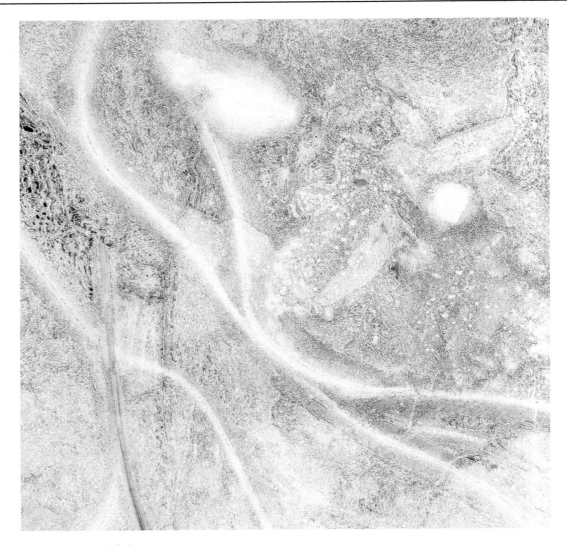

Winter comes.
Why is the world so dark,
so much smaller than before?
But in smallness there is pleasure.
A whiter shade appears.
Lyrical, dancing forms
hinting of new journeys.

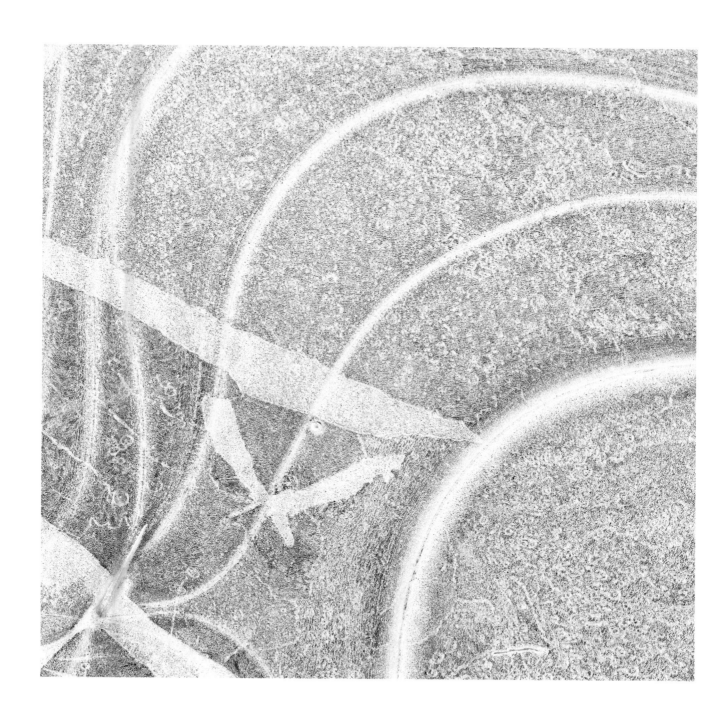

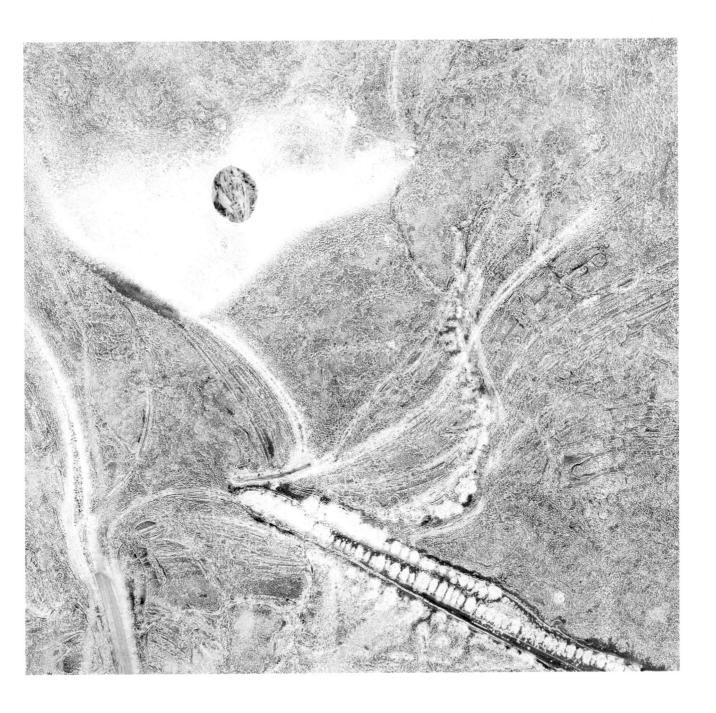

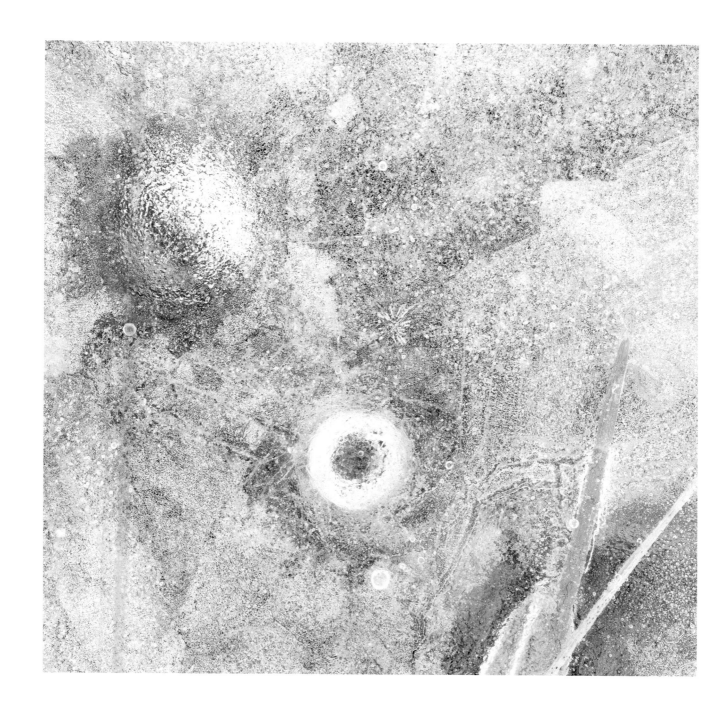

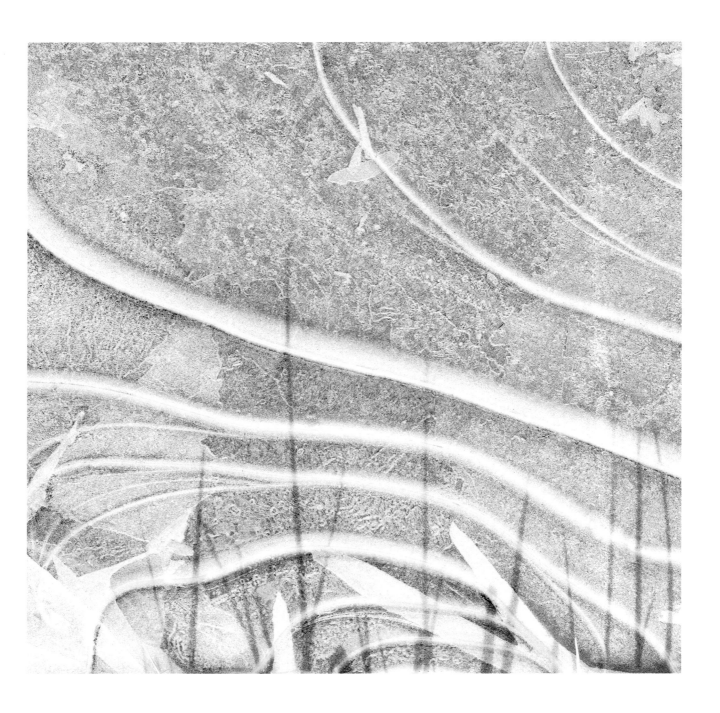

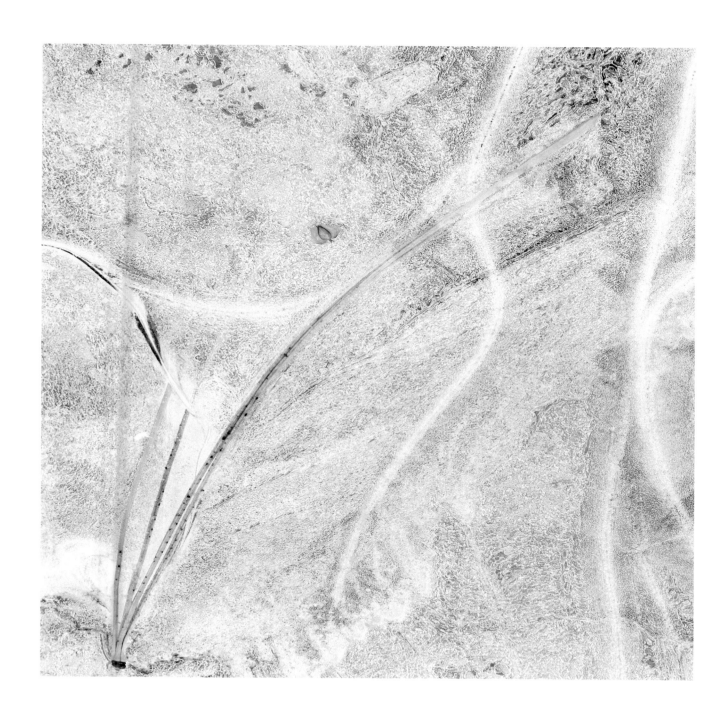

At the Conservatory: Transgressing Expectations

by Lynn Wohlers

www.Lynn-Wohlers.Pixels.com • wohlers13@gmail.com

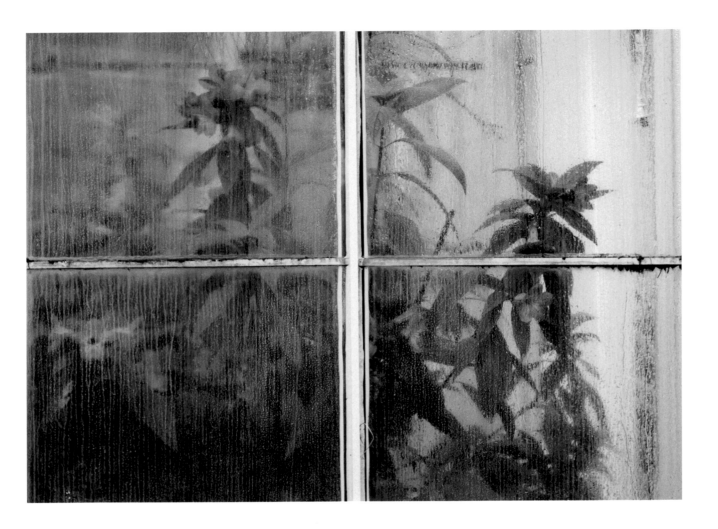

When we visit a conservatory we expect to see exhibits of plants on display, but there is another viewpoint — just outside the door. Seen through foggy windows, the arrangements are less coherent. Conservatory specimens push against the glass in a baroque tangle of living and dead plant material. Dirt collects in out-of-the-way places, and the glass grid is clouded with the breath of foliage. Carefully presented displays grope their way into beautiful chaos behind the scenes.

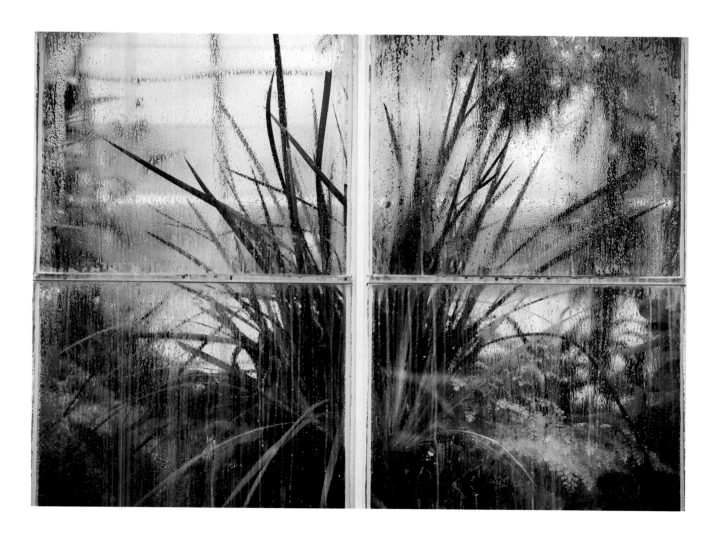

Where, exactly, does the display end? Are we supposed to see this? Do plants seen from outside, and framed by a window pane grid, constitute a "correct" viewpoint?

There needn't be answers; it's enough if the photographs ask the questions. For me, a glass house seen from the outside reveals unplanned juxtapositions and unsanctioned views, transgressing our expectation of the conservatory experience These views are an invitation to see "both/and" rather than "either/or." Manipulated and neglected nature coexist; both are beautiful.

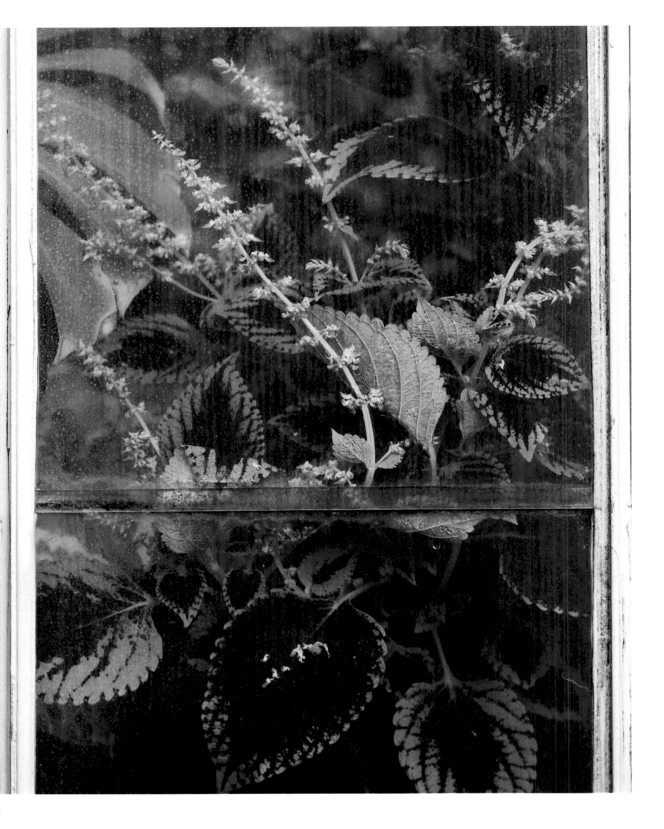

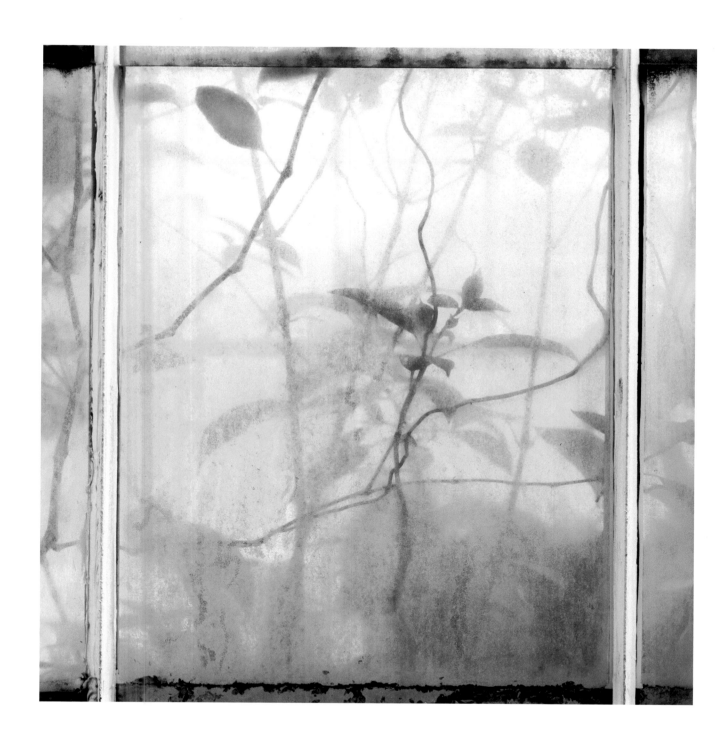

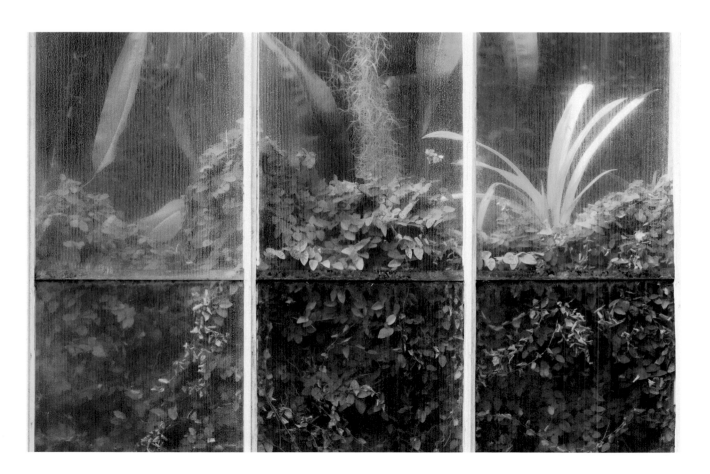

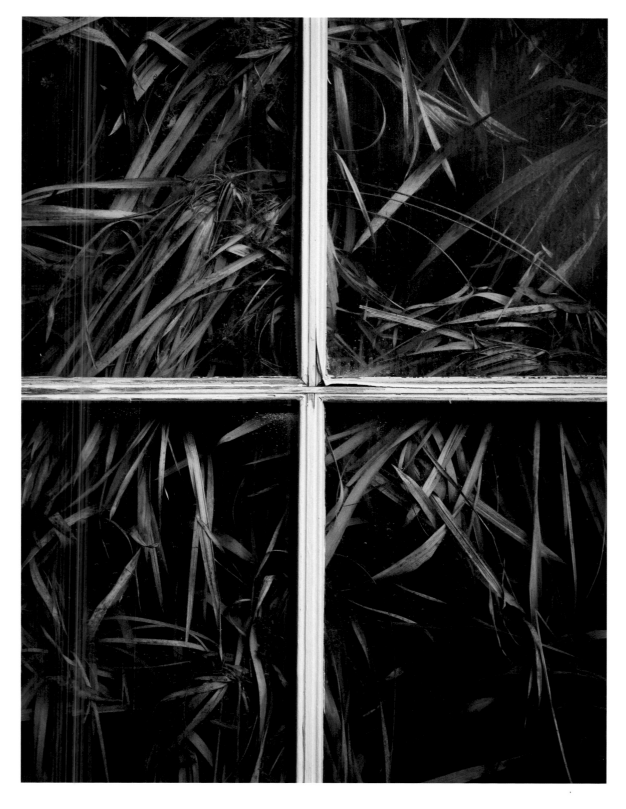

In Their Own Worlds

by Andrew Mielzynski www.facebook.com/andrew.mielzynski ◆ andrewmielzynski@gmail.com

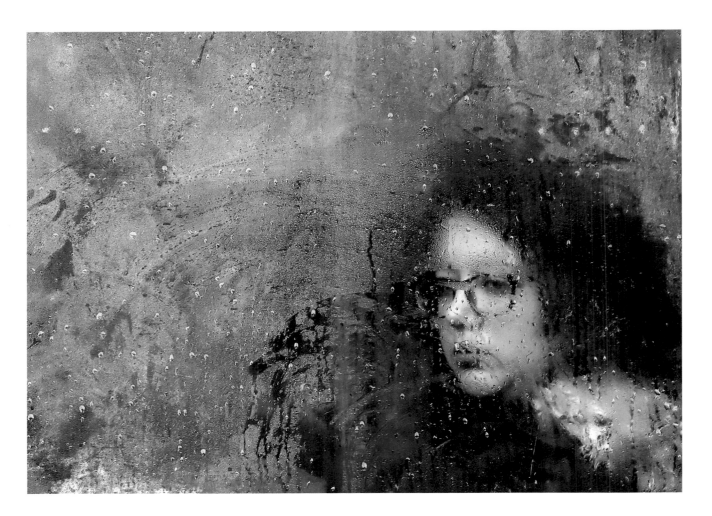

While shooting reflections of light on rain-soaked streets in Toronto, I was led to the sight of early morning commuters taking the streetcar to work. The rain and condensation on the cold glass of Steetcar #504 gave an abstract feel to the scenes being painted in front of me, creating an atmospheric mood that enhanced the feeling of their portraits.

The people behind the glass gave off a sense of disconnection and isolation. They were lost in their thoughts and actions and were spending time in their own worlds. I couldn't help but wonder what they were thinking about. Maybe nothing. Maybe everything.

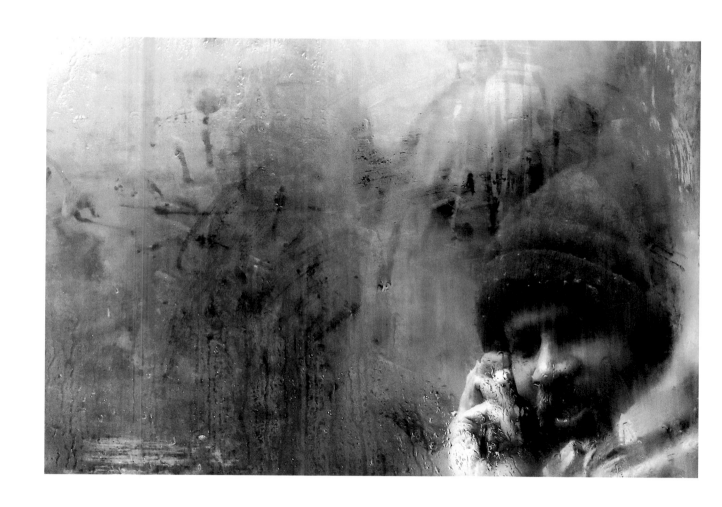

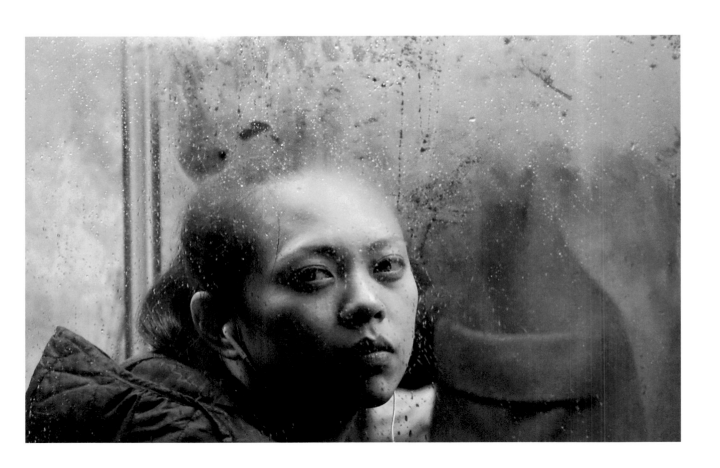

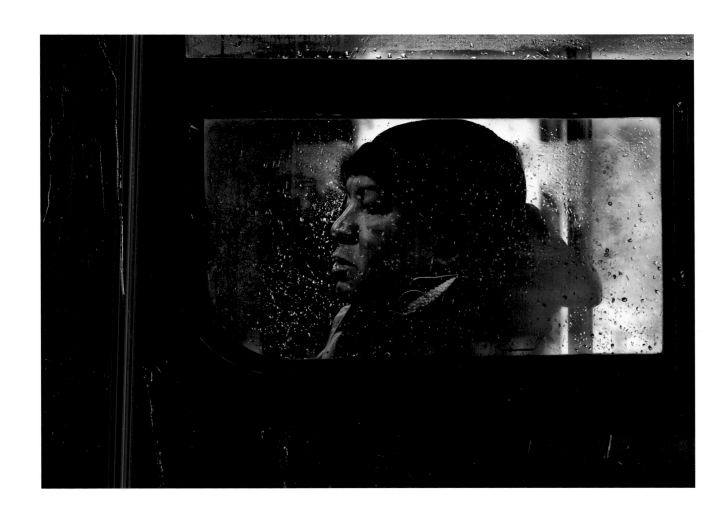

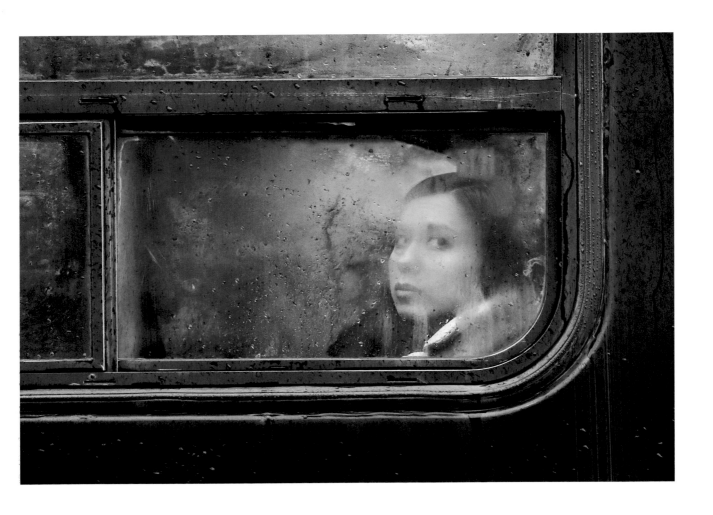

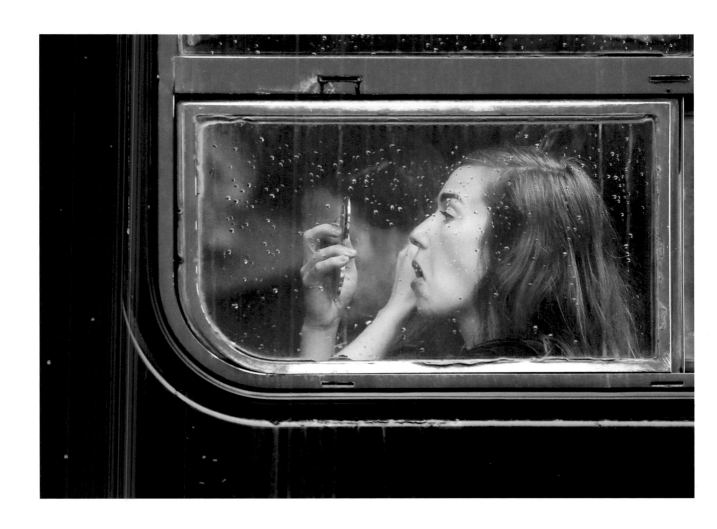

A Tranquil Morning

by Lynne Feiss Necrason www.LynneNecrasonPhotography.com ◆ lynnenecrason@gmail.com

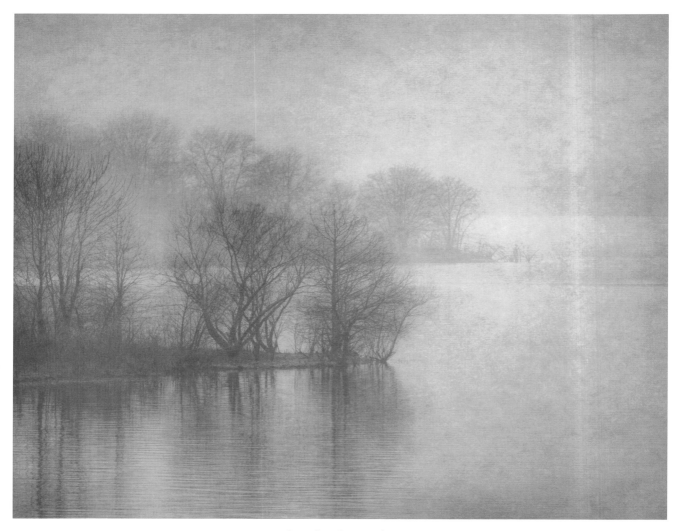

Receding Peninsulas

My primary aim is not to represent outer experiences — appearances, events, interesting subject matter, or fortuitous feats of light — but to imbue my images with a sense of inner experience — thoughts, moods, emotions, and epiphanies. When literal appearance and expressive intent are in contention, I have no qualms about departing from realistic depictions in the name of self-expression…

~ Guy Tal

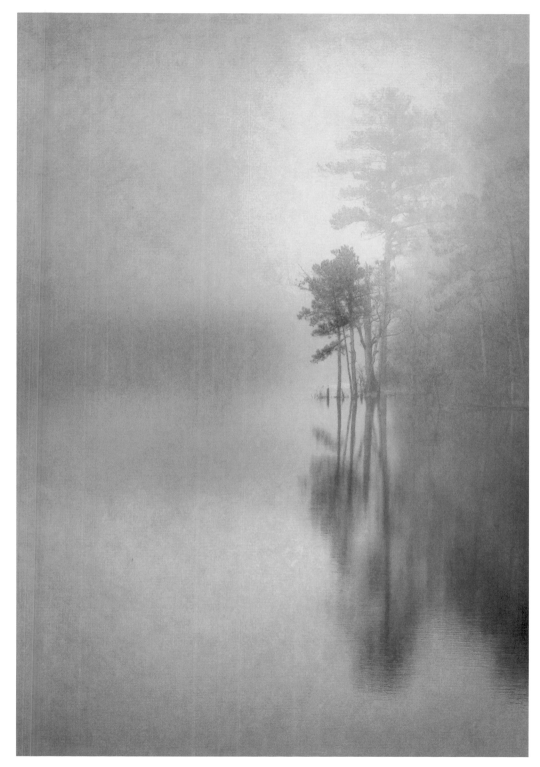

Finding Peace

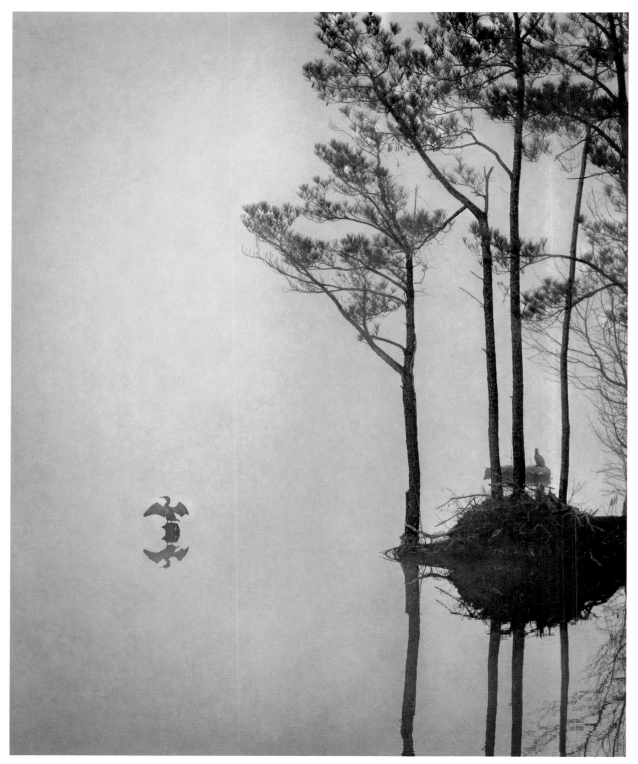

Vigilant

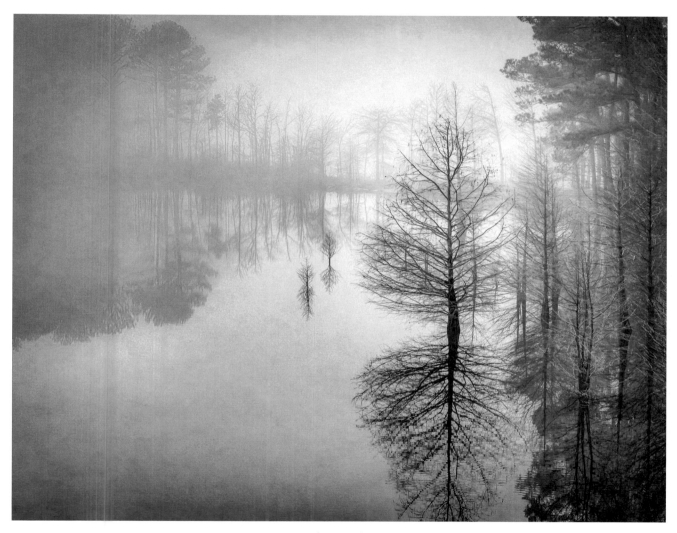

The Family

When all my favorite ingredients come together, I can feel the adrenalin pumping. Winter's trees, water and fog. I must move quickly as the fog drifts in and out, the light comes and goes. I find the composition I want. My subject is isolated and its supporting actors fade into the background. Now I must add my own interpretation of what I saw through the lens — the tones, the light, the textures of the fog. Early light. Cool day. Calm waters. My images must convey the mood. Tranquil. Quiet. Blue.

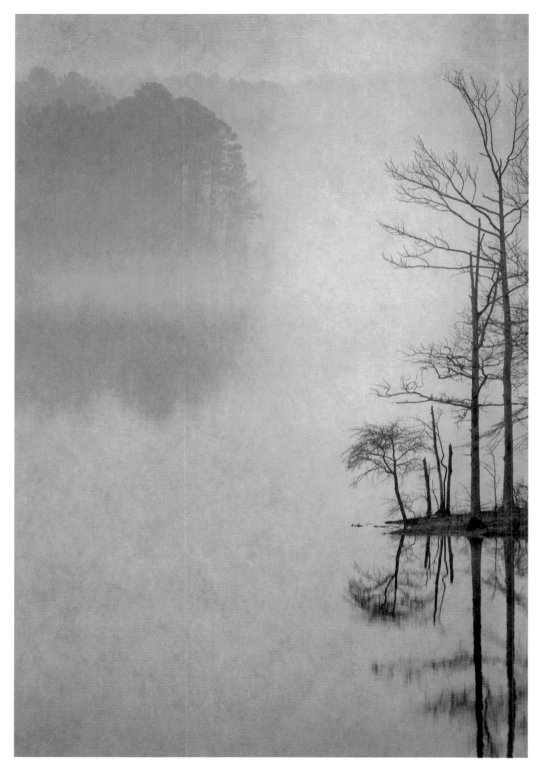

The Little Sentinel

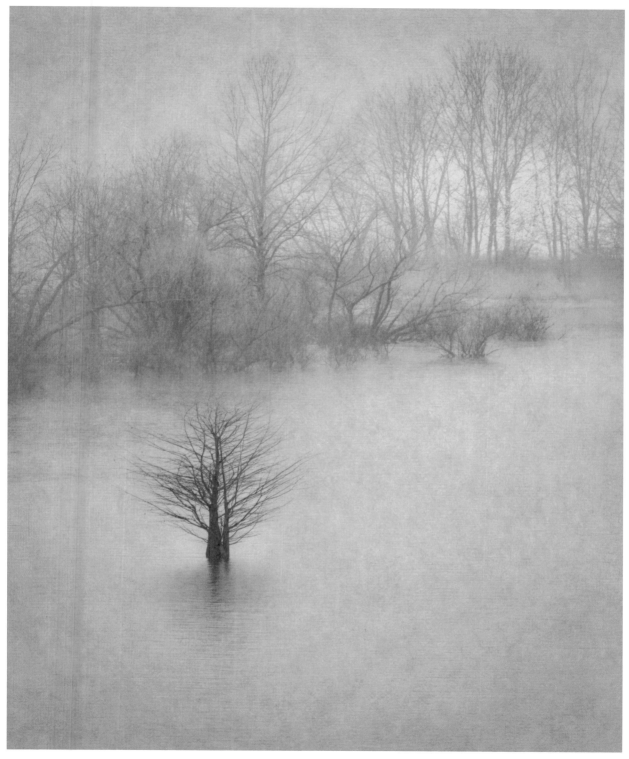

Standing Out

Stroke of Emotions

by Sara Harley

www.SaraHarley.com • sara.harley@bellaliant.net

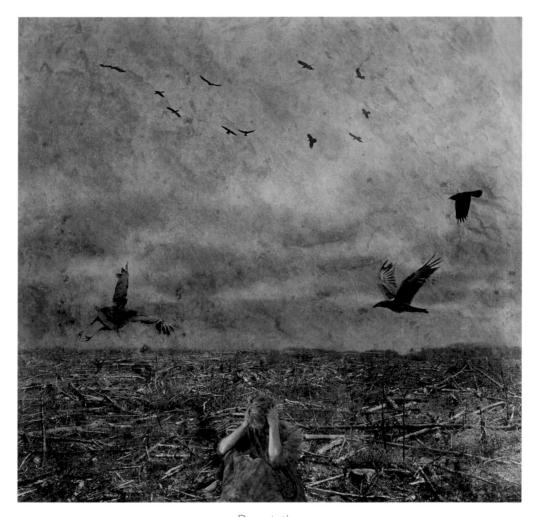

Devastation

Sometimes I cry so hard I think the tears will never stop. Sometimes I feel so tired I want to lay my head down and sleep forever. Sometimes I feel absolutely nothing and wonder if I will ever feel happy again.

No matter who we are, we all face life challenges. No matter what crisis we face, we all struggle with a range of feelings. These composited self portraits were created as part of a series to illustrate the emotional stages I went through after my husband suffered a major stroke.

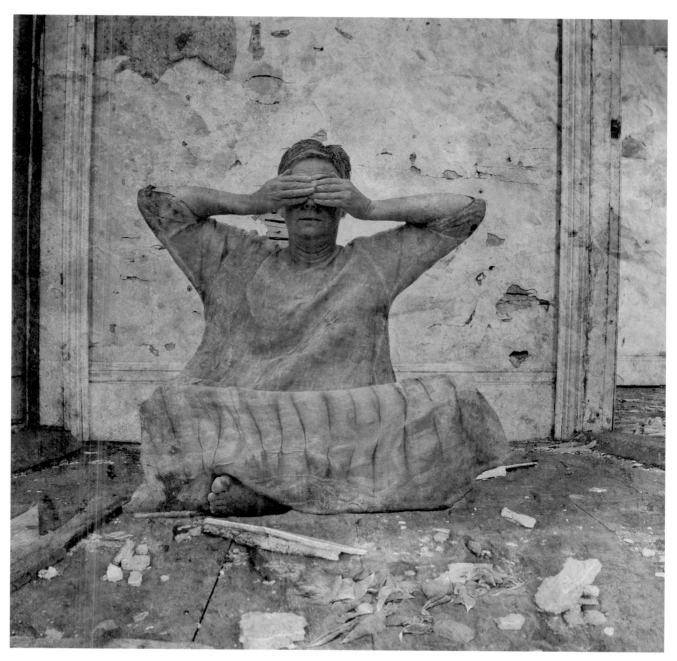

Denial

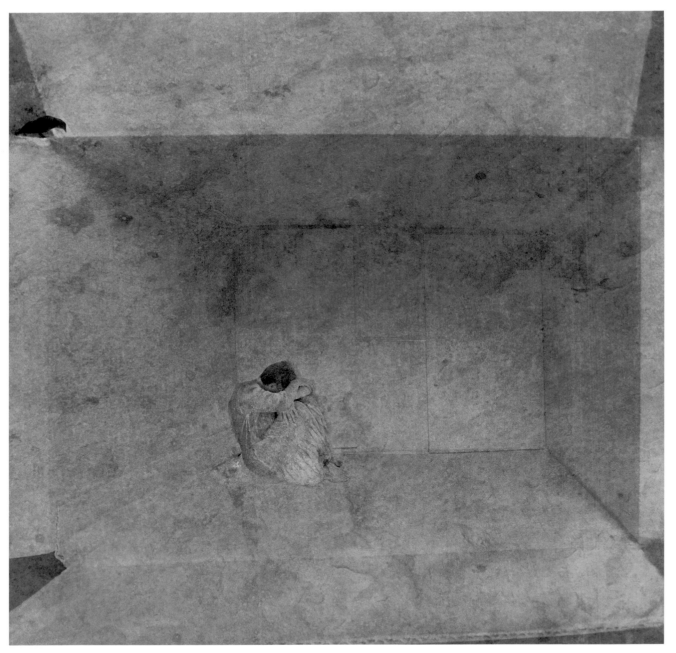

Depression

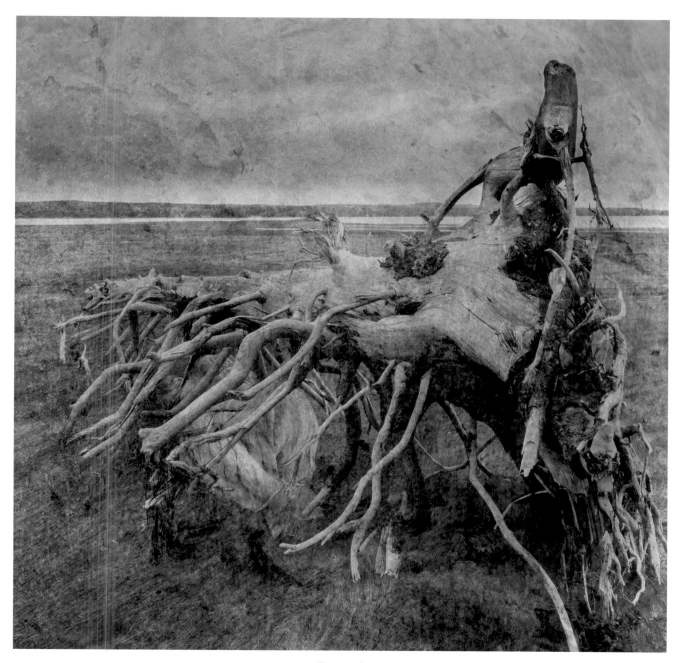

Trapped

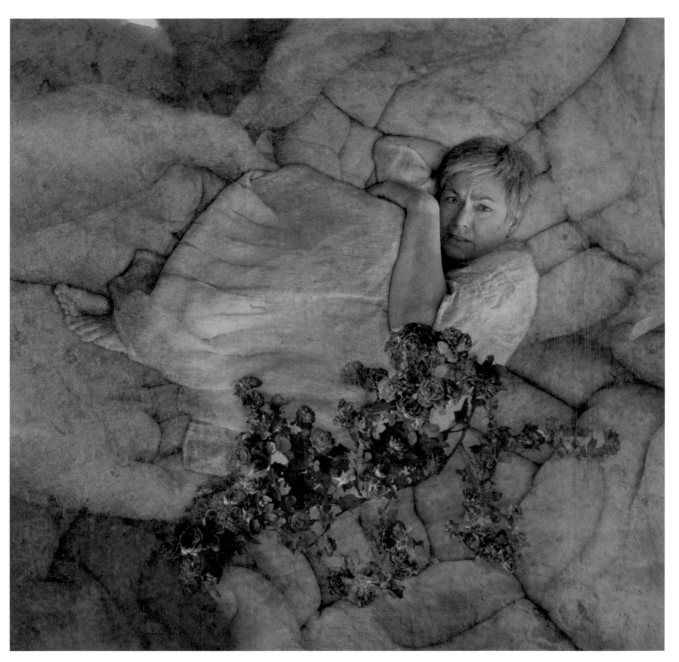

Support

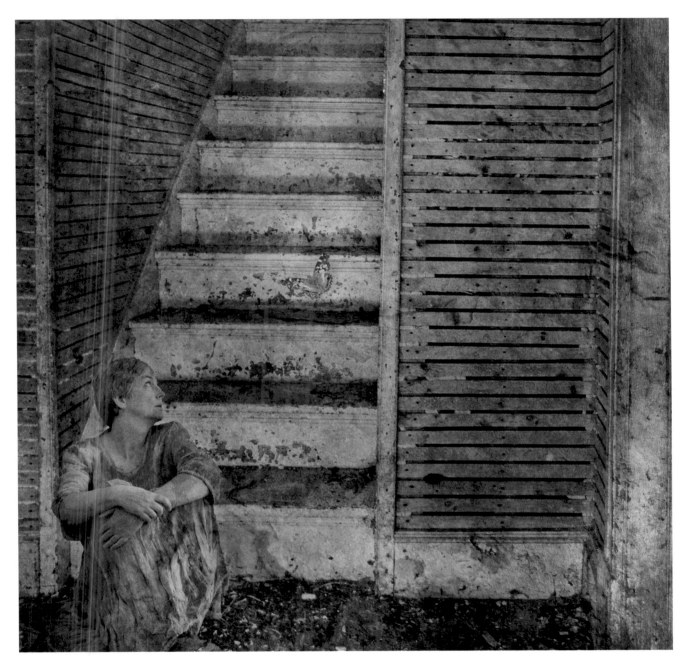

Hope

Channeling Sudek

by Al DaValle

www.DavallePhotography.com ◆ al@davallephotography.com

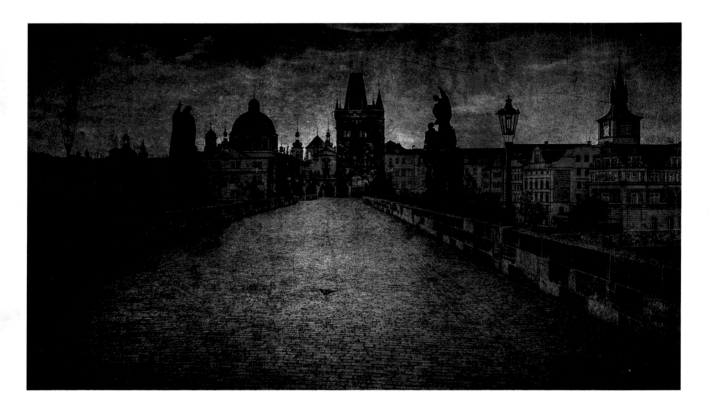

The Charles Bridge in Prague is an iconic landmark in the city of Josef Sudek. He created several wonderfully haunting images of this bridge over the course of his life. His use of light is as potent today as it was when he walked the streets of this beautiful city. For me, this is saying a great deal about the quality of his vision and his work. I found myself unconsciously channeling Sudek on my recent trip to Prague. Upon returning home and poring over my images, I realized the power of his impact on my own interpretation of the place.

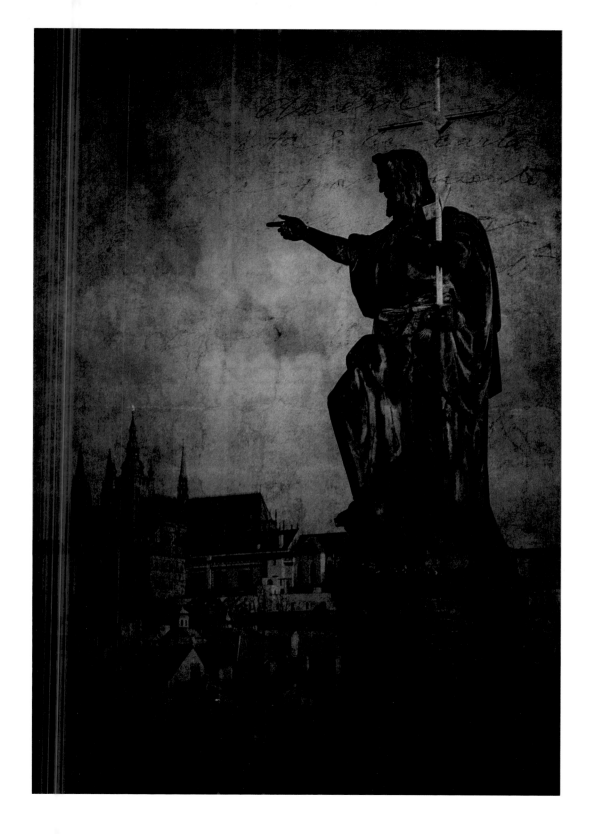

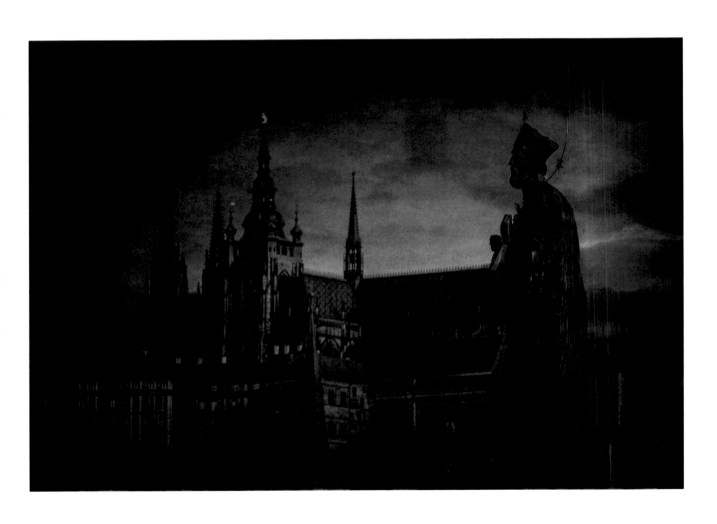

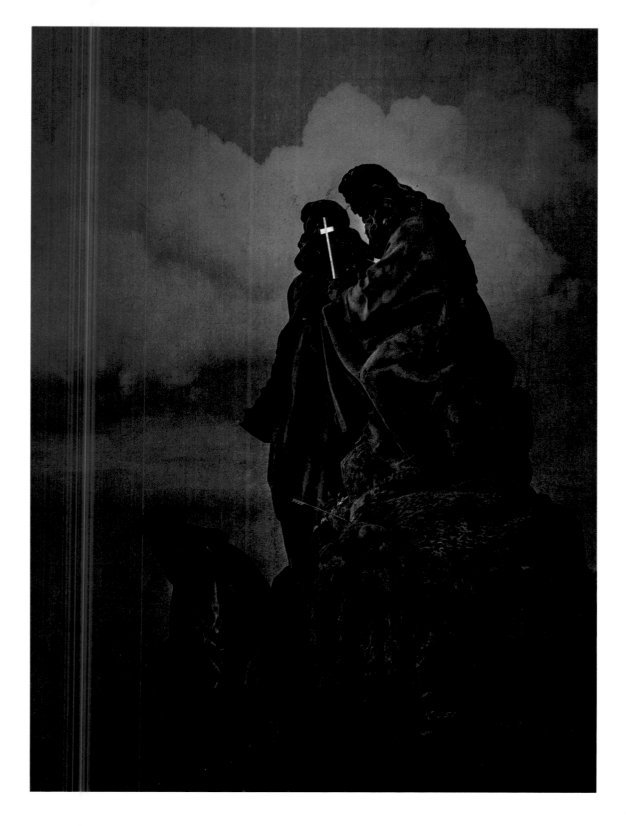

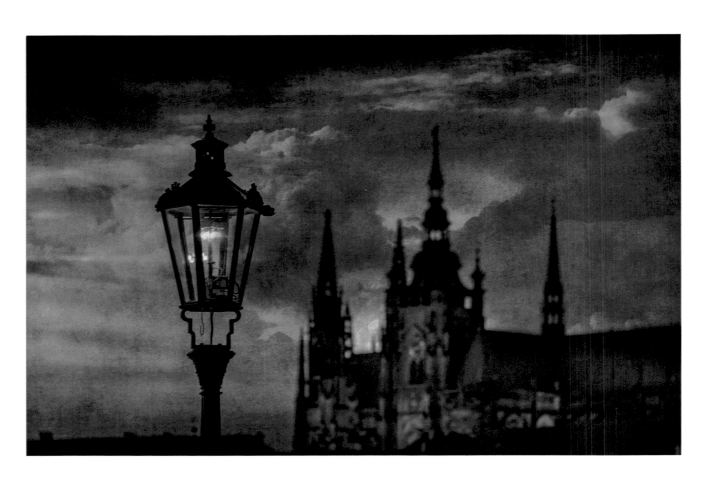

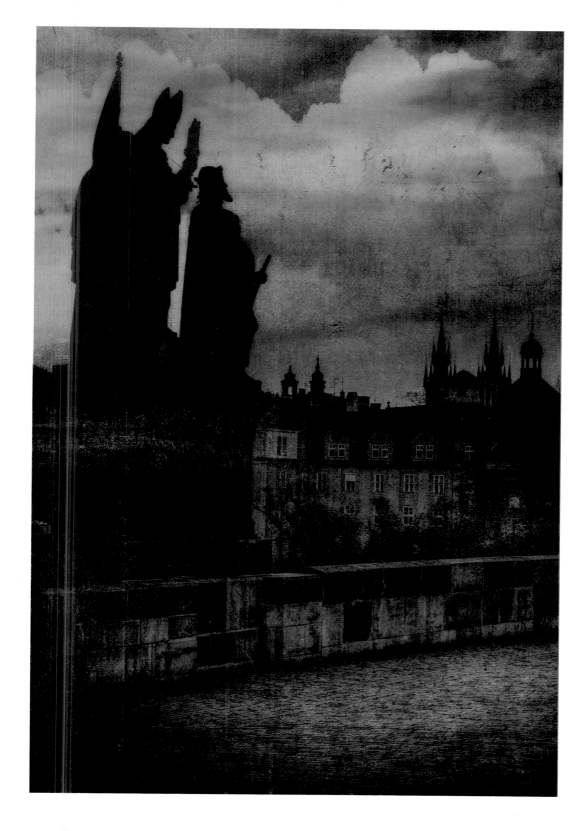

Notes from the Edge of Nowhere

by J. M. Golding

www.JMGolding.com ♦ FallingThroughTheLens@gmail.com

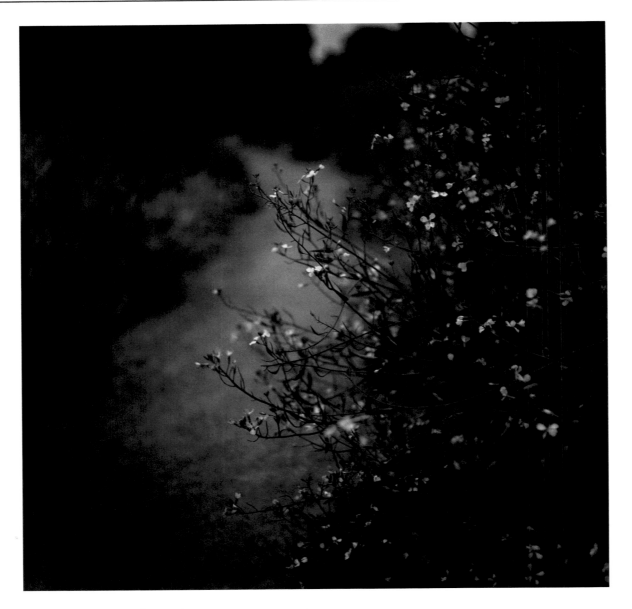

This descent, prescient…

Knowing, beyond consciousness,

That loss had begun.

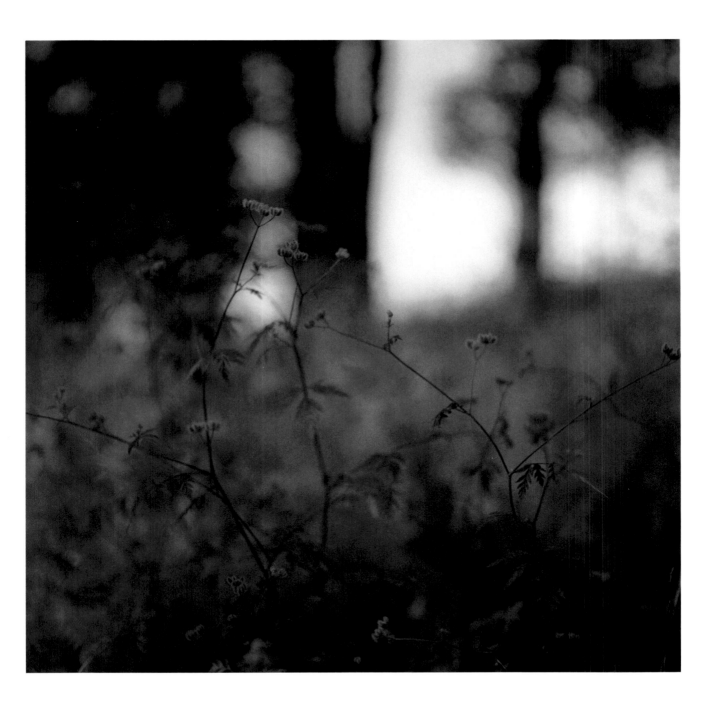

St. Louis Gateway Arch

by Errick Cameron

www.PhotographybyErrick.com

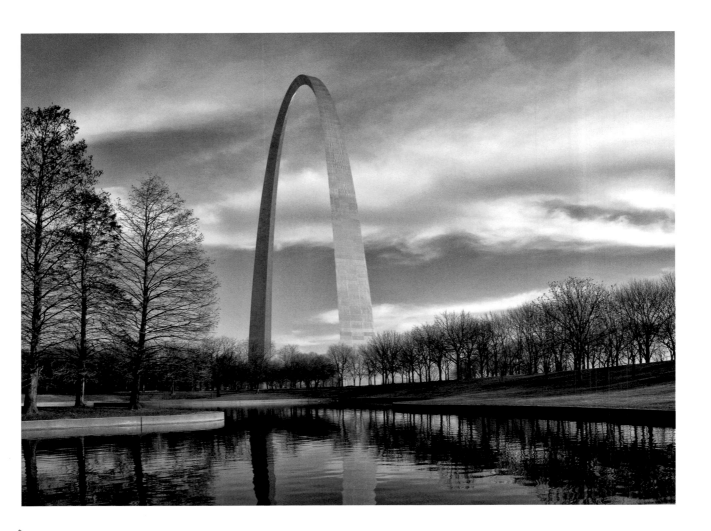

Probably the most identifiable iconic monument in the USA is the Gateway Arch. It is by far one of the most photographed structures in the country. Standing just a 30-minute drive from my front door, I have obviously made it a point to claim it as one of my photography projects. On each outing it becomes my goal to capture this magnificent treasure in a unique perspective.

Here is how I saw it… times six.

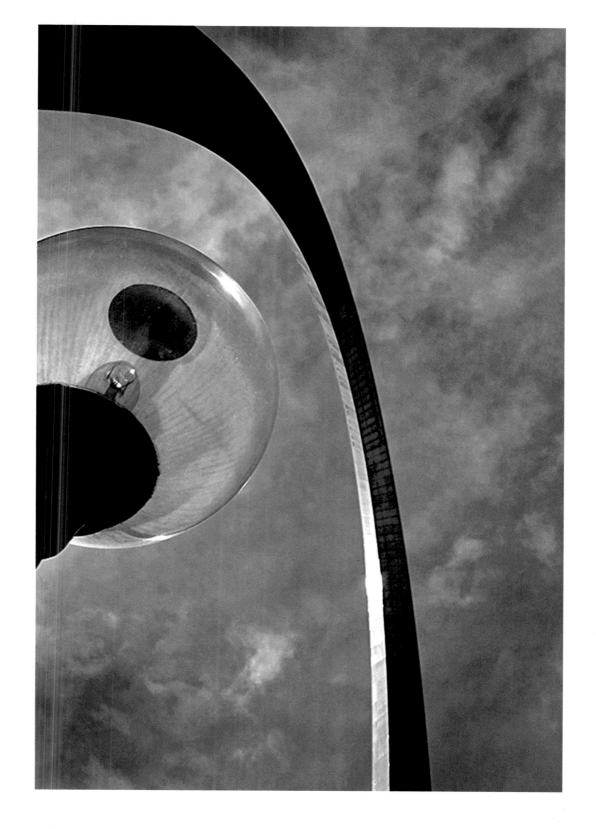

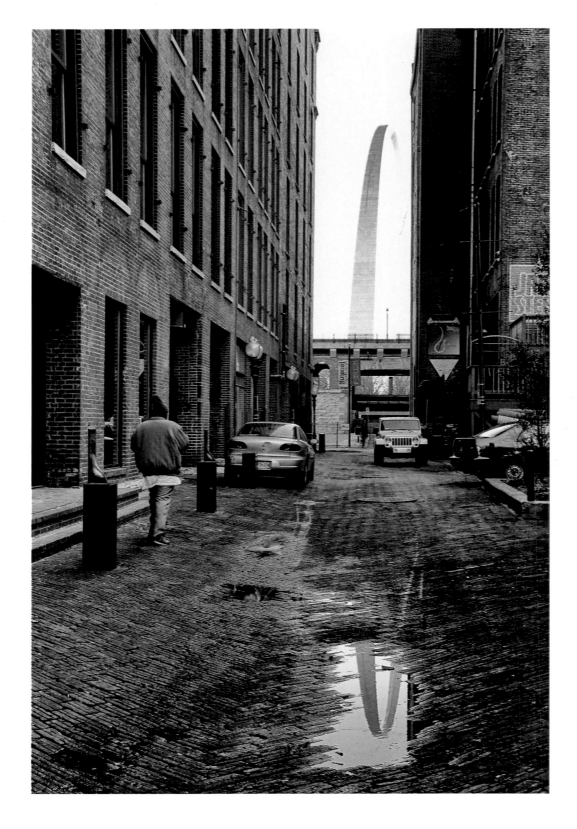

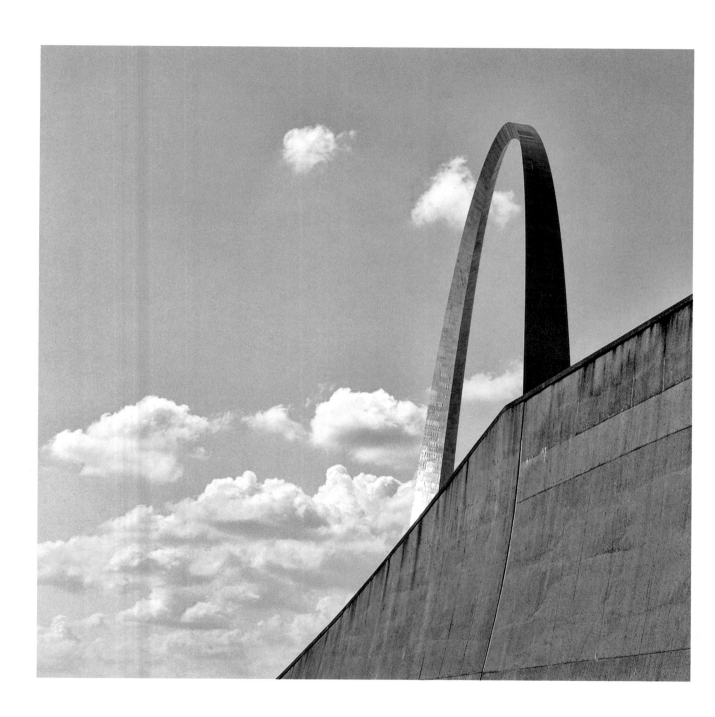

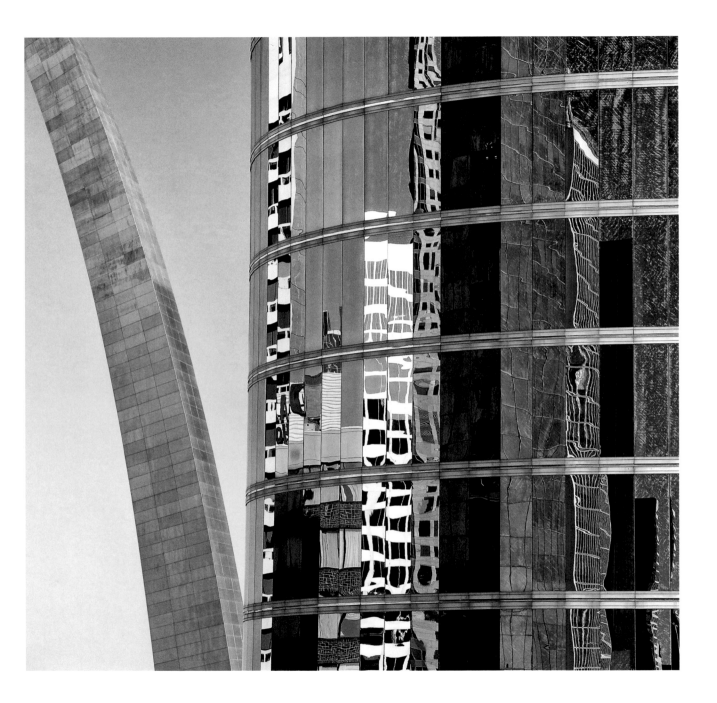

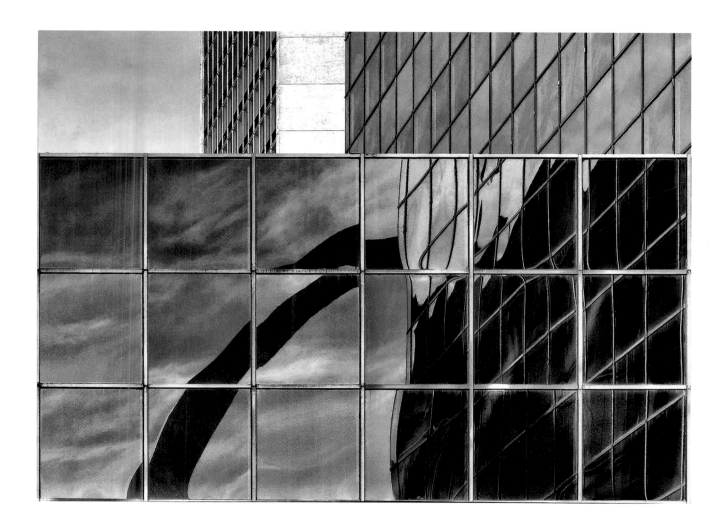

The Closet
by Paul Cotter

www.PaulCotterPhotography.com • pcotter28@gmail.com

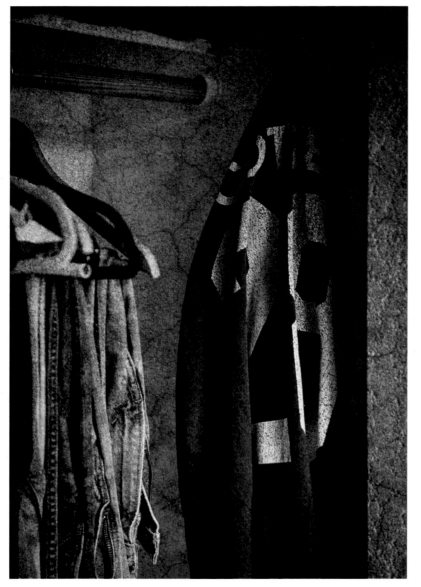

Jersey

A closet can be many things:

A metaphor for a secret life.

A graveyard for things collected.

A book filled with passing chapters.

A mirror reflecting who we are.

This is my closet. These are my stories.

My high school football jersey. A faded memory of the reckless bravado of youth. I was a 130-pound starting safety on our varsity football team, hurling my body at 230-pound fullbacks. What was I thinking?

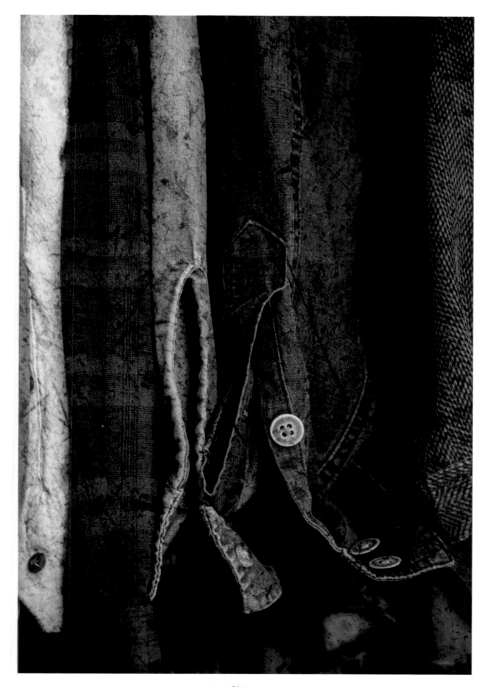

Shirts

There was a time when I was intent on climbing the ladder as a creative director in the advertising agency world. That was a time when I favored crisp pima cotton shirts that were professionally laundered. I left that world behind to go freelance and focus on photography. My shirts nowadays are softer, looser and very rarely ironed. A much better fit for me.

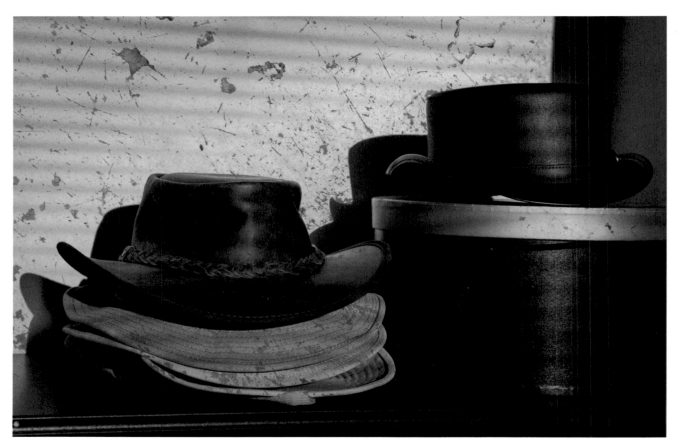

Hats

Ten years ago, I walked into a hat store in Dublin, Ireland, and bought a pair of fedoras. My blazing love affair with hats began, and those two Irish fedoras multiplied like rabbits — spawning a closet filled with wide brims, stingy brims, bowlers, porkpies, flatcaps, outback hats, Panama hats and Greek fishing caps. Yes, I love hats.

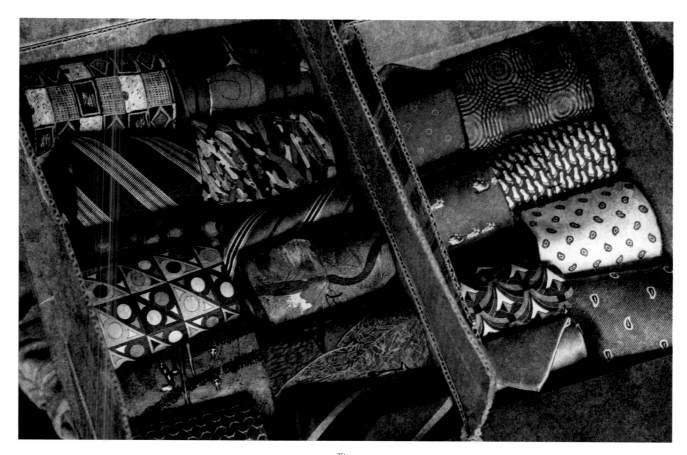

Ties

Once upon a time I wore ties every day to work. Then came casual Fridays. Then every day became a casual day. When we moved across country, I rolled the ties up and put them in little boxes for the journey. They've never left the boxes.

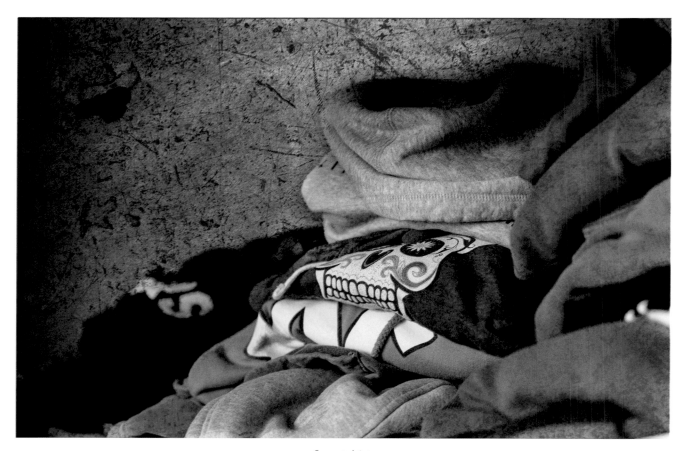

Sweatshirts

Places visited, teams rooted for, the name of a favorite Irish pub — it's all here on the hoodie sweatshirts stacked on the top shelf of the closet. I couldn't imagine living anywhere that is hot all year-round. When cool fall weather comes, it's nice to pull on a sweatshirt.

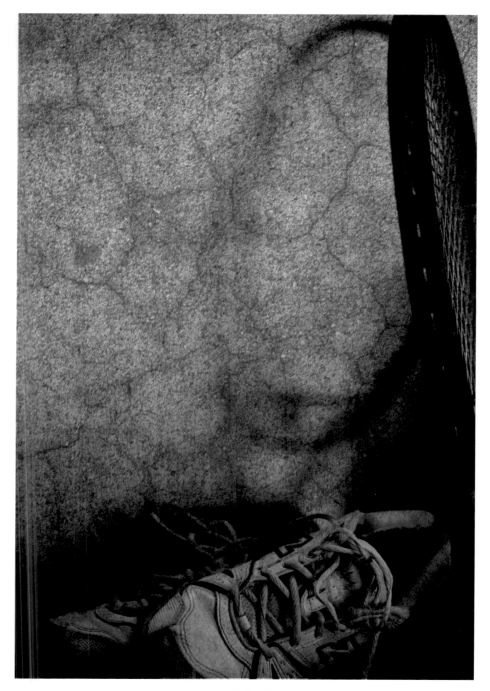

Tennis Racket

Playing tennis used to be one of my favorite things, and it's something my wife and I loved doing together. Shoulder problems forced me to put my tennis racket away for good. I suppose I should sell it or give it away. But like a lot of things in my closet that have outlived their purpose, it's a memory I like hanging on to.

Mandalas
by William Horton

www.WilliamHortonPhotography.com • william@williamhortonphotography.com

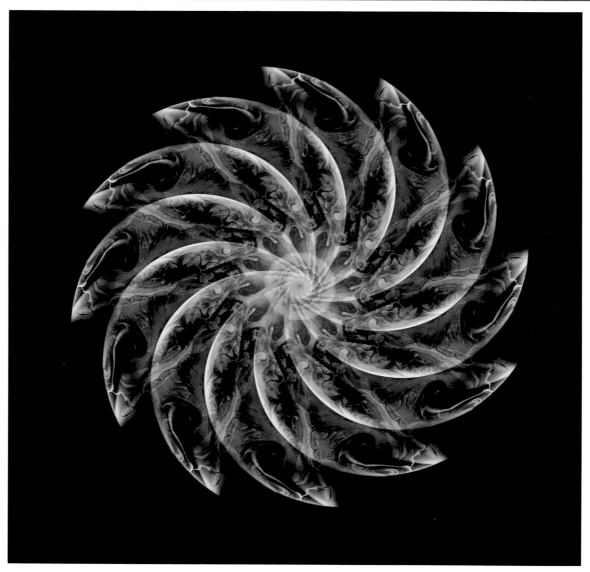

Mandala I - Constructed from a photograph of the edge of a bubble.

Mandala is the Sanskrit word for circle, the basic shape that organizes all its many forms. For thousands of years, across dozens of cultures, mandalas have guided meditation, promoted spiritual growth, recorded the passage of time, and symbolized the cosmos.

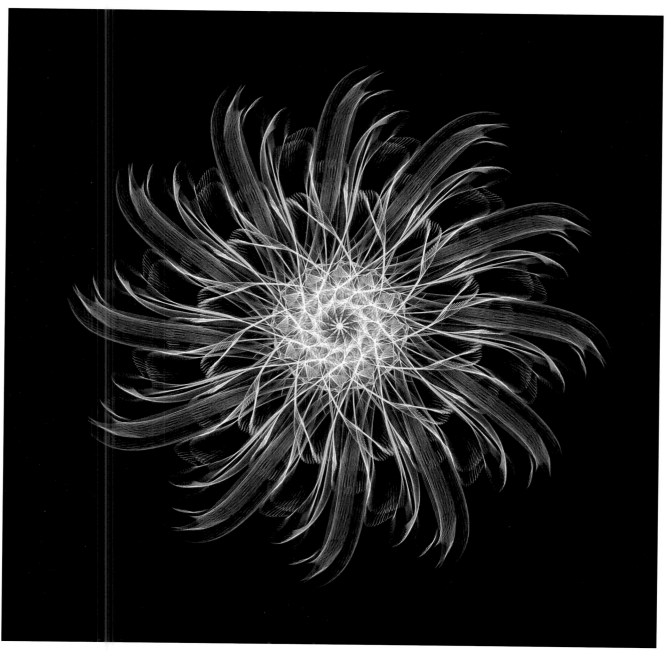

Mandala II - Constructed from a photograph of swinging LED lights.

In these mandalas, flower-like patterns emerge from simple forms repeated radially around a common center. These simple forms include wisps of smoke, edges of soap bubbles, swirls of food color in milk, strands of LED lights, and various natural objects. The forms are photographed separately and then combined and replicated in Photoshop. In this collection, the mandalas are black-and-white. By removing the color, the structure inherent in each mandala is revealed.

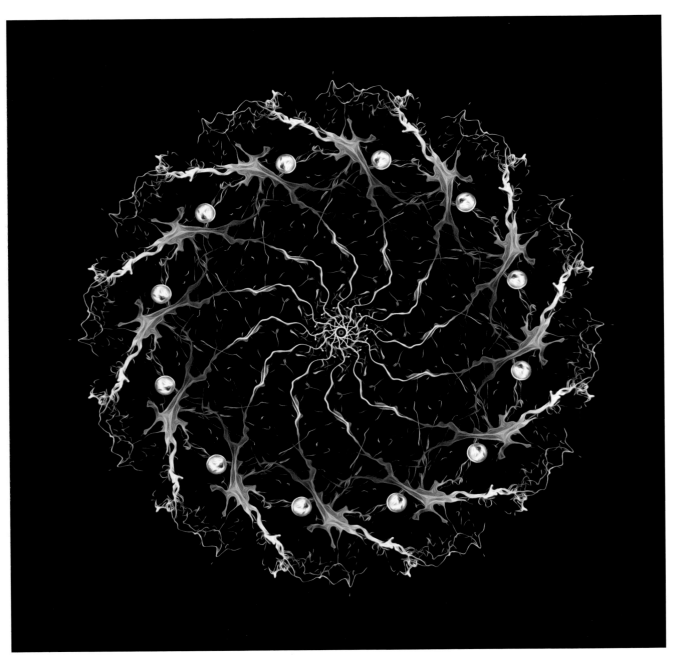

Mandala III - Constructed from a photograph of a burst bubble.

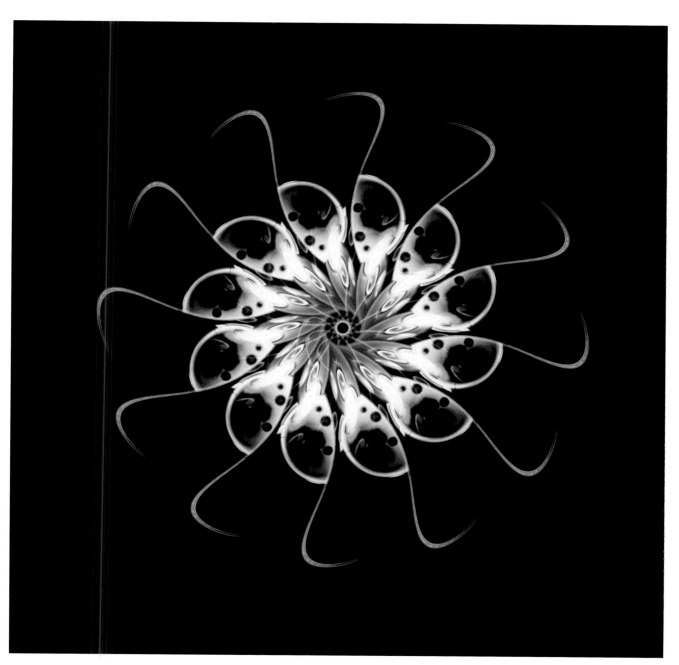

Mandala IV - Constructed from a photograph of moldy milk in a petri dish.

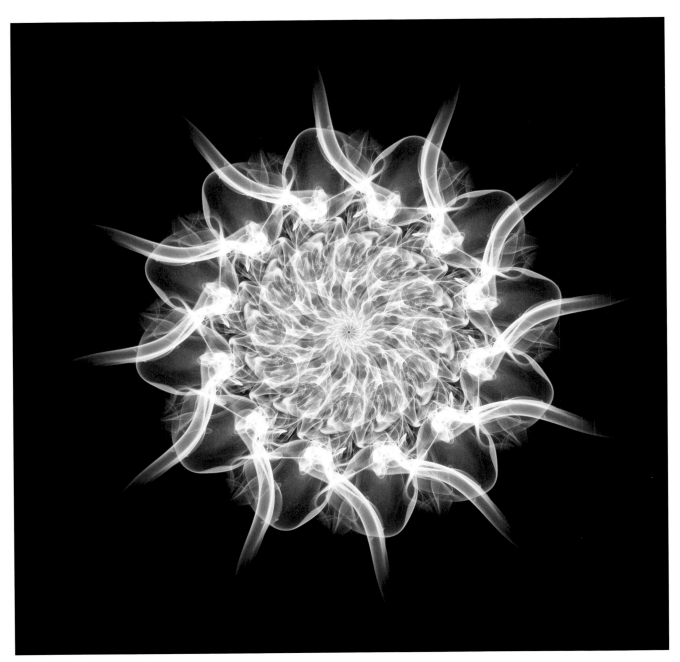

Mandala V - Constructed from a photograph of smoke drifting from a burning incense stick.

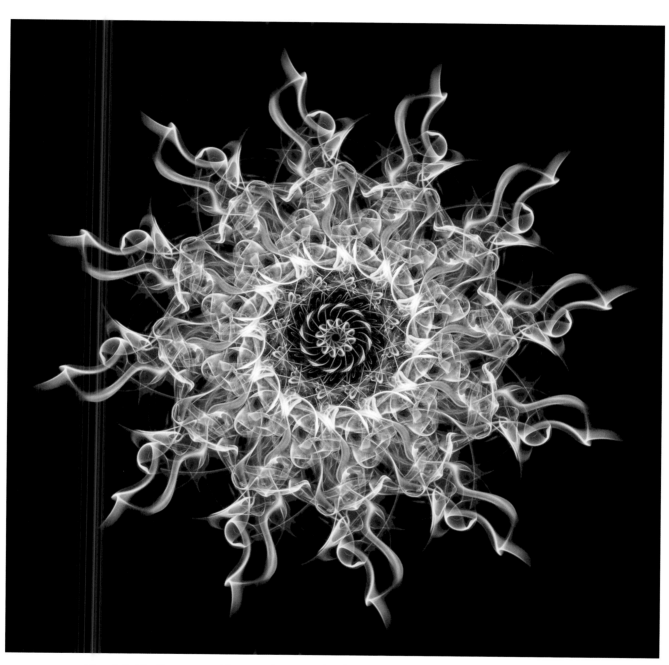

Mandala VI - Constructed from a photograph of smoke drifting from a burning incense stick.

Fleeting Visions
by Elizabeth Root Blackmer

www.BRootPhoto.com ♦ elizabeth@brootphoto.com

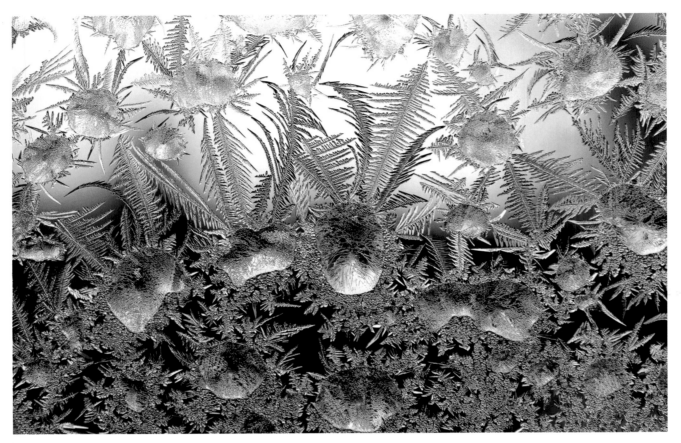

School of Frost

Thus shall you think of all this fleeting world :
A star at dawn, a bubble in a stream ;
A flash of lightning in a summer cloud,
A flickering lamp, a phantom, and a dream.

~ Buddha in The Diamond Sutra

The Diamond Sutra and The Sutra of Hui Neng, Shambala, 1969
Translated by A.F. Price and Wong Mou-Lam
Verse translated by Dr. Kenneth Saunders

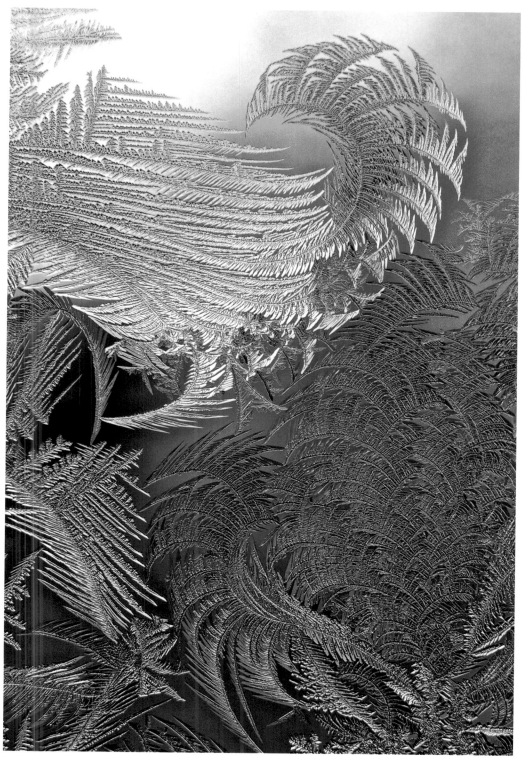

Catching the Light of Dawn

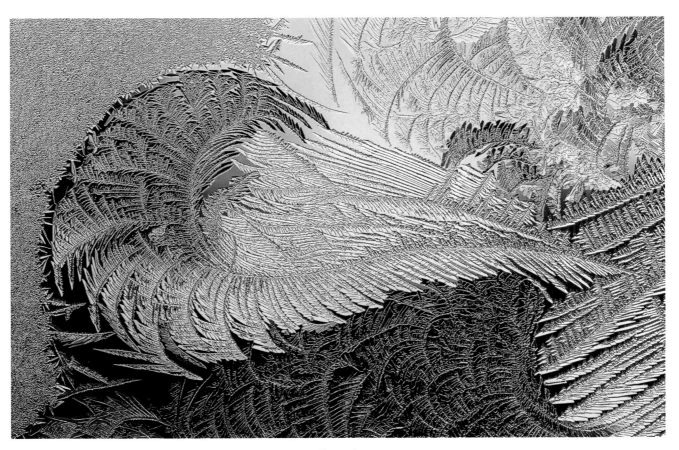

Flourish

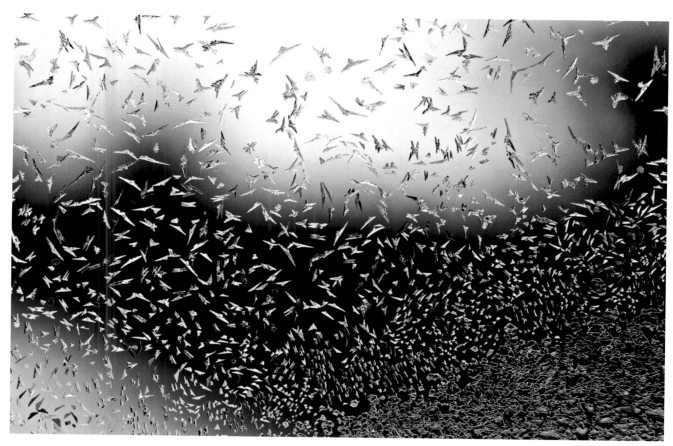

Wheeling

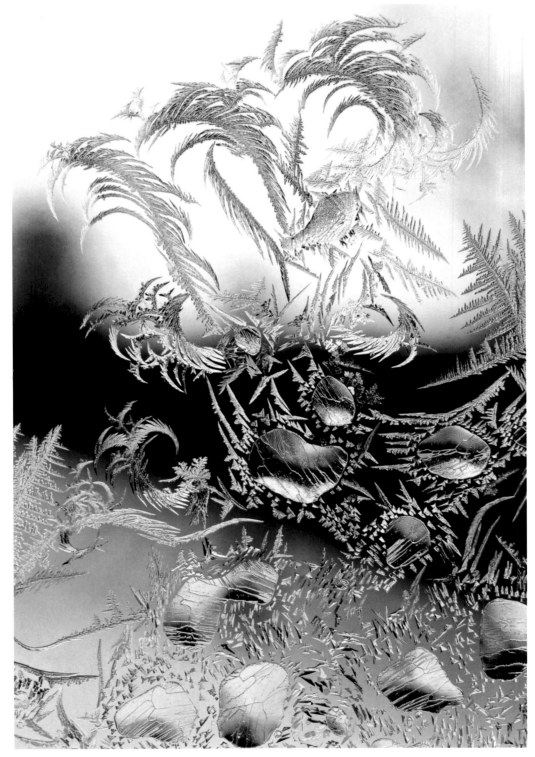

Harmony

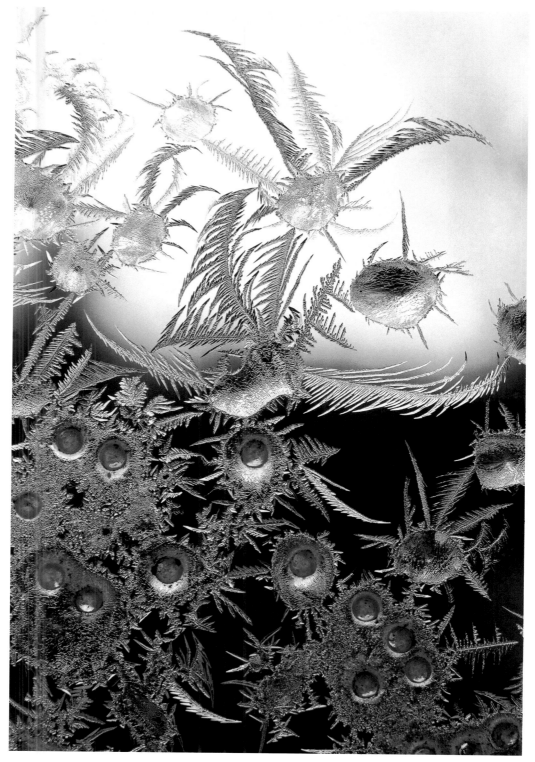

Flight

Pattern in the River

by Peter Gallagher

Images.PeterGallagher.net.au • peter@petergallagher.com.au

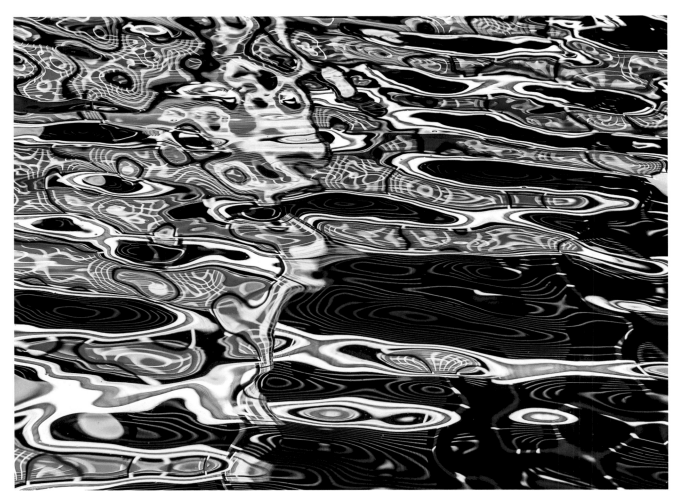

Isobars and contour lines of an impossible geography …

Patterns on the river… a transient batik on the surface of the river Yarra that flows through Melbourne… the leaves, bark, and mud of the Dandenong Valley… where it rises, stain the river's surface a dull yellowish brown… the opposite of picturesque. But the eye is too slow to see the mineral, dark or brilliant surfaces and the shimmering traces that the river surface reflects and refracts from the sky and the buildings along the banks.

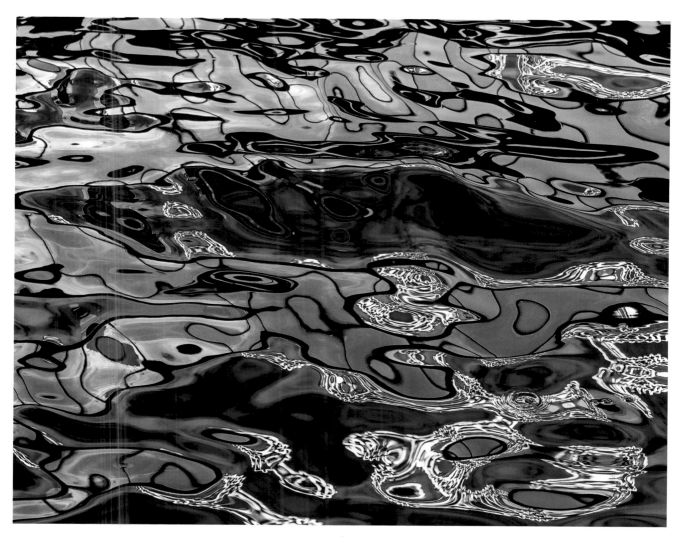

... a sea of storms ...

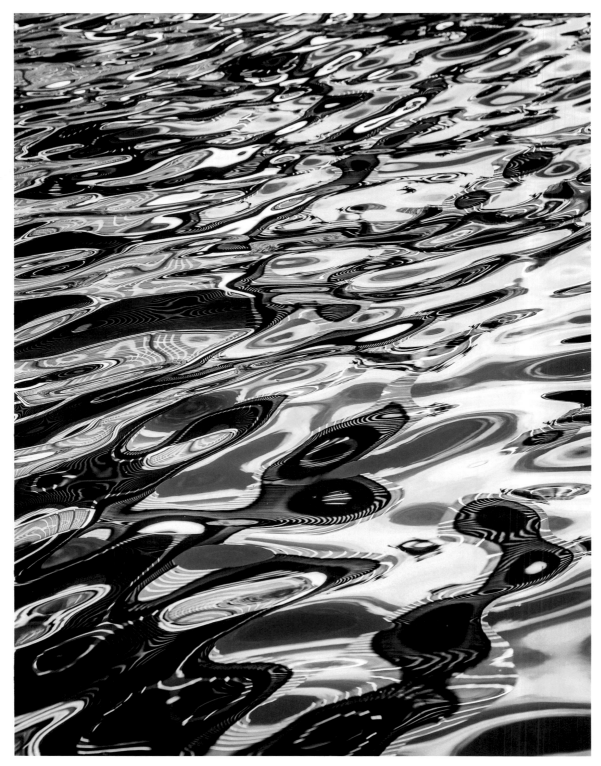

... or a stain of primitive cells.

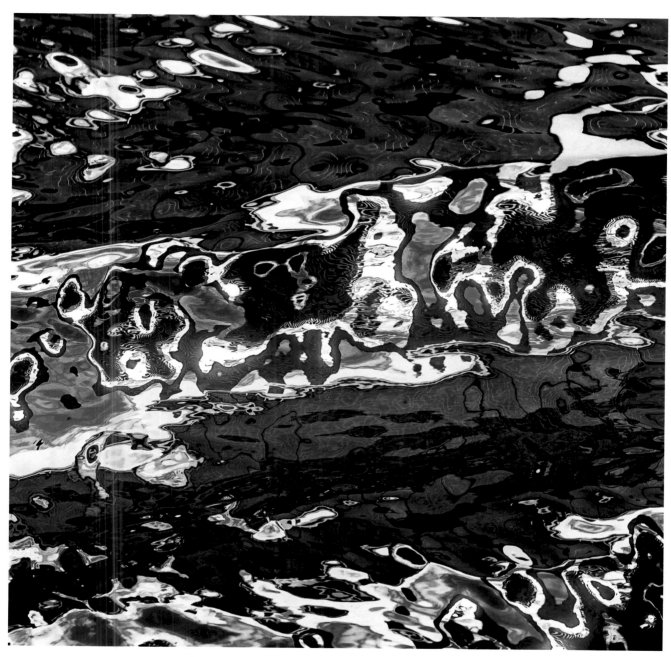

They can be crystals embedded in a structure of reefs ...

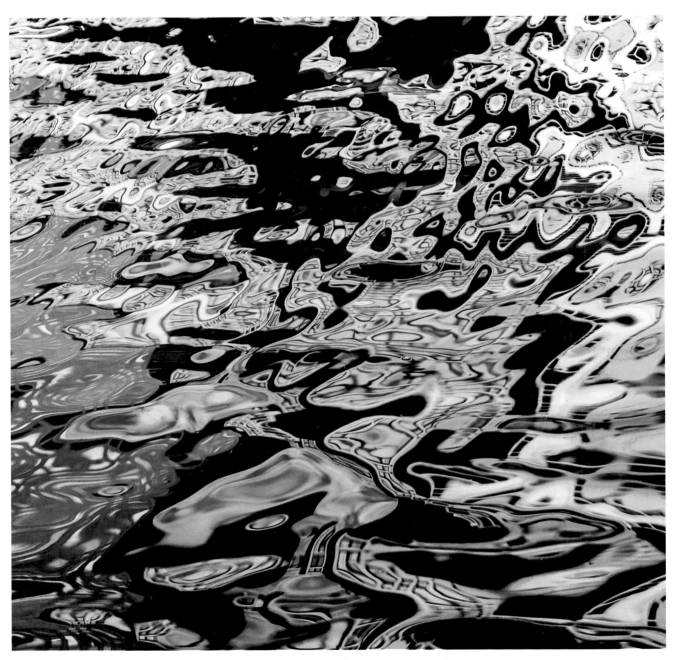

... or the windows of a melted cathedral.

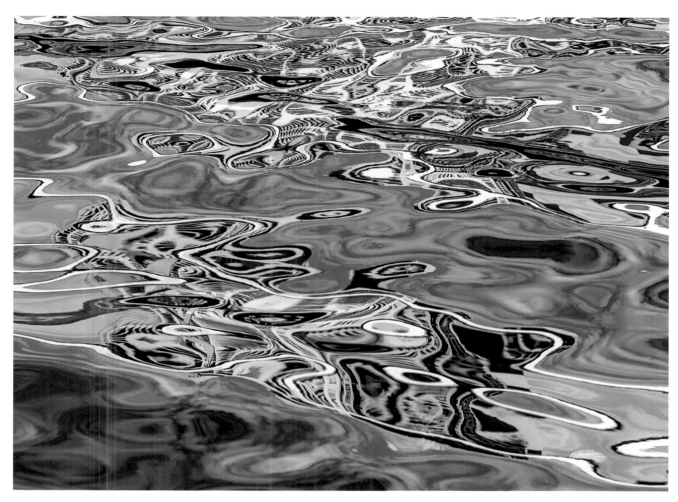

Pretty transients ... it's a game of "clouds."

Latin American Kaleidoscope

by Samuel Vovsi

www.Vovsi.com • samuel@vovsi.com

Guanajuato, Mexico

The first thing that you notice upon arriving in Latin America is colors. Seems that the brightest, the most saturated colors are used there for everything: for houses, for cars, for women's dresses, for graffiti, even for the sun and the sky. The impression is overwhelming and blinding. Your eyes hurt from these colors. But you can't stop looking.

Mexico City

When your eyes eventually adjust, you start noticing life around you, which is first of all the people: men and women, young and old, rich and (more often) poor. They are descendants of various ancient civilizations — Incas in Peru, Aztecs in Mexico, Maya in Guatemala — and are very different ethnically and culturally (there are 22 actively spoken Mayan languages in Guatemala alone). Combined with the Spanish heritage of colonial times and the remnants of colonial architecture, all of this creates a unique kaleidoscope of buildings, faces, dresses, tastes, smells, and sounds.

Chichicastenango, Guatemala

Guanajuato, Mexico

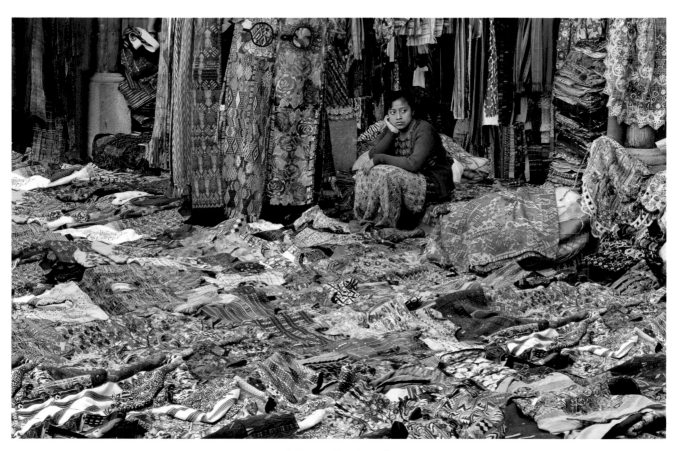

Antigua, Guatemala

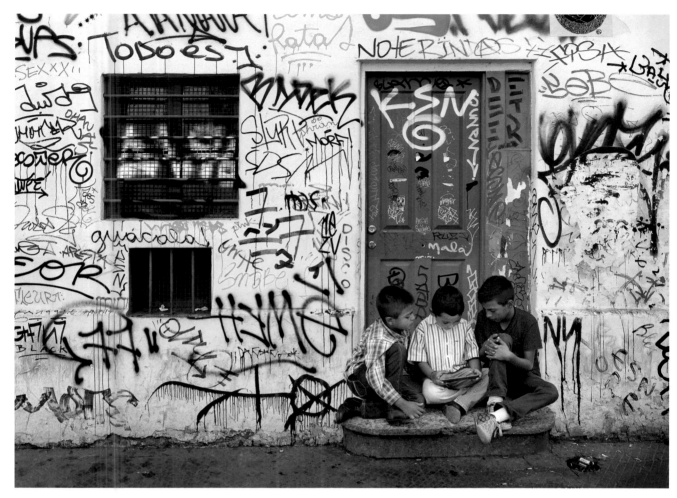

Santiago, Chile

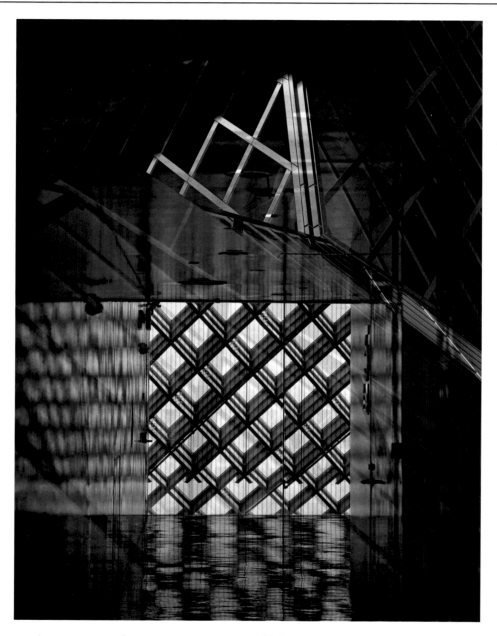

These works consist of two superimposed black-and-white images: one a positive, the other a negative (inverted) image. I became intrigued with the unusual tonal range and the often mysterious, surrealistic nature of the resulting combinations. I also enjoyed the random nature of the process which led to many surprises when first seeing the final result.

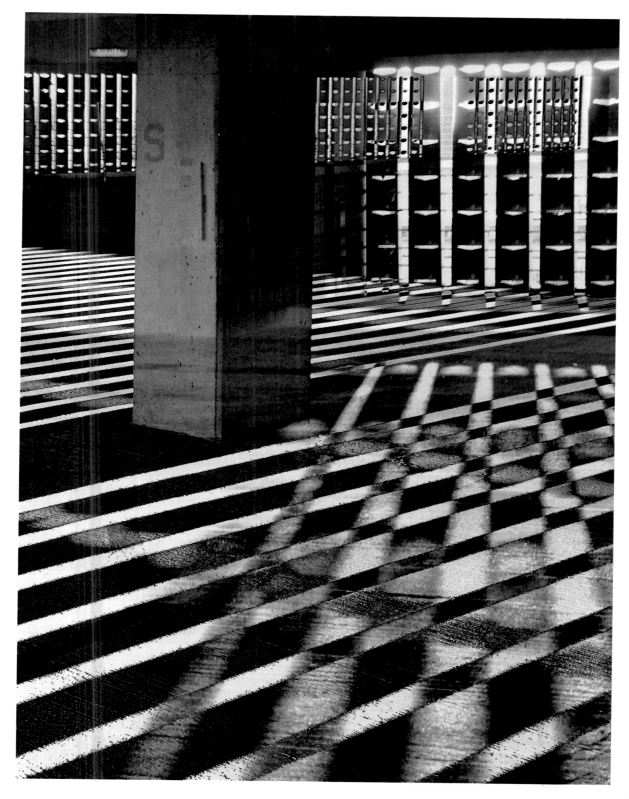

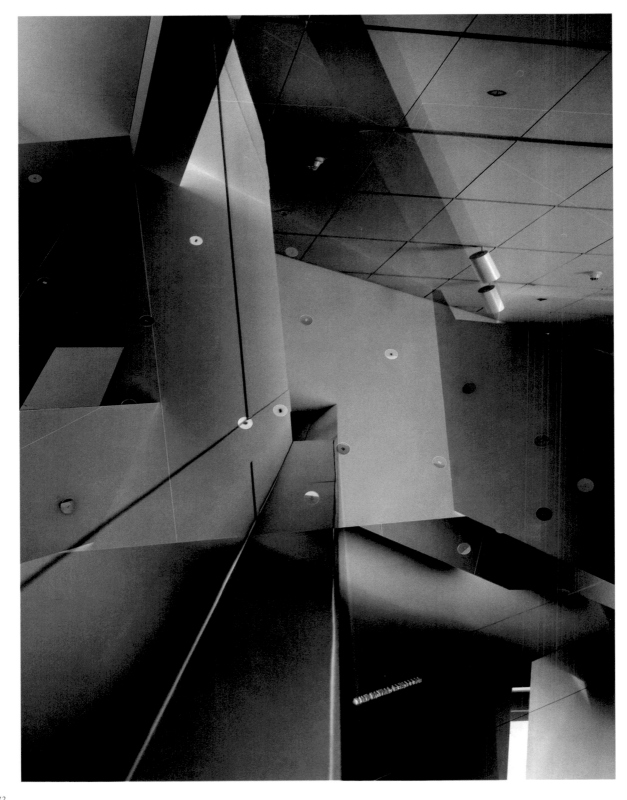

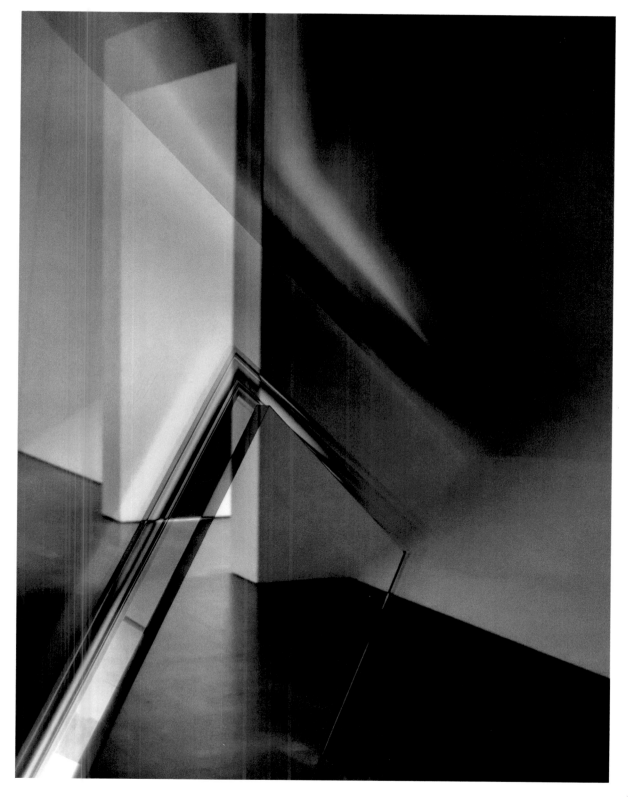

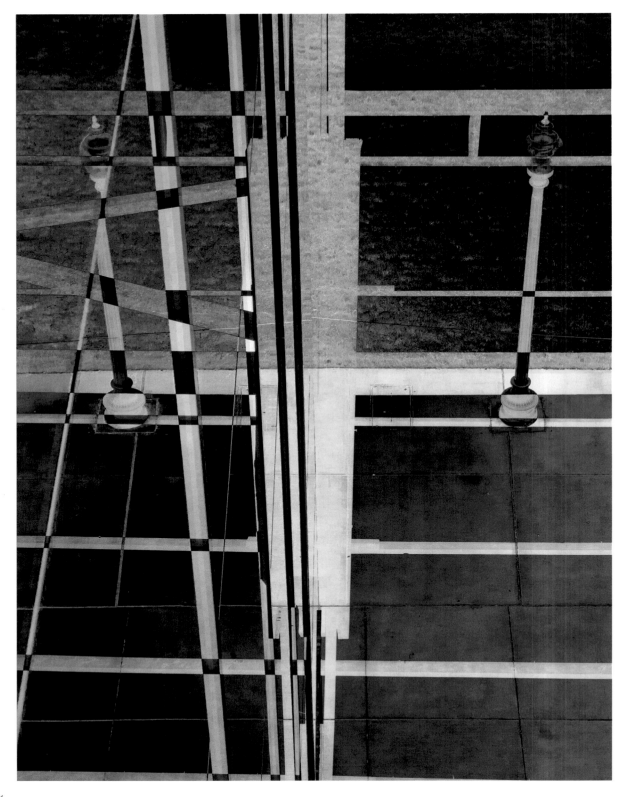

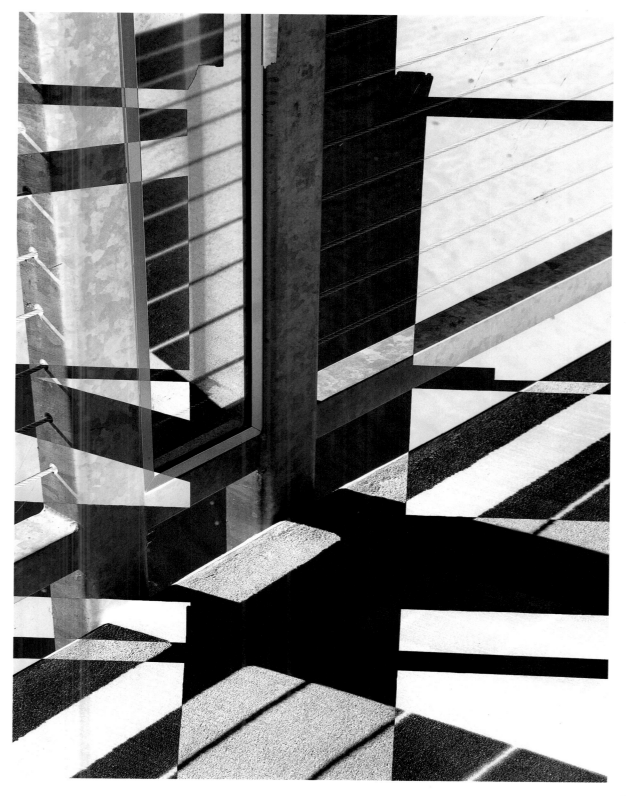

Tangled
by Janet Matthews

www. JanetMatthewsPhotography.com ♦ janetmatthews@verizon.net

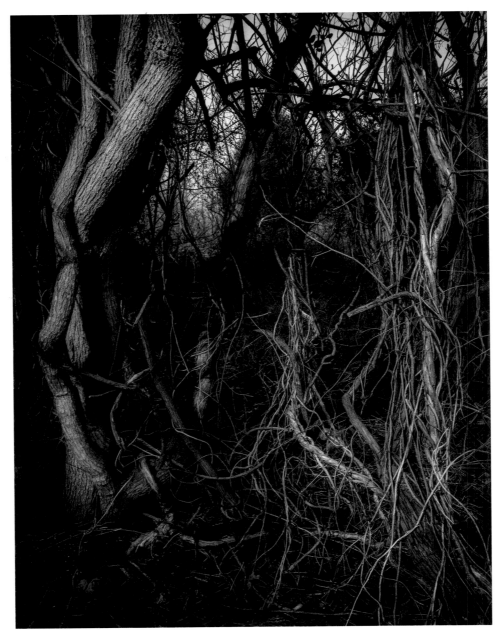

Last year I suffered a heart attack. It wasn't until many weeks later that I began to comprehend the gravity of that event. Photography became a way to contemplate ideas about existence and mortality that soon started to occupy my thoughts. The trees and vines that have always intrigued me as photographic subjects,

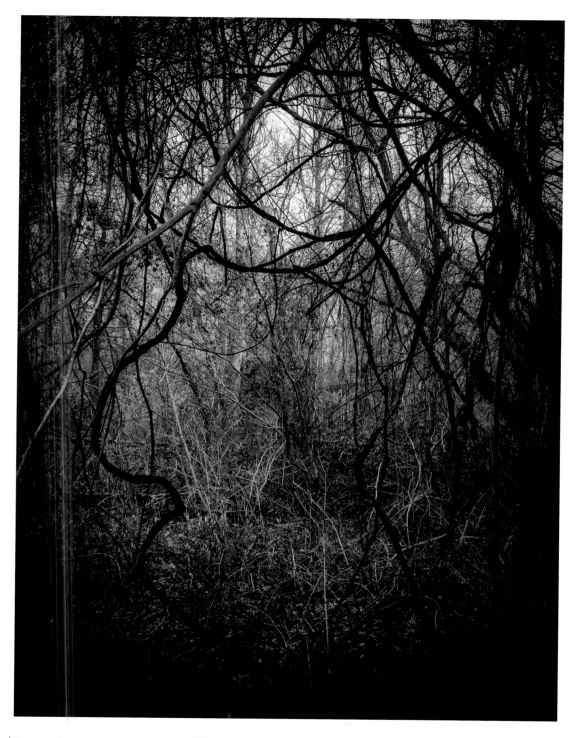

seemed to acquire more potency now. They were tangled, twisted and raw in ways that now felt very familiar. I was affected by their gestures of connection and confusion, clarity and resignation, comfort and hope. They offered a place for me to explore feelings and resolve issues. And an opportunity to make images of that process.

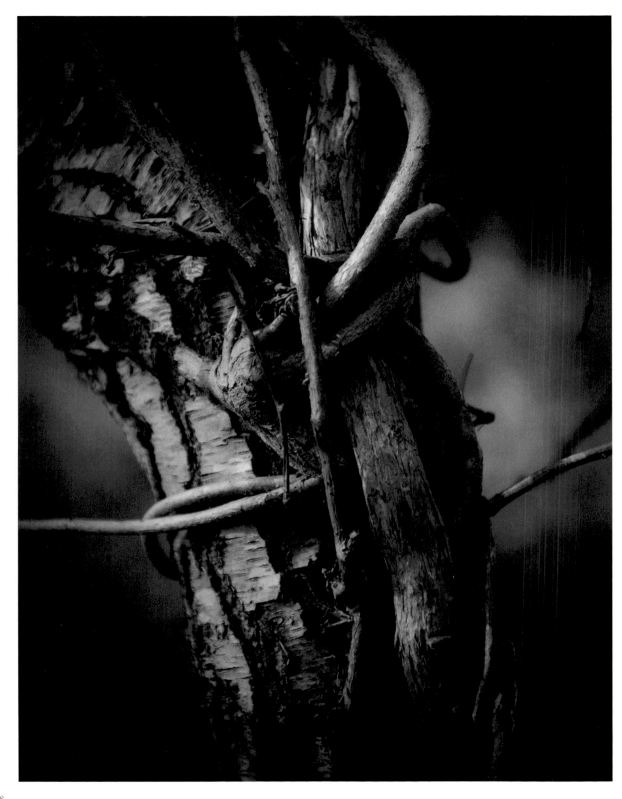

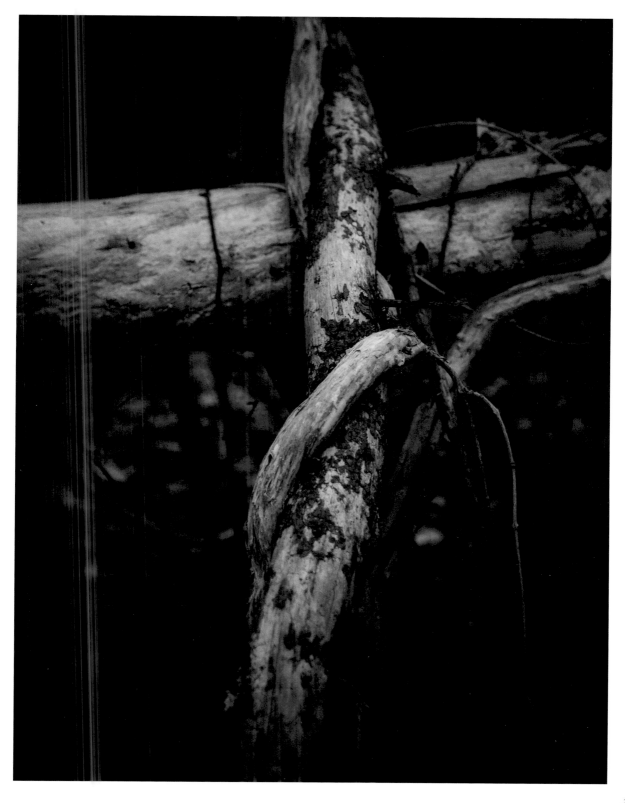

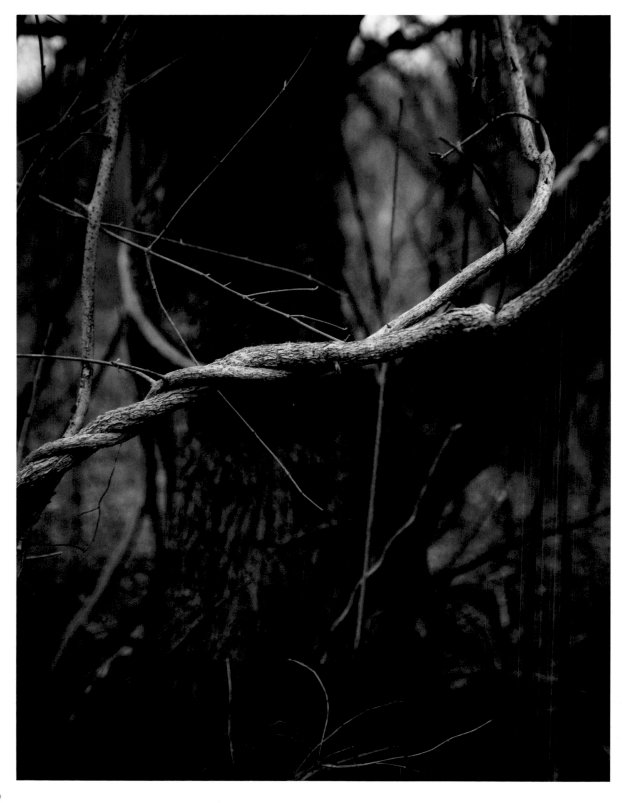

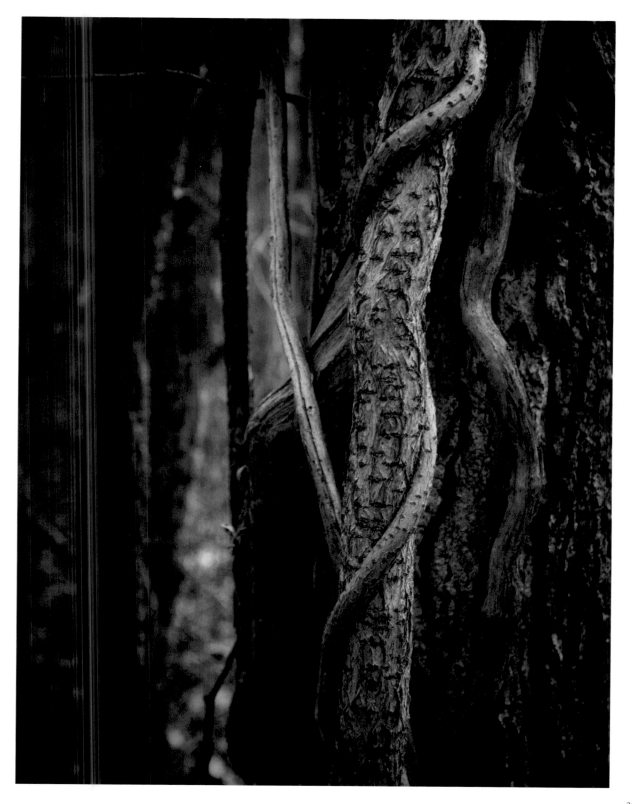

Majestic Monument Valley

by Gary Wagner

www.GaryWagner.com • gary@garywagner.com

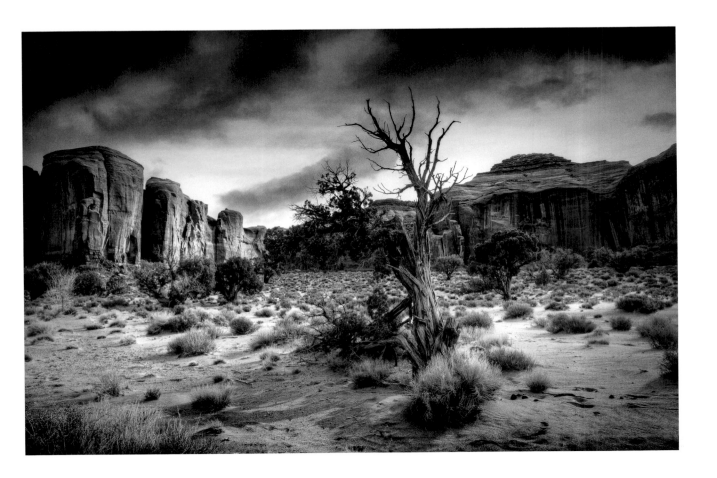

It had been thirty years since my last visit to Monument Valley yet little had changed to the magnificent features of the land reaching up to the heavens. It seems like there are few places you can go today where time and place seem to have remained the same as it did 30 years ago. There is only one unpaved road circling around this spectacular valley without a fast food place or lines of traffic to be found anywhere. The dust was thick and the wind was blowing strong at times, but the land and the sky performed a show for me that was a priceless event — and one never to be forgotten.

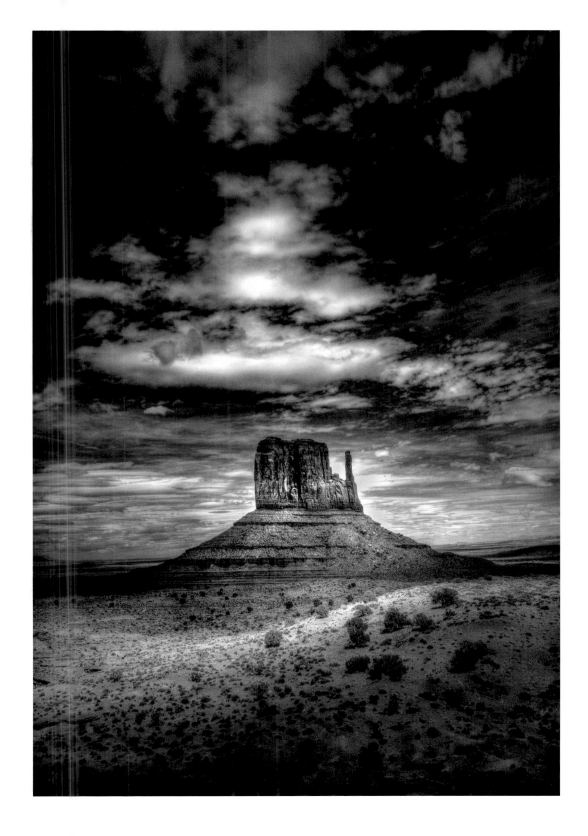

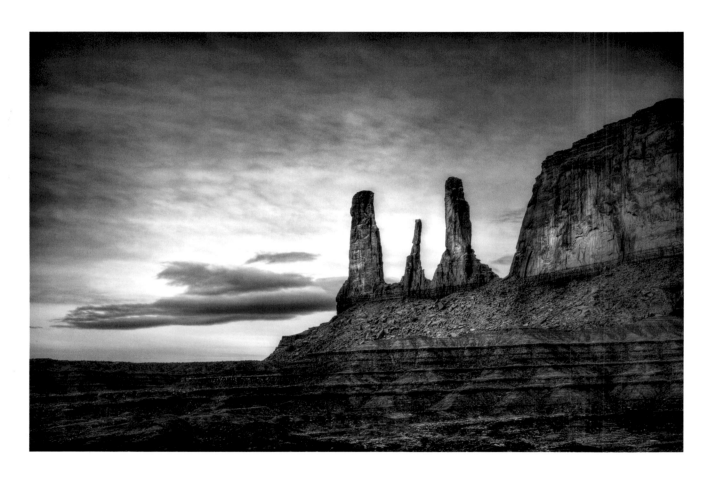

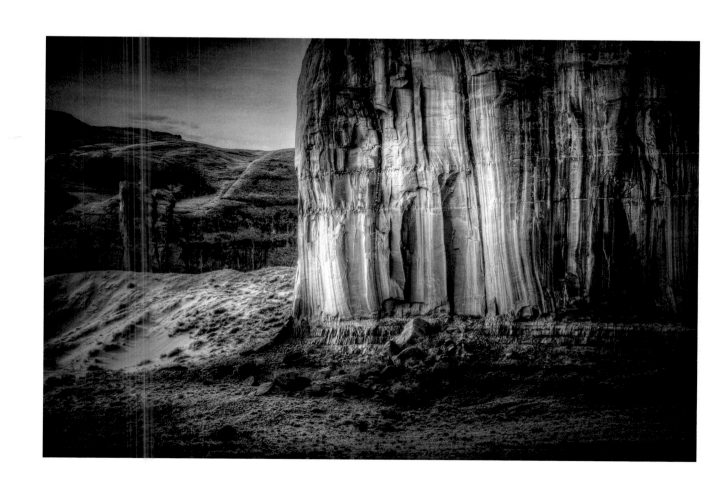

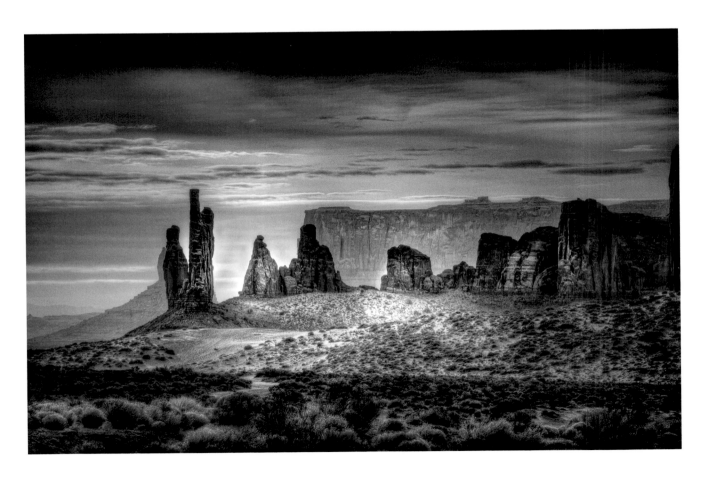

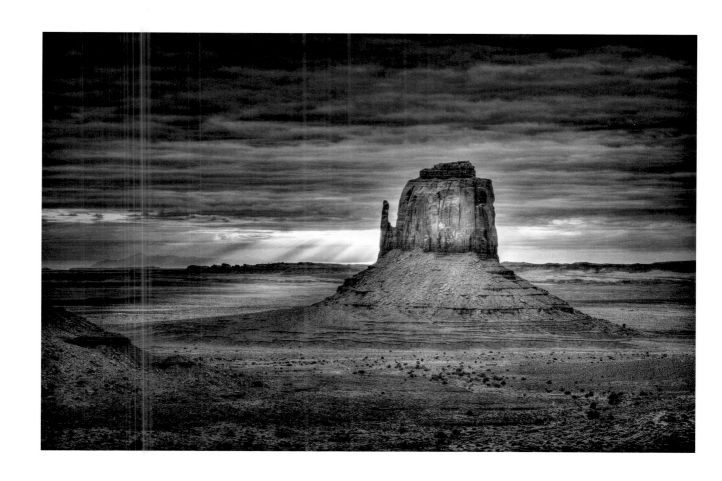

The Uruguayan Gaucho
by Kathy Silbernagel

www.KathySilbernagel.com • kjsilbernagel@gmail.com

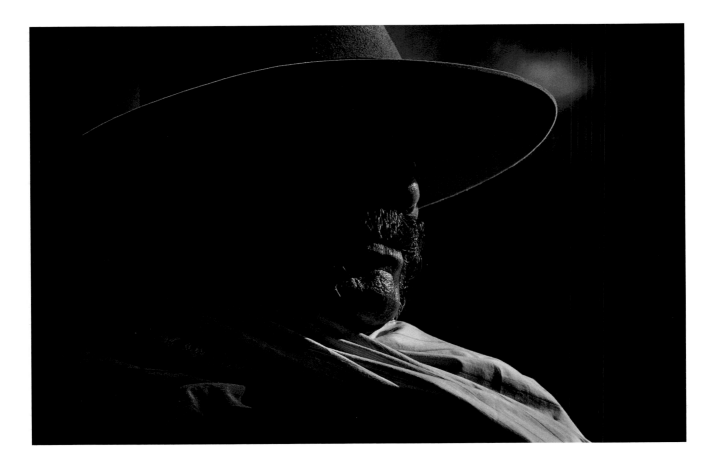

The Uruguayan gaucho dates back to the 1700's when settlements in the prairie-like countryside of Uruguay was being settled. These men, and now occasionally women, are accurately described as cowhands — but in Uruguayan society, they are viewed with much greater respect than the title "cowhand" might suggest. Their history of being nomadic, adventure-seeking men has been the subject of many a song and folk story. They were, and are, regarded as folk heroes — quiet, independent, humble, and romantic. Their garb is preciously chosen and cared for as are their horses. At the heart of this lifestyle is the horse: gauchos and horses are inseparable, and cut a significantly romantic silhouette as they go about their time-honored work.

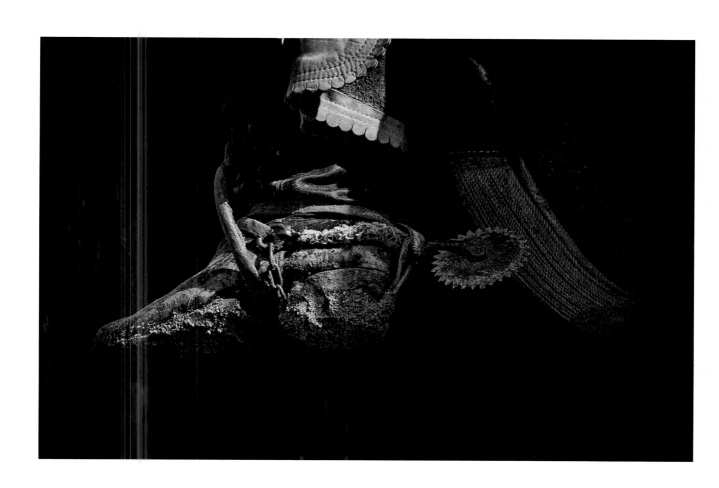

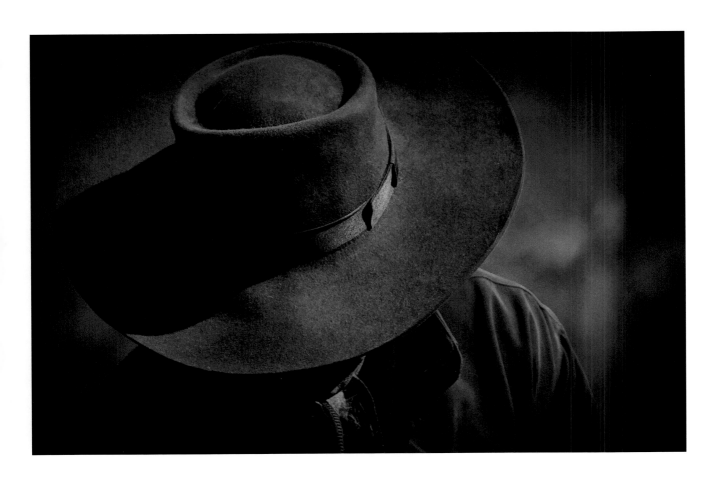

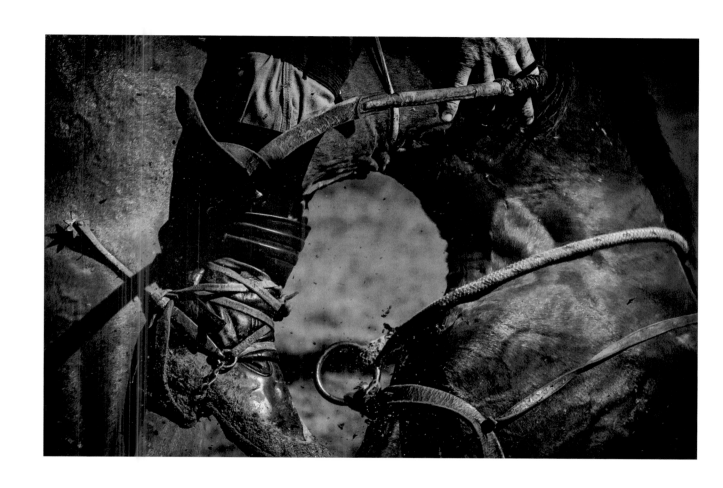

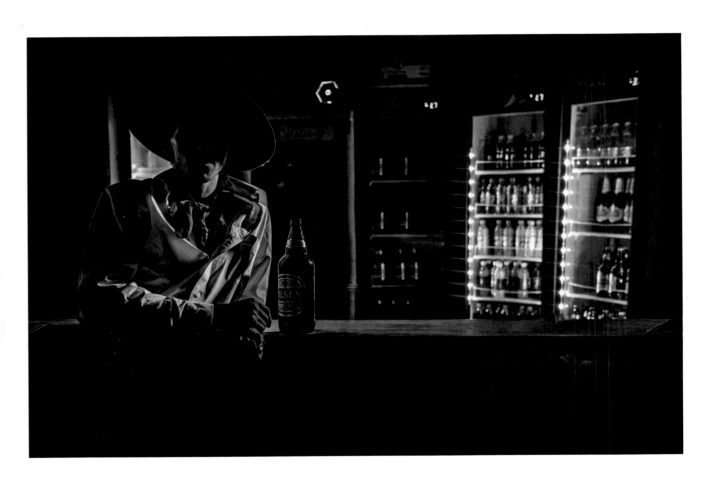

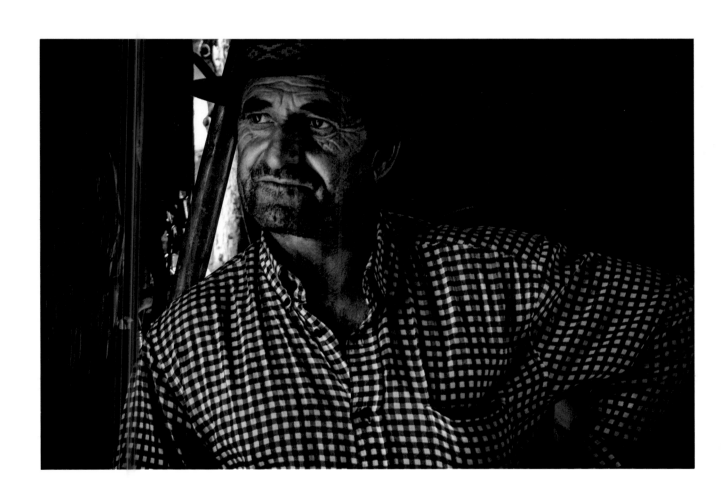

Matador

by Edgar Angelone

www.EdgarAngelone.com • edgarangelone@gmail.com

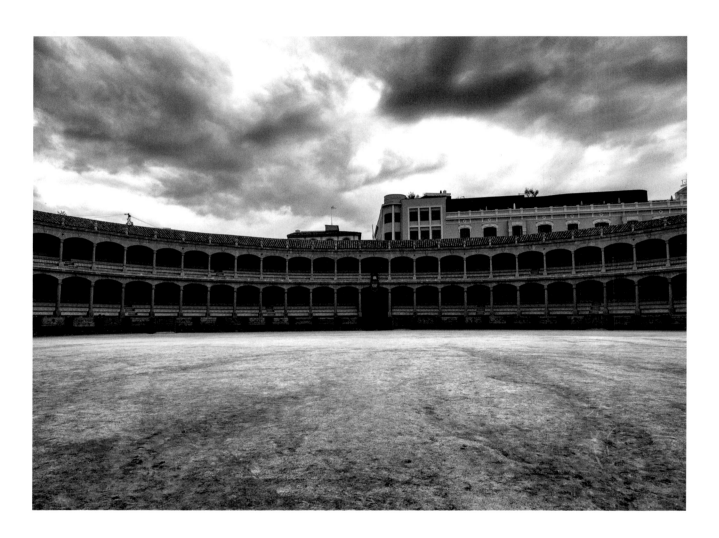

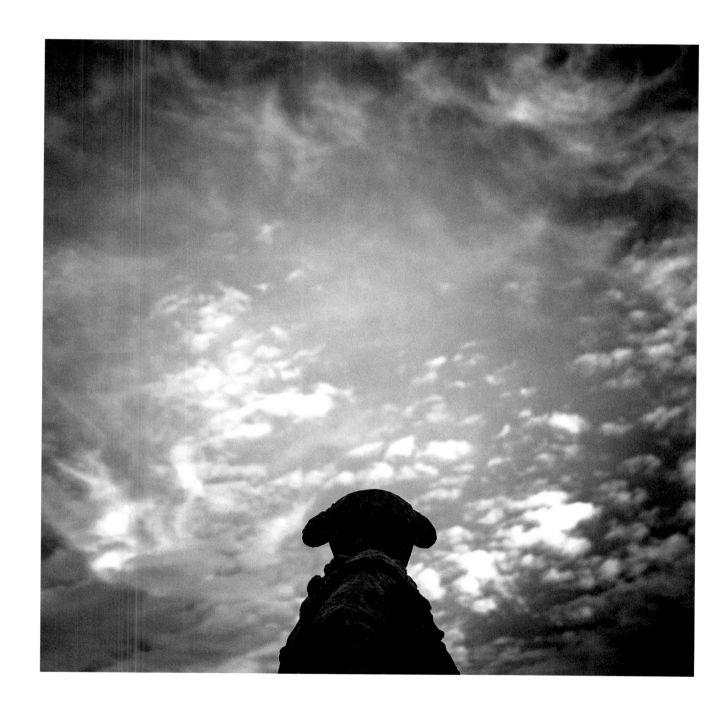

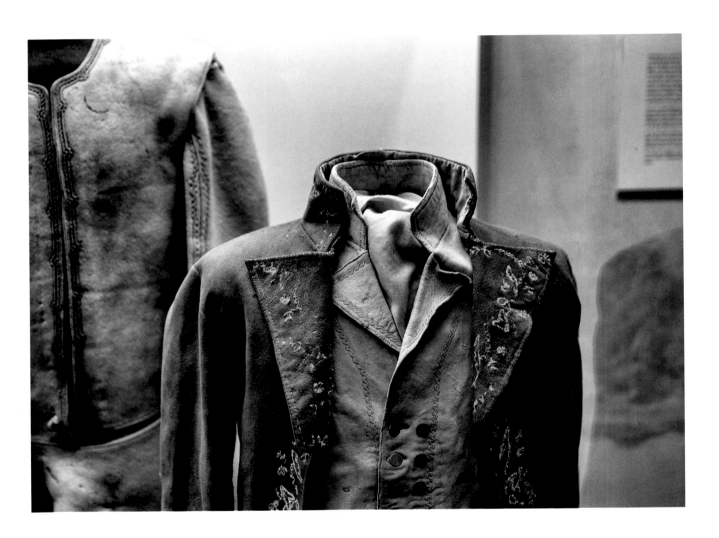

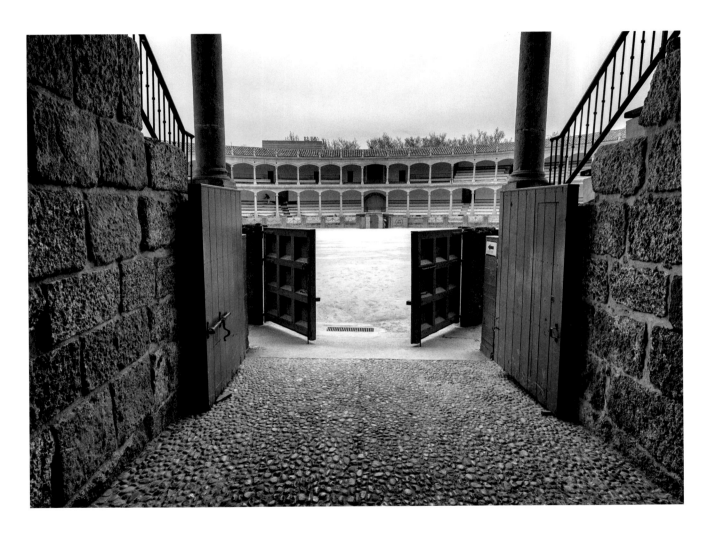

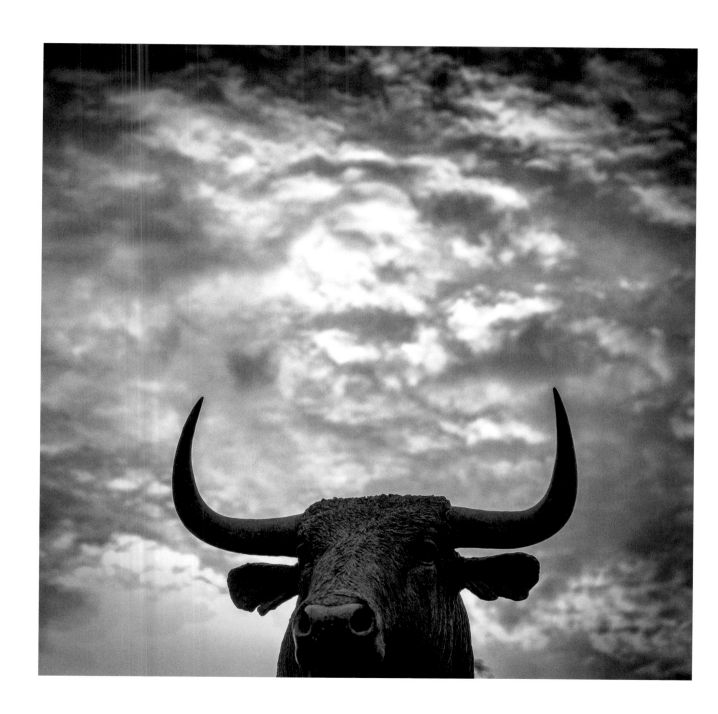

Distant Trees
by Stefan Baeurle

www.StefanBaeurle.com ◆ sbaeurle@gmail.com

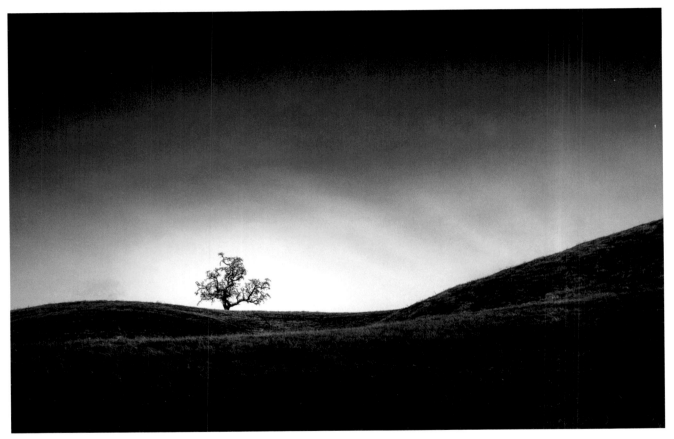

Joseph D. Grant County Park, California

I don't understand why distance must be measured in non-negative numbers.

~ Stephen Page

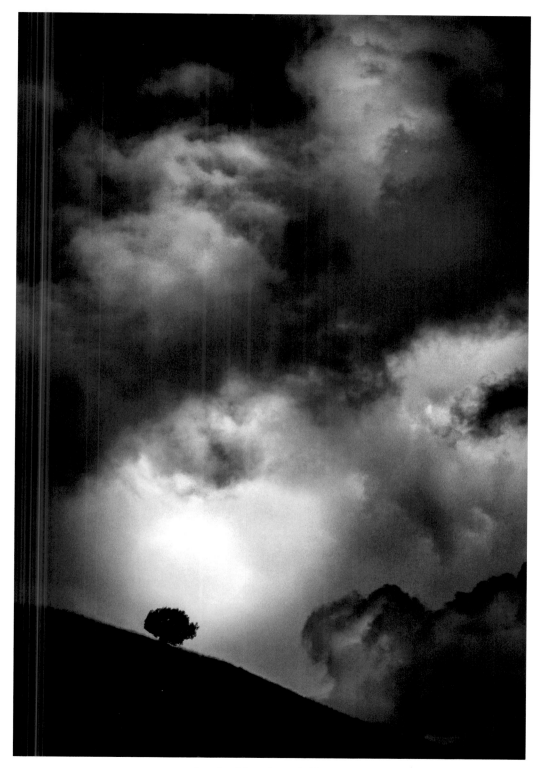

South of San Jose, California

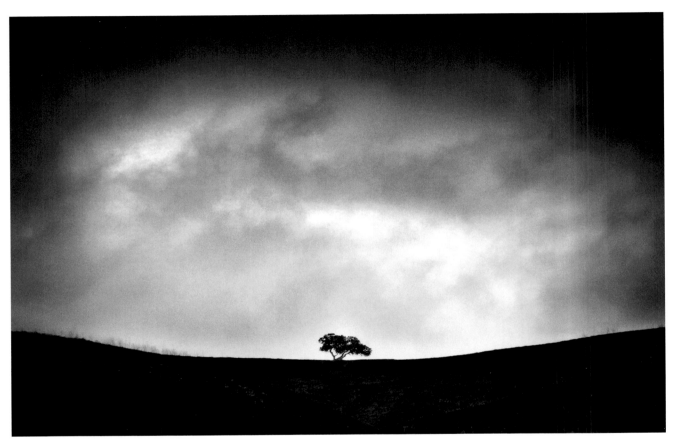

Pismo Beach, California

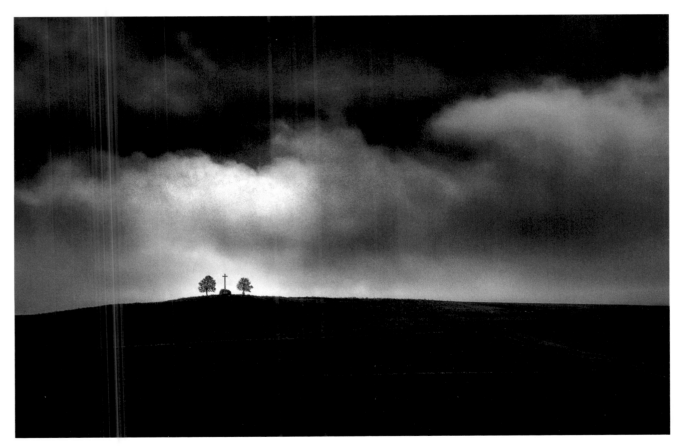

Ries, Southern Germany

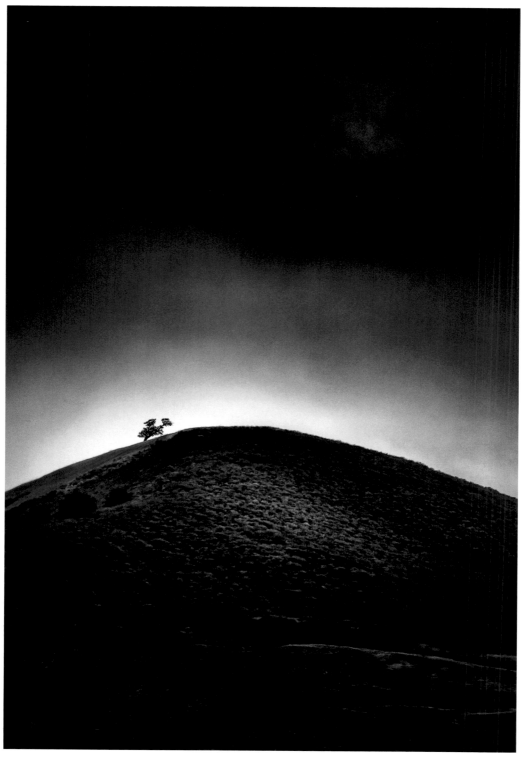

South San Jose, California

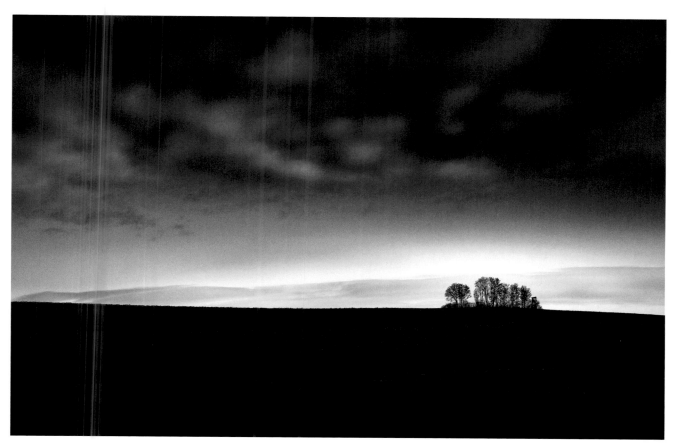

Ries, Southern Germany

Shadows on the Snow

by Christian Bucher

www.ChristianBucherPhotography.com • cbucher77@gmail.com

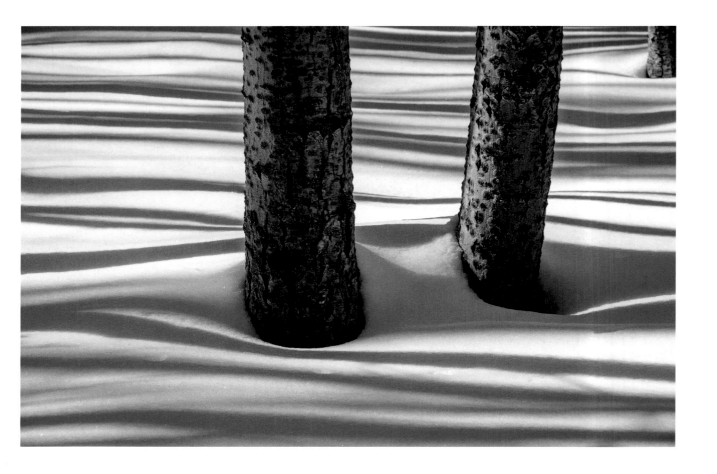

Silhouettes on snow

The shadows of aspen trees

on a winter day

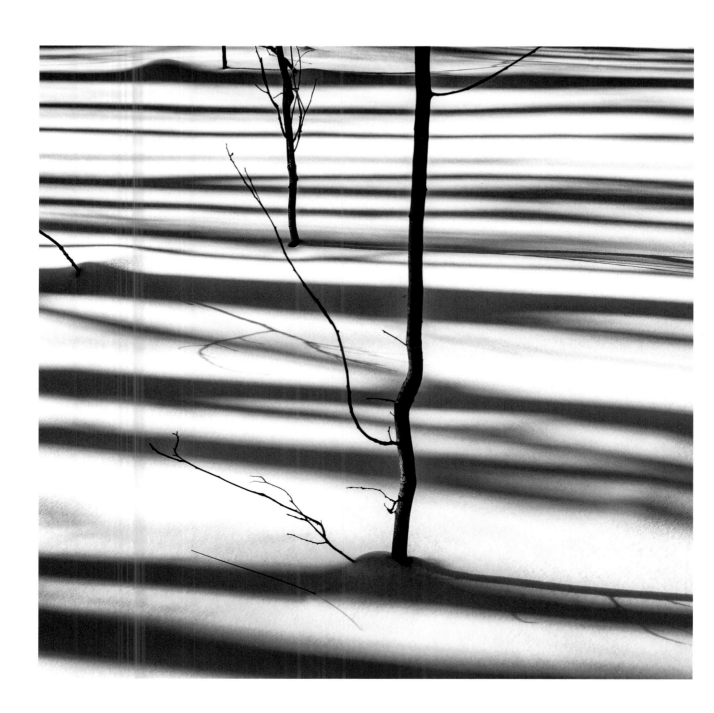

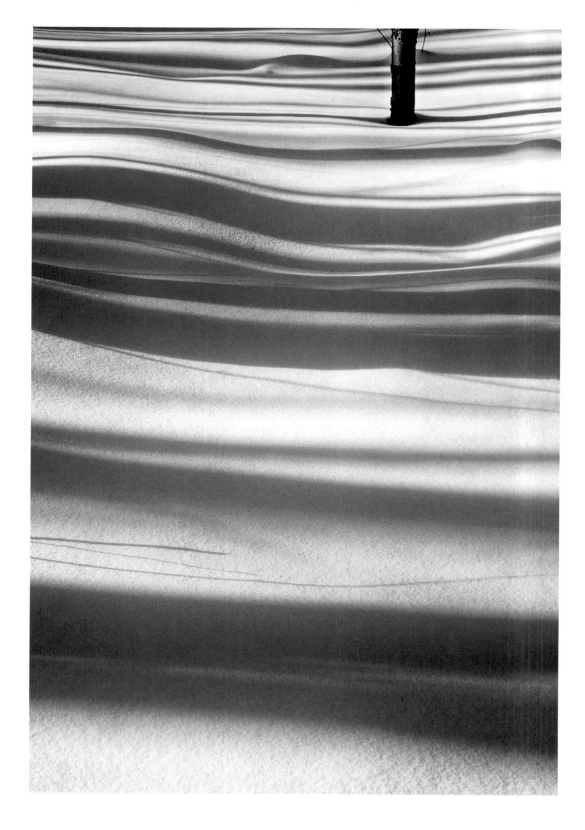

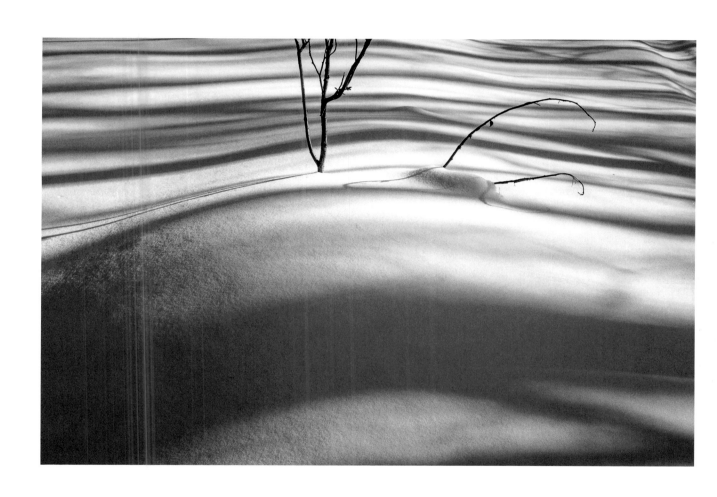

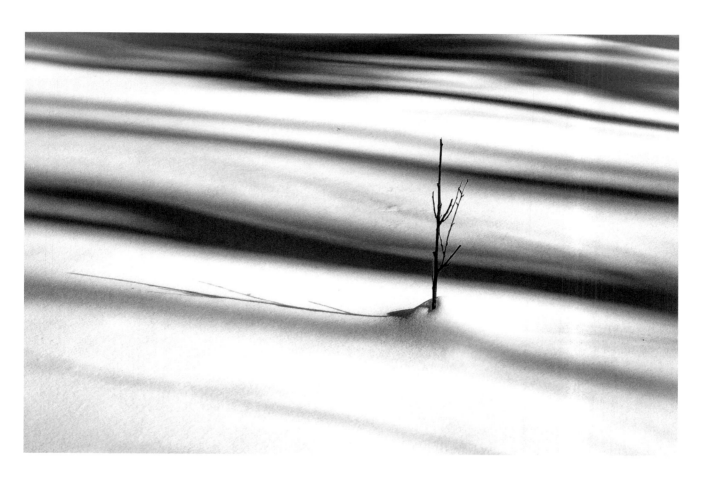

Signs of God

by John Conn

www.JohnConnImages.com • iconn55555@aol.com

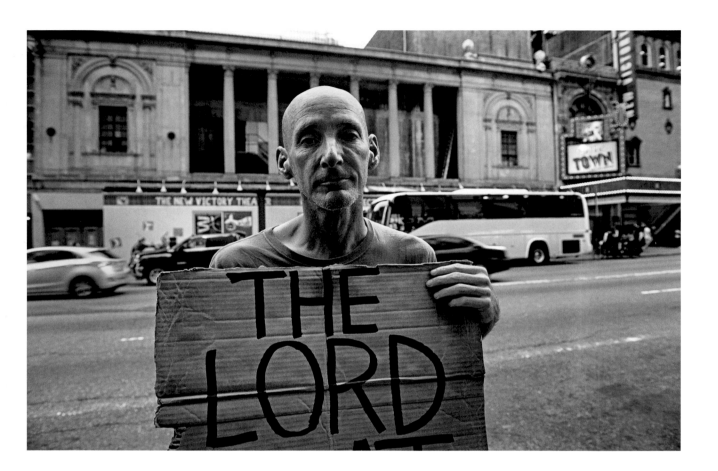

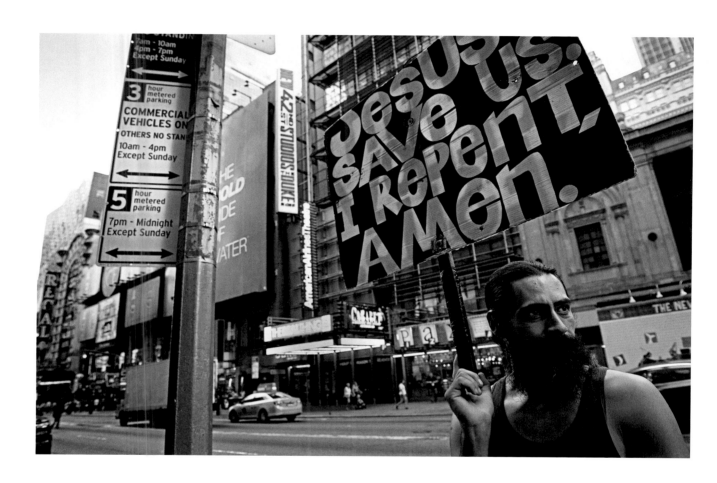

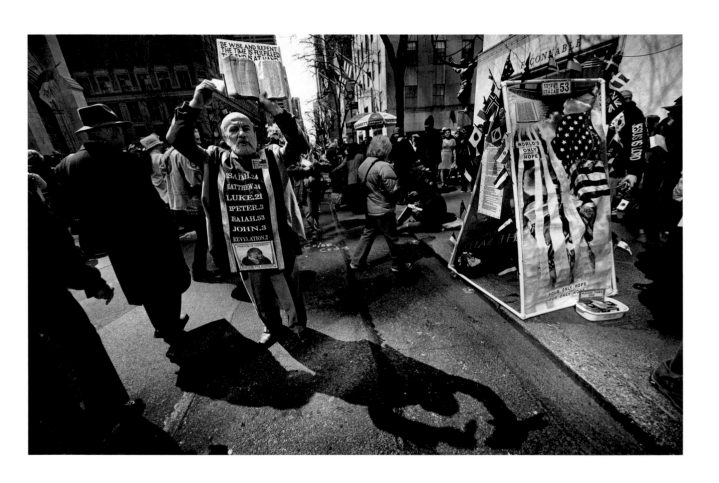

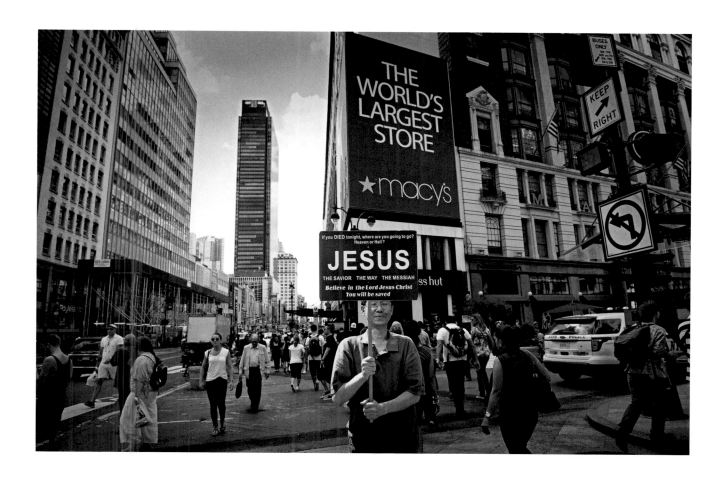

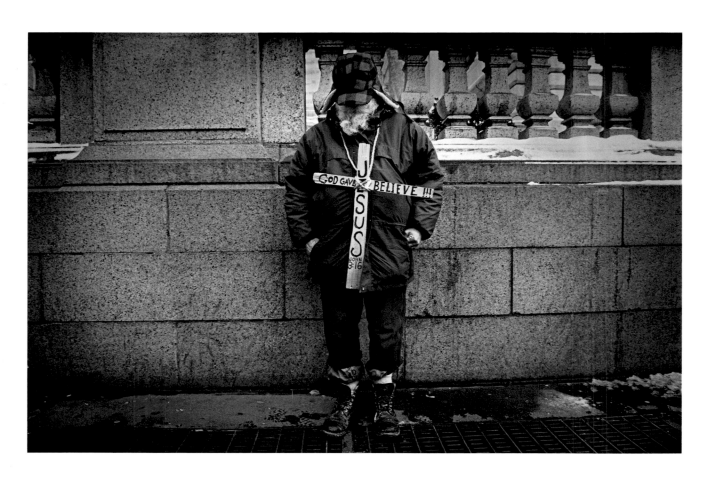

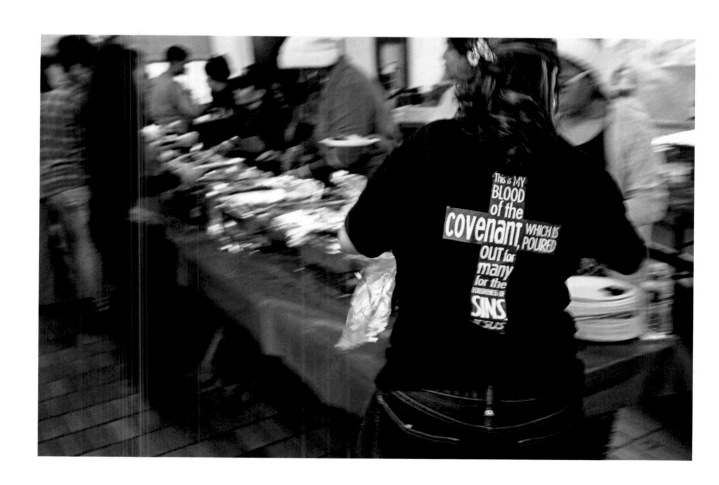

Hand To Dog

by Jenna Leigh Teti

www.JennaLeighTeti.com • jlteti@gmail.com

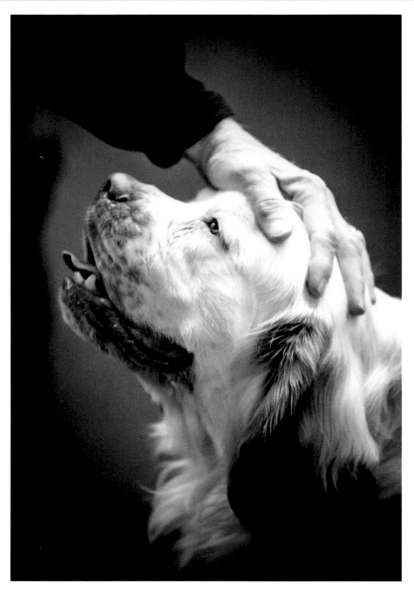

Adoring Gaze

Our hands strengthen our bond with dogs. They provide treats, food, or sometimes, the lingering scents of them. They deliver a message of a job well done, comfort, and companionship through petting, or for the more dignified pooch — primping and pampering so they may better strut their stuff. Our hands are the signature on a contract with man's best friend to nurture and love them as they do us, so help us dog.

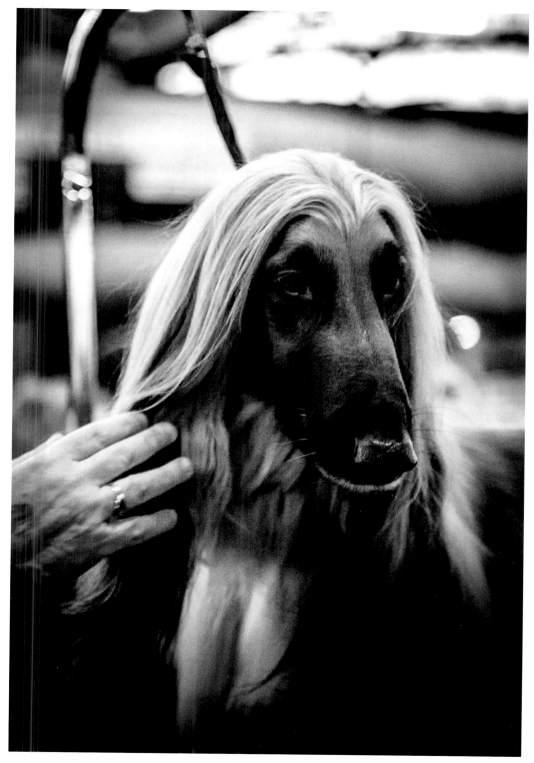

Glamorous

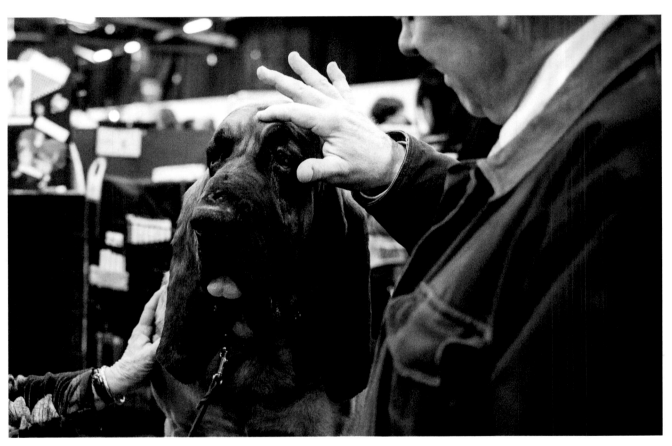

Just A Touch

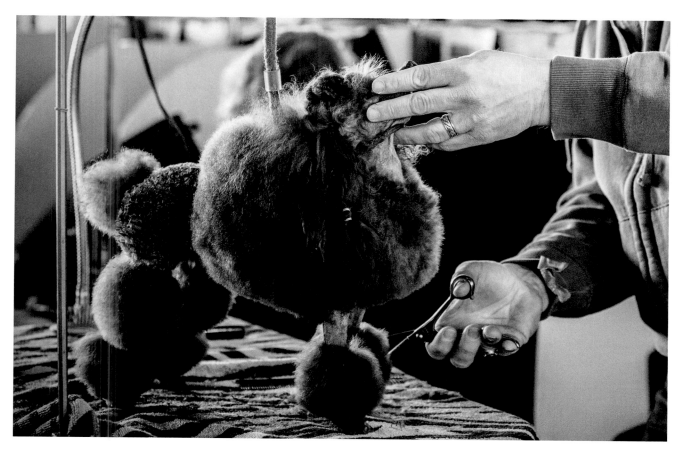

Petite Poodle Primping

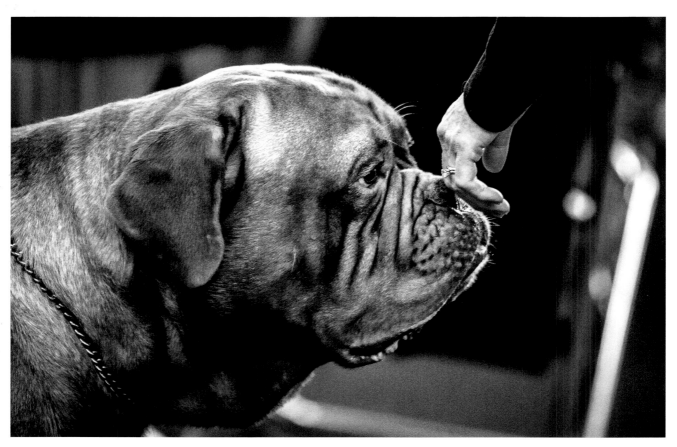

What Did You Have For Lunch?

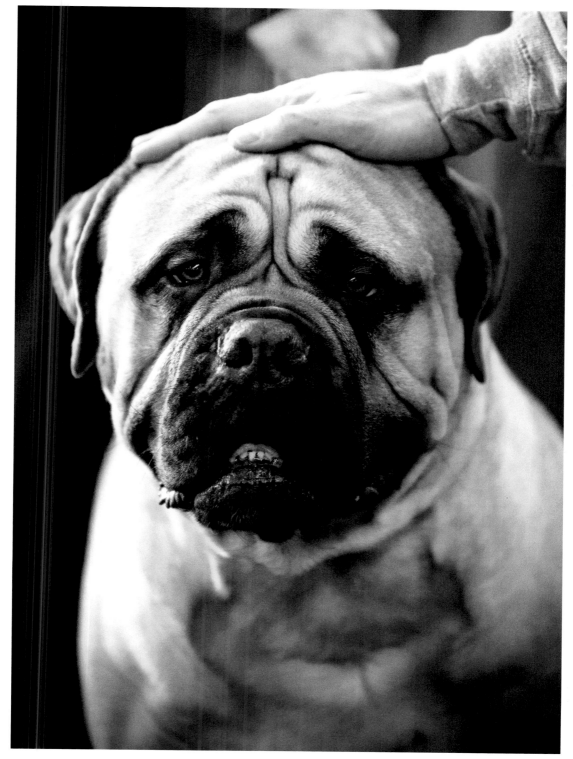

Good Dog

The Candelaria Celebration

by Jose Antonio Rosas

www.JoseAntonioRosas.com ◆ jarosas@me.com

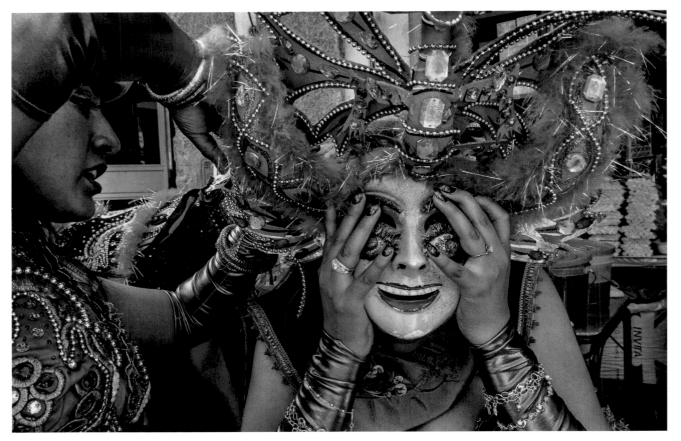

One dancer helps another to set her mask before the dance contest.

The "Fiesta de la Candelaria" is the largest public celebration in Peru. It is a two-week long devotional party held every February in the city of Puno, in the Southern Peruvian Highlands. The celebration begins with Catholic Masses and processions in honor of "La Virgen de la Candelaria" — an advocation of the Virgin Mary.

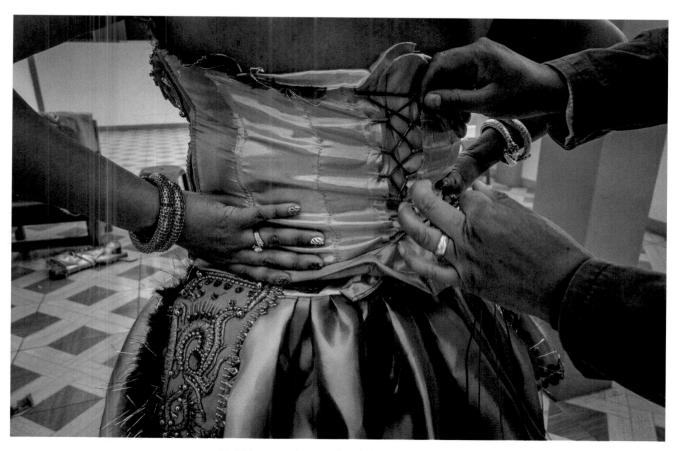

Finishing touches on the elaborate costume.

As the days progress, devotional activities are replaced by street partying, as people from all over the country watch more than 50,000 dancers from 80 dance troupes parade through the streets to their signatures songs and steps. I followed one of the best known troupes, the "Diablada" from the Bellavista neighborhood, from the early stages of their preparation to their final party following the big parade.

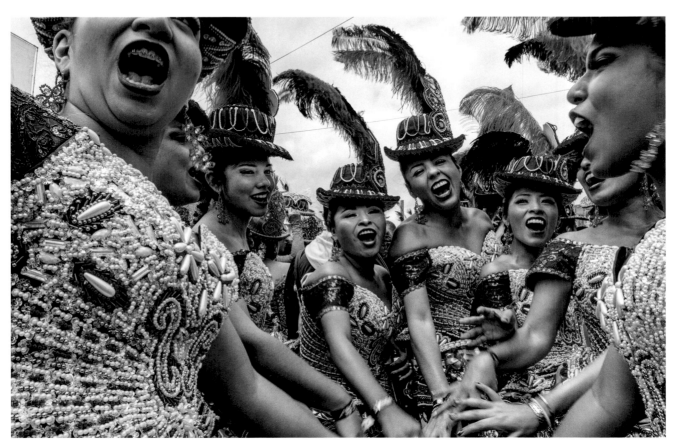

Last hurray before the contest starts.

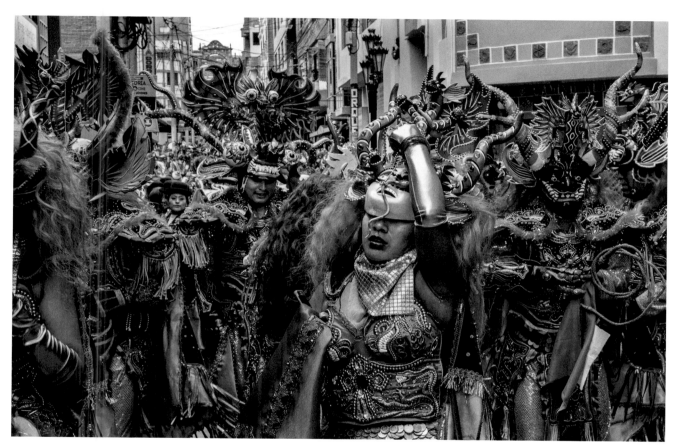

Relief and pride as the parade ends.

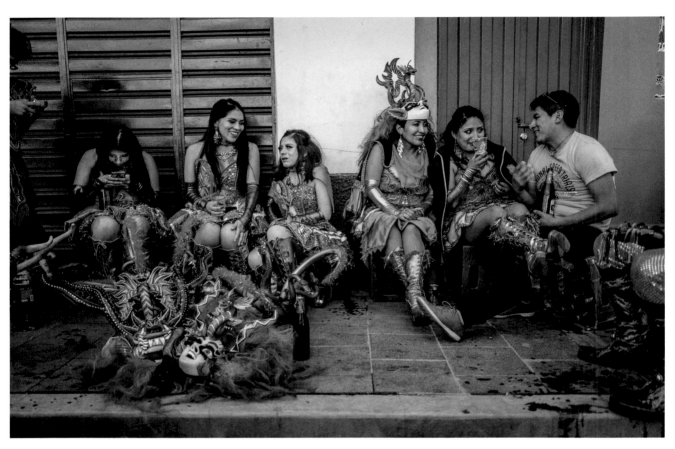

A moment of relaxation at the end of the contest.

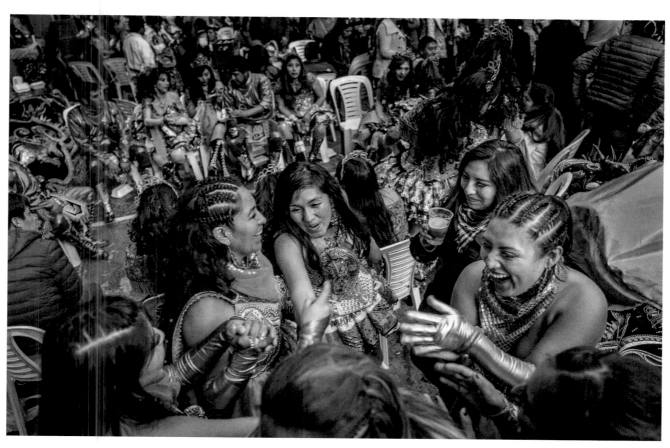

Celebration with music, beer, and dancing after the contest is over.

Textures of Death Valley

by Jennifer Renwick

www.JenniferRenwick.com ◆ jennifer@exploringexposure.com

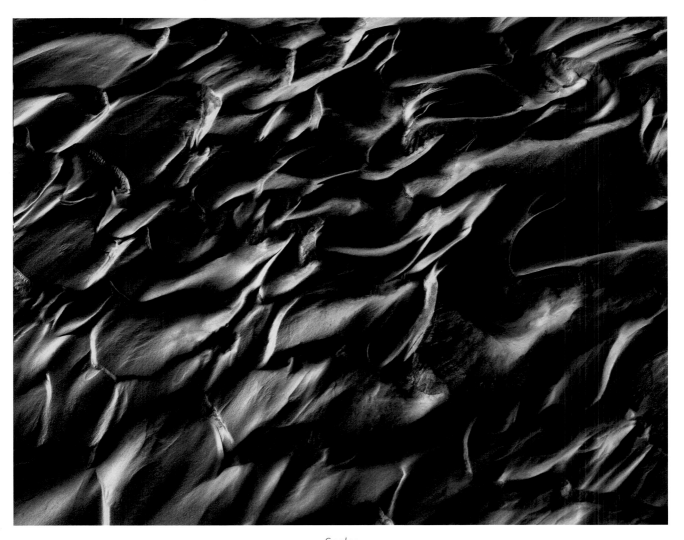

Scales

Death Valley National Park is often thought of as a barren wasteland, devoid of any unusual features or life. The name alone implies that it is a harsh environment to exist and survive in, yet I find myself visiting every winter. The park is full of vast valleys filled with sand dune fields, mud cracks, salt flats, and almost every erosional feature you can imagine.

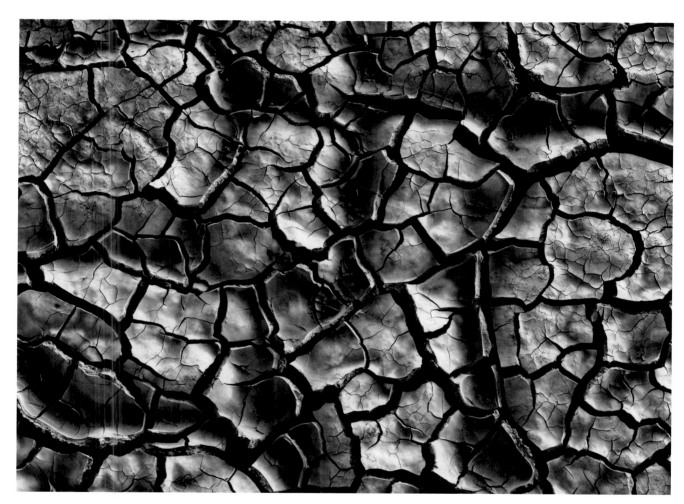

Pathways

Every year I challenge myself to find different and exciting things to photograph. This past winter, I looked past the grand views and found a whole other world on the desert floor. If one looks closely at the ground, there is another dimension of texture and patterns to be seen. I found myself focusing on these smaller yet impressive creations. These patterns in the mud, compositions in the sand, and mosaics of Earth are formed from the seasonal and erosional cycles in the desert. These represent fleeting moments in time when the rain puddles dry, and the currents of water flow through the sand and mud. It's evidence that moisture does exist in this desert land.

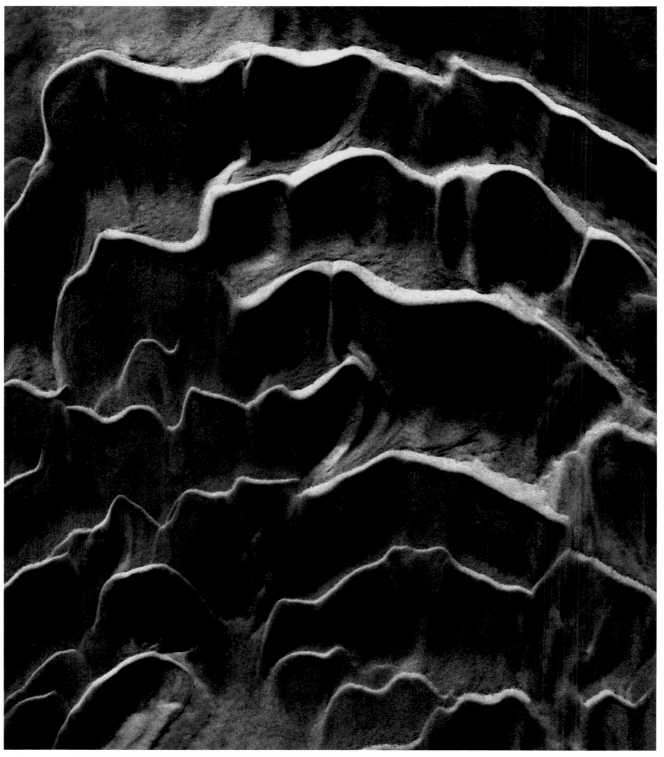

Corrugated

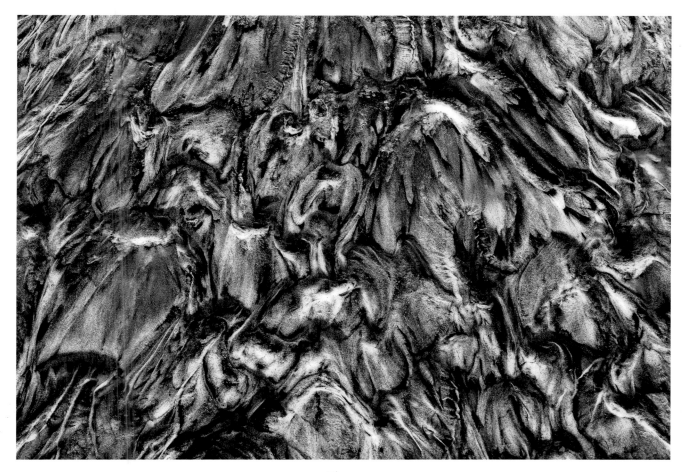

Chaos

As quickly as it happens and dries — in just a few weeks under the harsh sun — these patterns are beaten down and eroded away, never to be seen again. The textures draw my eye and lens in every time — because Mother Nature is a gifted and prolific artist: the chaos of turbulent sand, the cracking mud, and evidence of small mud flows is what she leaves behind, and what I love to get lost in. With imagination, they could represent anything. Even I forget at times that these are small-scale tapestries woven from the elements.

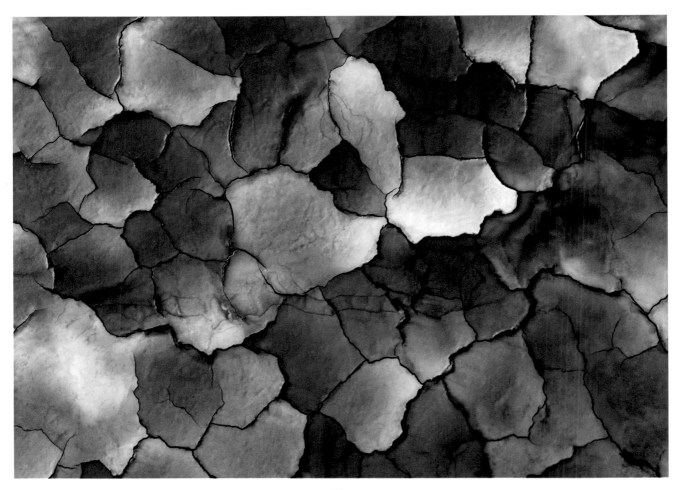

Tiles

All of these were photographed from only a foot above the ground, yet I found myself feeling like I was shooting aerial photographs or walking on an unknown planet. It's easy to get lost in the grand landscapes around you when you're visiting a place. Sometimes, if you look down at the ground around you, a whole other world will appear to you.

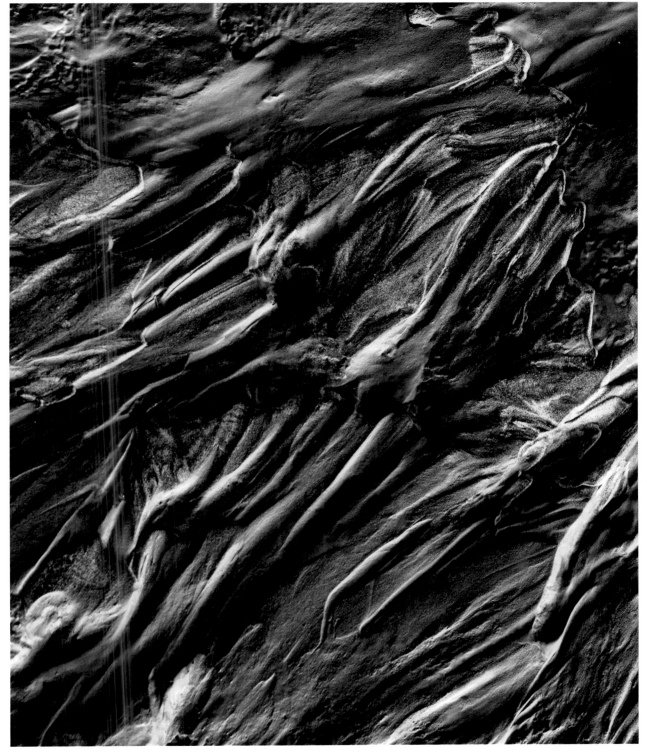

Flow

In Thrall

by Saman Majd

samanmajd@gmail.com

The drones sent to explore the distant moon sent back images of immense crystal structures glowing with ethereal light. Drawn to these structures like moths to a flame, the drones settled into orbits around the crystals, never to return.

First Edition, First Printing September 2018

ISBN # 978-0-9904681-6-5

Published by LensWork Publishing, 1004 Commercial PMB 588, Anacortes, WA, 98221 USA

www.lenswork.com

To order quantities at discount pricing, please call 1-800-659-2130

Printed in Canada